THE SILENT ORGASM

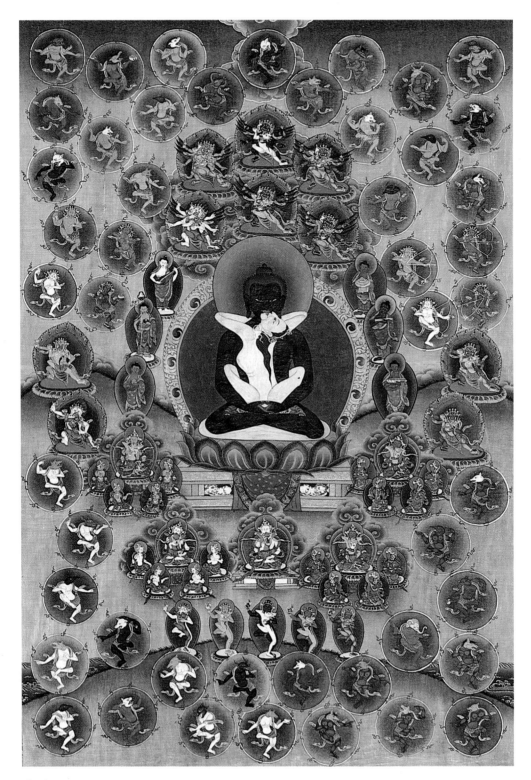

Thanka
Thangka with central Adibuddha in yab-yum position. Nepal, 1989 (52 x 74 cm)

Günter Nitschke
(Swami Anand Govind)

THE SILENT ORGASM

From Transpersonal to Transparent Consciousness

TASCHEN

KÖLN LISBOA LONDON NEW YORK OSAKA PARIS

This book was printed on 100% chlorine-free bleached paper in accordance with the TCF standard.

Original edition
© 1995 Benedikt Taschen Verlag GmbH
Hohenzollernring 53, D–50672 Köln
Edited by Monika Zerbst, Stuttgart
Cover Design: Angelika Muthesius, Cologne;
Mark Thomson, London
Production coordination: Bernd Hirschmeier, Aidlingen;
WZ Media Stuttgart

Printed in Italy
ISBN 3–8228–8907–5

In gratitude to my masters

Osho

Suzuki Kou,
master of calligraphy

Henry Lee,
my initial guide to the Far East

The irises
in my garden in Kyoto

Contents

Towards Transparency of Consciousness

It has been a century now since Western scientists began developing the discipline of psychology, and a century since our rationalist culture began absorbing concepts and practices associated with the Eastern spiritual traditions as well. Most Westerners today have some intellectual familiarity with psychology as a tool for understanding the self, and millions more of us have some idea or experience of Eastern-style practices such as yoga, tai chi or meditation. Human beings in all eras and all settings thirst for self-knowledge; in many western societies today, the search is colored by this ambiance of psychologistic thinking and meditative experimenting.

From its inception Western psychology has targeted the mind and its contents for analytical investigation. In the East, since ancient times such efforts have been regarded as a game which is ultimately a waste of time. The traditional assumption is that one must go beyond the mind in order to begin to understand its workings. How can an apple see itself? The East does have its own tradition of psychology, in the literal sense of discourse about the psyche. In India, especially, but also in other areas, various conceptions of consciousness have developed over the centuries, but for the purpose of pointing to and beyond the process of awareness rather than analyzing its content. Practice has always been much more important than theory—individual, experiential practice of meditation.

I hold meditation to be the means and the end of real self-knowledge. My main qualification for writing about self-knowledge is that I am a meditator, a meditator who has become fascinated with the styles and roots of meditation practices and who seeks to illuminate them for other meditators and would-be meditators. The inspiration to write about meditation came from my personal discovery of a particular technique (see Chapter Six), and my subsequent finding that it has not been documented.

The myriad techniques of meditation can be generally classified around the two poles of passive and active styles, which I describe in Chapter One as the hunting and the orgasm types of meditation.

Today, meditation tends to be naturally approached within a context of thinking and questioning concerning the nature of the mind. To depict this intellectual baggage, I have devoted Chapters Two and Three to a critical discussion of selected models of consciousness. These include the main traditional models of South and East Asia as well as three contemporary Western models. The discussion is not intended to synthesize East and West, nor to identify a supremely true path; but rather to set the stage for describing various techniques for knowing the self.

The experience and understanding of meditation in the West is also commonly enough linked with therapy. This is also true in my case, and the particular discovery that motivated the writing of this book occurred within a therapeutic context. My own somewhat eclectic experience is the baseline for my descriptions of several sorts of therapy in Chapter Four. These particular therapies fit in with the topic of meditation because they are transpersonal or designed to reveal the self in a perspective larger than the present context of individual consciousness.

Personal experience is also the starting point for "*The Silent Orgasm*" (Chapter Six), which introduces and documents the central topic of this book, the post-orgasm meditation which I call **transpersonal sex** or **mandalic sex therapy**. This chapter is preceded by a review of contemporary teachings of Tantric and Taoist practices of sex and meditation; and it is followed by an Appendix which surveys some exoteric elements of classical Tantric ritual in a search for precursors of mandalic sex therapy.

While I have been both a receiver and a provider of therapy, my approach is essentially that of a lay practitioner as opposed to a trained clinician. References to psychology and its jargon are kept to a minimum and are made in order to describe processes of awareness. I have ignored the clinical realm of so-called insanity and its literature, because the question of the degree to which one is insane is not relevant to my thinking or practice. We are all insane to some degree: we are all fragmented, 'cracked', which is the meaning of 'crazy'; we are not whole and therefore not holy. The rare exceptions are the enlightened ones, and their wholeness shines forth from the depth of their simple language.

Recent literature on consciousness research is studded with references to non-ordinary or altered or expanded states of consciousness. These are set against our normal waking states of con-

sciousness, thus tending to create a new ontological duality. I have made a particular effort to depart from this practice, since the first two terms have too much of a psychopathic or hallucinatory nature, while the term 'expanded' implies that completely new territory of con sciousness may be conquered and occupied by special techniques of meditation. My own experience is that consciousness is one, and that the whole territory of consciousness is already one's own. Strictly speaking, consciousness is holistic, even though for mundane purposes we tend to conceptualize its various degrees of complexity in terms of separate levels, such as the conscious and the unconscious, or the personal and the transpersonal.

Following the lead of Jean Gebser, I would prefer to use such terms as *intensified, integrated* or *transparent* to describe the states of consciousness which are reached by meditation or various kinds of therapy. Such techniques only render consciousness more transparent, more diaphonous to the meditator; nothing is actually added. The term 'transparent' does not introduce new conceptual duality to the discussion. To speak of a transparent state of consciousness implies that nothing special has to be done to reach it; that no one particular technique can cause it; that with stillness and patience, the mud of the thinking mind will settle as in a river after a storm. To use an age-old metaphor of consciousness, things become crystal clear.

In many ways this one word *transparency* has the power to herald a paradigm shift in our understanding of consciousness. It frees consciousness equally from time, space and causality; it shifts attention away from the sequences of different phenomena and toward a synchronistic, mandalic whole. It opens the way to the holy, at least in the sense of the holistic, the holiness of whole consciousness. The more integrated and holistic consciousness becomes, the more it owns what has been its birthright all along. Such is the basic tenor of this book.

In one stanza of his Yoga Sutra Patanjali has already spoken of such adamantine or crystal clear consciousness as the very characteristic of meditation:

"When the activity of the mind is under control, the mind becomes like pure crystal, reflecting equally, without distortion, the perceiver, the perception and the perceived."
(*Rajneesh, Yoga*, Vol. 3, 1976.)

Scholarship has been a part of my profession for a number of years, and two decades in academia have left me with little respect for purely scholarly pursuits. When it comes to meditation I find it especially difficult to understand the scholarly approach. You either do it or you do not do it. To talk about meditation without reference to one's own experience is not genuine. Hence most of the innumerable treatises on Taoist and Tantric meditation seem strangely empty; those scholars who refrain from reporting their own practices, experiments and judgments must admit that they are merely scribes.

I myself do make value judgments throughout the book. I am a meditator and thus I present discoveries made on my own path using them to evaluate the physical practices and metaphysical claims of any text, ancient or brand-new. My purpose is to stimulate discourse among people who meditate, scientists who carry out research on consciousness, and those who are simply curious. It would gratify me if I were able to lure someone toward a first direct taste of meditation, that ultimate fountainhead of both human energy and awareness. This volume is very much a cookbook of meditation techniques, containing old and new recipes along with evaluations as to whether these recipes lead to any meal at all and what those meals taste like.

I was awakened to meditation in 1974 by Osho, formerly known as Bhagwan Shree Rajneesh,and even though I have worked hard myself, it seems that most of what little I know has come through him. I acknowledge this most profound gratitude from the outset. My relationship to that unusual human being, and to many friends associated with him, has been so long and so intense that I am sometimes incapable of distinguishing my own voice from his voice inside me.

I am also deeply indebted to a woman who worked with me during 1989 and 1990 and made the discovery of mandalic sex therapy possible. If the results of this beautiful meditation can be replicated and verified by others, then they should join me in gratitude to a courageous and unusual person, who shall remain nameless here.

Thanks are also due to my friend and longtime editor Stephen Suloway, whose conscientous efforts have brought a greater transparency to this manuscript.

Günter Nitschke, K y o t o , 1993

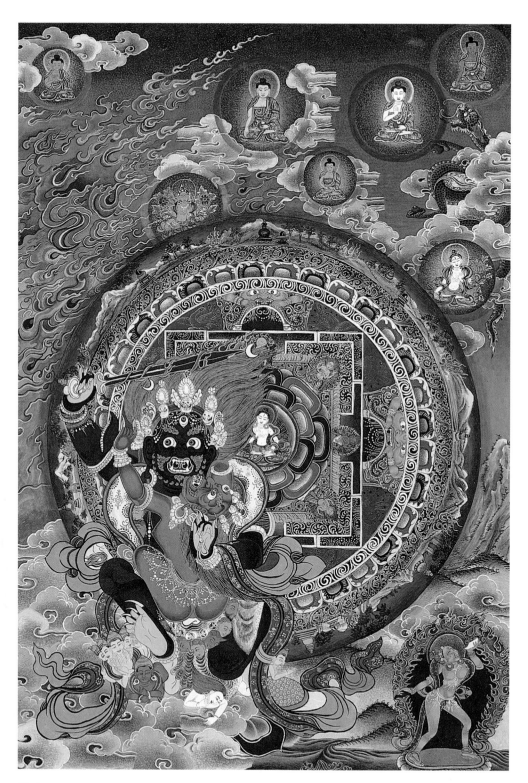

Bhairara
Bhairara, a terrifying manifestation of Siva, with his Sakti (44 x 63 cm)

Meditation as Hunting, Meditation as Orgasm

Our formal knowledge of the personal exploration of consciousness includes two contradictory explanations of how our ancestors discovered meditation. These two paradigms have become general models or religious intellectual traditions by which we differentiate and understand the infinite number of meditation techniques, whether transmitted from the dim past or recently invented. The first paradigm believes that meditation occurs in absolute stillness; the second, in utmost ecstasy. How strange that such divergent models for achieving a common goal have existed for at least three millennia, and that each is still adhered to by a large community of meditators.

Stillness
The hunting paradigm

One paradigm presents the prehistoric human being who, as a hunter, had to sit absolutely still for long periods in order to encourage wild animals to approach close enough so that they could be killed. That is, he was led to practise what the Japanese call *zazen* (sitting meditation). Through this sitting technique, the hunter became aware of the rhythms of his own breathing and heartbeat, especially when he faced personal danger. Perhaps, and this will forever remain a guess, he discovered deeper layers of his being, and he may even have fallen by accident into meditation— into an experience of oneness with the whole of the universe. Strictly speaking, this would not have been an experience in the usual sense of the word, for in that moment the experiencer would have disappeared. This state of being will be termed 'meditation' in this book, as distinct from 'techniques of meditation', of which there might be as many as there are human beings.

As the technique of sitting still, of being absolutely silent, marks the one extreme of human motion and emotion, the other paradigm of the discovery of meditation is its polar opposite, utmost ecstasy: orgasm. In orgasm the human being momentarily transcends the sense of separateness, the sense of time and place, the sense of self and other. It is true even now that orgasm is the only occasion when the typical person becomes truly authentic and whole. The paradigm holds that the bliss of transcending all duality, however brief, drove our forbears to search for

a means to lengthen it, or to trigger it, by techniques other than sex.

The hunting paradigm is not very widely known in the West. I was first made aware of it in the 1970s through the writings of Gary Snyder, who drew on East Asian sources. It constitutes an umbrella large enough to spread over the explorations of all the individuals and communities, ancient and modern, who have tried to achieve meditation by means of utmost quiescence, through keen, choiceless watchfulness.

Ecstasy
The orgasm paradigm

The orgasm paradigm, on the other hand, runs like a leitmotif through nearly all studies of South or East Asian erotic art. It is generally accepted as the raison d'être of the Tantric and Taoist paths of love. Most religions have worked to suppress sex, usually for social reasons. In Tantra it is not sex but orgasm which is manipulated and suppressed, for spiritual reasons. We should therefore give very careful scrutiny to the ancient and modern claims of combining orgasm and meditation. Through my own experience with meditation, covering eighteen years, I have come to believe that orgasm is nothing more than a limited and very short-lived source of psychosomatic pleasure.

Indeed, there seems to be no record of anyone having become enlightened at the moment of orgasm. The many books on Tantric and Taoist love offer various methods to delay or prevent orgasm, but little or no practical advice on the use of orgasm to trigger states of intensified consciousness. In practicing inward (or 'valley') orgasm—retaining the semen in order to move sexual energy from the lower to the higher chakras—one may choose to prolong sexual ecstasy. But the use of this practice to achieve spiritual ends, as suggested by Tantric writings, both old and new, remains a dubious endeavor in my view. Still it cannot be denied that the representation of sexual union in painting or sculpture may serve as an easily understood symbol for a higher experience of non-duality. It might even symbolize a state of no-mind (to use the Zen term), in which the acquired and ever-noisy software in the human brain has finally been silenced.

A revision is called for in the current interpretation of Tantric and Taoist methods of meditation which use sex as a vehicle. It is possible to liberate ourselves from the obsession with sexual satisfaction through orgasm. We should instead shift our attention to the period following orgasm (often dismissed as post-coital de-

The Silent Orgasm

pression but really offering a chance for post-coital bliss), which presents a unique chance to achieve higher states of consciousness up to meditation.

On the theoretical level, I propose to resolve the opposing paradigms of meditation—the hunting paradigm and the orgasm paradigm—into another which is more inclusive, and also more effective for achieving unified states of consciousness. But it was on the actual, experiential level that I stumbled upon this truth, while conducting a primal therapy session. It has taken me more than a year to arrive at a theoretical explanation of what I call mandalic, or transpersonal sex.

The purpose of this book is to share a personal discovery, in the hope that it may help move human consciousness toward greater awareness and integration. I doubt that I am the first to have reached this awareness, and yet it is glaringly absent from contemporary literature on explorations of consciousness. I shall summarize it in two key points:

Silent Orgasm
The combined Paradigm

1. States of relatively diaphanous or unified consciousness can be experienced without the aid of professional therapists and without psychedelic drugs. Through the techniques described in Chapters Four and Five, anyone can attain insights into dormant and hidden aspects of consciousness with very little guidance. Whilst drugs can easily be life-endangering and addictive the suggested meditation techniques are not.

2. A very powerful, safe, and above all enjoyable technique for achieving transpersonal awareness is sexual orgasm—provided that one concentrates on the period *after* orgasm, the *Silent Orgasm*. This technique, which I call mandalic or transpersonal sex, differs from the current presentations of Tantric and Taoist practices, which deal mainly with the manipulation of sex up to the moment of orgasm or its complete repression.

It must be emphasized that all the techniques described in the following chapters are only means; the goal is meditation, a state beyond mind, a state of consciousness without content. Meditation is not really a state of consciousness; it is a state of pure awareness. Sri Nisargadatta Maharaj called it a state 'prior to consciousness', Lopon Tenzin Namdak termed it simply 'the natural state' defined by the unification of awareness and emptiness.

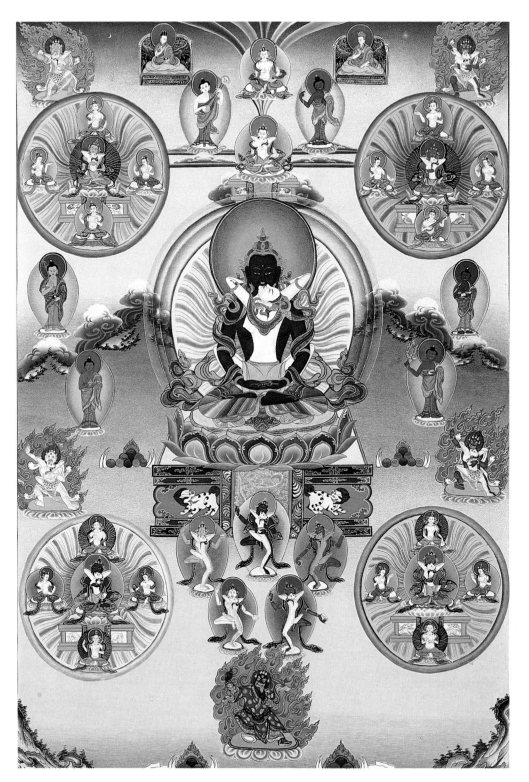

Mandala
Mandala of peaceful Vajrayana deities, Nepulese copy of Tibetan thanka, 1980 (55 x 77 cm)

Eastern Models of Consciousness

To prepare for our excursions into techniques for triggering intensified states of consciousness, and to find some order among the confusing multiplicity of meanings of the such words as god, spirit, soul, mind and brain, several ancient and recent models of consciousness will be discussed in this and the next chapter. The selection will serve our purposes here, but it is by no means an exhaustive or complete compilation of such models.

Models are of course distinct from theories and paradigms. A model is an analogy; it illustrates one thing by reference to another. A theory is a final mental abstraction of reality based on a chain of hypotheses derived from a set of given and verifiable data. A paradigm is the sum total of often unconscious or implicit assumptions upon which models and theories of a particular epoch are based.

In this and the following chapter I shall function mainly as a commentator. The models are presented in the most original form possible, by turning directly to their authors in the case of recent Western models, and by referring to basic texts and the explications of acknowledged masters in the case of ancient Eastern models.

Even those who are well grounded in Western religion and philosophy and familiar with the young discipline of psychology may be impressed by the profundity of the oldest Indian model of consciousness, which by all appearances was based on direct experience rather than mere speculation. In one place or another in each of the countless books on Hinduism one will come across an affirmation that the rishis, the sages of the Upanishads, divided human consciousness into four elements. I call these elements layers, because this term points to the oneness of consciousness and its ultimate transparency. The four layers are: the normal waking state, dreaming, dreamless sleep, and another known as "the fourth" *(turiya)*.

A clear explanation of this tradition appears in the discourses of Osho, who in my experience was an enlightened master (and

Vedanta Model

Three-plus-one division of consciousness

Jagriti
The waking state

who for some years was a professor of Indian philosophy). He stresses that the first, waking state of consciousness, or jagriti, is tainted by mediate rather than immediate knowledge. "Senses are the means, the windows, through which we know the extension beyond us... When senses inform us of something, it is not simple information. It is an interpretation also... They impose something, they add something to the information... This imposition creates an illusory world around every consciousness, and everyone begins to live in a world of his own. This world, the Eastern esoteric mind says, is maya, the illusion. It is not the real, the objective, that which is" (*Rajneesh* 1972,p.36).

I should like to illustrate this with an experience I had while leading an encounter group in Kyoto in the early 1980s: After fifteen minutes of silence, a middle-aged man suddenly addresses a student in his early twenties, saying that he loves his smile. Finding this suspicious, I ask him to seat himself opposite the perplexed young man at a cushion's width and repeat the statement, this time with his hands clenched. In no time he is repeatedly shouting "I hate you." I guide his breathing and soon he breaks down crying, and comes out with a story of his lifelong hatred of his father, whom he feels he has now finally 'murdered'. The whole episode has very little to do with the young student, and much more to do with some sensation on the part of the older man of an external similarity, some interpretation which leads him to project the pent-up anger against his father. At that moment in his normal waking reality the young man is his father. In the end no-one is more surprised than the older man; he asks forgiveness of the other, whom he can finally see as the separate person he actually is.

Since Heisenberg Mysticism has found an echo in Western science. In particle physics, at least, the classical view of 'objective' observation by human senses (or their extension, scientific instruments) has been discarded. Instead, the observer is seen to project his or her own values, influenced by the blinkers of a scientific paradigm, onto reality.

Sobna
The dreaming state

The second layer of human consciousness, the dreaming state, sobna, does not make use of the senses. They are asleep, leaving you closer to yourself. The learned social masks and behavior patterns are dropped. Dreams are involuntary and completely honest. Indeed it is understandable that so much emphasis was laid on

dream analysis in early Western psychology. You cannot lie in your dreams, you cannot easily control them; but still you create your own world. The sobna layer is part of the personal mind, which is conditioned by everything one has known or felt, an accumulation not only of the present life but also of all past lives, both human and animal (*Rajneesh* 1972, 37). And as modern psychology recognizes, the mind has a tendency to complete things. If something is left incomplete in the external world, then a dream will be created to complete it; otherwise there will be an unresolved restlessness. Encounter groups, Gestalt therapy and dream workshops are among the recent Western arenas where dream- related meditation techniques are used to complete 'unfinished business'.

Long before Freud, the value of looking at the content of dreams was emphasized by Patanjali in the Yoga Sutra, with the instruction, "Also meditate on knowledge that comes during sleep." In connection with that stanza, Osho has distinguished five types of human dream activity. The first type, which includes most dreams, is the psychological dust or rubbish collected during the day which the mind wants to throw off. It is useless to go on analyzing it. The second type of dream contains a message from the vast unconscious mind which stores the accumulated wisdom of the ages. That mind knows one's real needs, just as the conscious mind knows one's ever-changing desires, and the dream may indicate which of those needs has been neglected or suppressed. The third type of dream is rare; it contains a communication from one's 'superconscious' which may help in finding a mystic path and master in real life. The fourth and fifth types convey glimpses of one's past and future existences, respectively (*Rajneesh* 1976, 2). We shall see in a discussion of astral projection (Chapter Four) how time simply collapses in those two cases.

The overlapping of the waking and dreaming layers of consciousness is very intimate. Close your eyes at any time and you are in your own private cinema where you are simultaneously director, projectionist, film and audience: a daydream. The inner film or dialogue can become so strong that people sometimes walk around talking aloud. The dreaming mind is of course living in an illusory world, separate from the present reality.

To be in the present and to be in a dream is impossible, hence those who live fully in the here-and-now do not dream. Medi-

tation techniques have been referred to as dream-emptying or dream- negating devices.

Sushupti
The dreamless sleep state

The third layer of consciousness is dreamless sleep or sushupti. Observing this state is a real challenge. Normally one cannot remember it, because it has no content. Neither outer objects nor inner objects, i.e. dreams, are present. Osho referred to it as subjective consciousness without any object, as the self without any relation or content. "In the third state, consciousness equals unconsciousness" (1972, 39). Gurdjieff devised arduous meditative techniques of self-remembering to break open the unconsciousness of his disciples. They demand that one become conscious at any moment of whatever one is doing (direct consciousness outwards) and simultanously of who is doing it (direct consciousness inwards).

Turiya
The fourth state

The last unnamed layer of consciousness is qualitatively different. "The fourth state is not a state", said Osho. "The fourth is beyond these states. The fourth is Being. The fourth is the knower of all these states. These three states come out of the fourth and are again dissolved in the fourth. But the fourth never comes out of anything and is never dissolved into anything" (1972, 40—1).

On the way to turiya or "the fourth" the seeker and everything sought will disappear, in the sense of being in a state or an identity or a form. What remains, the sages say, is the "original source of all". (Gebser's model of consciousness, discussed in Chapter Three, similarly holds that "origin is always present".)

There are techniques to penetrate the three states of consciousness. One such technique, called the inner flame meditation by Osho, is based on one of the 112 meditation techniques presented in the *Vigyana Bhairava Tantra* (discussed in Chapter Six). Paul Reps translates it as:

"Waking,

sleeping,

dreaming,

know you as light." (*Reps*, 169)

Imagine that a flame like that of a candle is lit in your heart and your whole body is but the aura of that flame. Whenever you remember during the day, close your eyes briefly and imagine yourself as that flame. Continue this first stage of the practice for three months, then enter the next stage: When falling asleep, try to remember that your body is just the light of that flame. A mo-

The Silent Orgasm

ment will come when, even in your dreams, you will remember yourself as the light and other dreams will disappear. This technique can be used to transcend the three normal states of consciousness. Osho comments: "If you can carry this image of flame and light through the doors of sleep, you will never sleep again, only the body will rest. And while the body is sleeping, you will know it. Once this happens, you have become the fourth. Now the waking and the dreaming and the sleeping are parts of the mind. They are parts, and you have become the fourth—one who goes through all of them and is none of them … Bodies need rest, consciousness needs no rest; because bodies are mechanisms, consciousness is not a mechanism" (1976, 23).

Underlying this Vedantic 'three-plus-one' classification of human consciousness is thorough scientific research into the nature of the human being, a science of the inner, with thousands of years of experimentation. If one accepts the results of these experiments, one sees how futile it is to analyze dreams over and over again, as was done in early Western psychoanalysis. According to this ancient Hindu model, thoughts and dreams have to be transcended, not analyzed, in order to penetrate to one's source.

Psychoanalysis since Jung has accepted three levels of human consciousness: waking consciousness, the unconscious and the collective unconscious. This of course constitutes an extension of the Freudian scheme, adding the collective unconsciousness. Still it leaves no separate space for 'the fourth' which the rishis collated in the Upanishads. Psychoanalysis knows only consciousness with content.

If such a 'map' charting the path to the self has been available for millennia, then what have the priests and prophets of the world religions, including Hinduism with its impenetrable pantheon of deities and maze of rituals, been selling throughout the ages? The cul-de-sac we have negotiated ourselves into became clear to me once again at a recent lecture on "the concept of emptiness in Buddhism" by some renowned professor of Buddhism (a contradiction in terms). Emptiness, 'the fourth', is not a concept. Its realization is not that easy. To get some tiny taste of it, rather than a lecture, perhaps one needs an alarm clock.

The Tibetan model of consciousness does not contradict the ancient Hindu one, but fills it with detail. Based on Indian

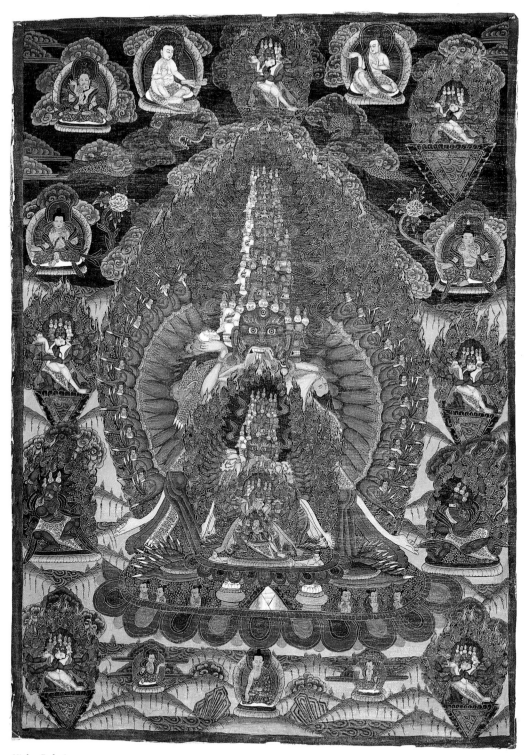

Visho Bahairav
Visho Bahairav, thangka of terrifying Vajrayana deities, Nepalese copy of Tibetan thangka, 1991(59 x 83 cm)

Buddhism, Tibetan Buddhism distinguishes among six states of consciousness which the human being is subject to in the cycle of birth and death, and six methods by which one can be liberated from those states. To start with the latter, there can be liberation through hearing, through wearing, through seeing, through re-membering, through tasting, and through touching. Any of these is believed capable of triggering enlightenment, that is emanci-pation from all finite phenomenal existence. These probably very ancient techniques are said to have been written down in the 8th century AD by Padma Sambhava, who is accepted as the founder of Lamaism, one version of Tantric Buddhism.

One of these methods, "the liberation by hearing on the after-death plane" or Bardo Thödol, commonly known as the The Tibe-tan Book of the Dead, is now available to the English reader in five different translations from which I shall draw. Central to the theme of the present book would be information on the Lamaist techniques of liberaration through touching, but unfortunately I have neither received instruction nor encountered literature per-taining to them. Sogyal Rinpoche does not mention any tech-niques of touching.

In the Tibetan model, the human being up to enlightenment is always in one of six bardos or 'intermediate states' of conscious-ness; one is always on a bridge, as it were, or in a kind of twilight zone. Lama Lodö translates the six possibilities as:

> the Bardo of Life,
> the Bardo of the Dream State,
> the Bardo of Meditation,
> the Bardo of the Process of Death,
> the Bardo of the State after Death,
> the Bardo of the Search for Rebirth.

There is a chance of liberation from finite existence in any of these bardo states. All that is necessary is full recognition of the particular state one finds oneself in at any one moment in time. "We experience the Bardo every instant and it is because we don't recognize it as such that we are here, in this existence. The Bardo ends when enlightenment begins"(Lodö, 13). Dreaming ends when we wake up. It is difficult enough to be conscious of the fact that one is dreaming when one is asleep; it is even more difficult to stay fully conscious of what is happening in the tumultuous after-death state.

Bardo Model
Six intermediate states of consciousness

The first three of the bardos or intermediate states are experienced while in the body. "The Bardo of Life encompasses the experience of the illusion of waking reality. It includes all negative and positive actions during each lifetime from birth until death. The Bardo of the Dream State includes all mental activity while the physical body is sleeping. The Meditation Bardo includes the myriad mediation experiences from the lowest levels of realization to the attainment of enlightenment" (Lodö, 2).

Even with our contemporary materialistic view of human life, we might accept that the most important states of being in our life are birth, love and death. But unfortunately, we are not present when they actually happen. In general, we are born unconsciously; we 'fall in love', that is are unconscious in love; and we die unconsciously, with the flow of consciousness interrupted at the moment of death. What happens to us before birth and after death can be likened to the content of fairy tales told to us by our elders. We commonly believe that it has not been experienced by us and cannot be subject to our experience. Meditation techniques which make this birthing-loving-dying transparent to our consciousness are virtually unknown to us. The desire for conscious experience has been replaced by blind belief. Belief, however, means to never know.

The three states of consciousness which one can experience when out of the body are the subject of the *Bardo Thödol*, the Book of the Dead. I am forever indebted to the translators who have made this treasure of insight into human consciousness available to so many. Yet I must confess that when I came across the first Western version of this book (the Evans-Wentz translation) in the 1960s, I was not prepared to understand much of its confusing detail shrouded in Buddhist iconography. I did absorb the basic point that whatever is 'experienced' after death is of the nature of projections of one's own consciousness. And so, I thought, there is nothing to be afraid of. At that time I had no direct experience of meditation, only indirect knowledge from books. What has remained clearly in my mind up to the present is a statement by Lama Anagarika Govinda in the foreword to the book:

"It may be argued that nobody can talk about death with authority who has not died; and since nobody, apparently, has ever returned from death, how can anybody know what death is, or what happens after it? The Tibetan will answer:' There is not one per-

son, indeed, not one living being, that has not returned from death. In fact, we all have died many deaths, before we came into this incarnation. And what we call birth is merely the reverse side of death, like one and the two sides of a coin, or like a door which we call *entrance* from outside and *exit* from inside a room" (*Evans-Wentz*, LIII).

As powerful and memorable as it was, Lama Govinda's statement remained academic knowledge to me until 1979 when, during a primal therapy session, I relived my own birth trauma and the death of my last existence at the same time. From that time on I knew, not just believed or wanted to believe, that Govinda's claim was true. Here we touch on a theme that will run like a leitmotif through this book: For personal growth, only experience gained through personal experiment, not knowledge acquired from other sources (including the Tibetan Book of the Dead) is ultimately valuable.

Another sage of our times, Aivanhov, boldly states that "without reincarnation nothing makes sense in religion or in life" (*Aivanhov*, 151). He cites many sayings of Jesus himself for support. Belief in reincarnation was actually common in early Christian communities. It was in 553 AD at the Second Council of Constantinople that it was declared heresy for the first time, and banned forever from Christian belief (*Kersten*, 104).

Yet belief alone is not enough to have any major effect; changing from a belief in one life to a belief in several lives is like changing one prison for another. Only experience liberates. Actually reliving one's former incarnations and excarnations will effect a strange, deep sense of peace, a first taste of liberation, a first feeling that you are an integral part of the whole, of the Great Chain of Being. To a great extent the always lurking fear of death, of ultimate annihilation disappears as well.

To return to our text, the "great deliverance through hearing while on the after-death plane" describes what happens to human consciousness immediately before and after death in three successive stages or bardos: the process of dying, the afterdeath, and the search for rebirth. The whole process up to reincarnation is reported to take about 49 days, which probably don't signify calendar days. The text contains very practical advice, to be recited over and over into the ear of the dying and beside the dead body, on how to reach liberation from any stage of the inner show that the consciousness is witnessing.

Woman's sketches of her experience of merging with a great clear light in mandalic sex therapy.

Surrounded by starry deep dark-blue night sky.

Flying towards a bright star consisting of a multifaceted crystal or diamond.

Closer approach to light crystal.

Realization that the crystal is herself.

The first bardo with instructions on the symptoms of death Leary translates as the "period of ego-loss or non-game ecstasy". It explains the drama of dying in terms of the gradual disintegration of what Buddhists call the five skandhas, which are the psychosomatic aggregates of the body, sensation, feeling, volition, and consciousness.

The dying is then overcome by a great luminosity, the Primary Clear Light. "O son of noble family [enter his or her name],listen. Now the pure luminosity of the dharmata is shining before you;recognize it. O son of noble family, at this moment your state of mind is by nature pure emptiness, it does not possess any nature whatever neither substance nor quality such as color… But this state of mind is not just blank emptiness, it is unobstructed, sparkling and vibrant. These two, your mind whose nature is emptiness without any substance whatever and your mind which is vibrant and luminous, are inseparable… This mind of yours is inseparable luminosity and emptiness in the form of a great mass of light, it has no birth or death, therefore it is the Buddha of Immortal Light. To recognize this is all that is necessary" (*Fremantle and Trungpa*, 37).

Western medicine has begun to investigate this territory from the angle of near-death experiences. The many episodes collected by Dr. Michael B. Sabom lead him to conclude that dying consists of two successive and different steps: first, an "autoscopic death-experience" in which the separation from the body takes place and the physical body is 'perceived' by an entity outside it; this is followed by the "transcendant death—experience" in which a beaming luminosity appears that one does not so much see as become. Sabom does not claim that these experiences constitute 'scientific proof' of life after death, and yet the similarity between the stories he reports and the description of the Primary Clear Light in the Tibetan Book of the Dead are quite striking. Sogyal Rinpoche calls it the Ground Luminosity.

In the Bardo, the first appearance of utmost luminosity is followed by a period of secondary luminosity. If the dead person by now has not recognized herself as that luminosity and thus reached liberation, she will enter the next bardo, which is dominated by karmic apparitions (Leary calls it the "period of hallucinations"). There are peaceful visions at the start and violent ones at the end, envisioned by Tibetan Buddhists in colorful mandalic

The Silent Orgasm

schemes of benign and wrathful deities with their respective female consorts. While this 'magic show' is surely difficult for the typical Westerner to understand, it is also considered difficult for the untrained Tibetan.

Ultimately, recognition of the meaning of the deities depends on prior training. One is admonished to meditate on them again and again while still alive, using elaborate mandalas. Practice of meditation is constantly emphasized by Buddhists.

Stricly speaking, these are not visions, "because", states Trungpa, "if you have a vision you have to look, and looking is in itself an extroverted way of separating yourself from the vision. You cannot perceive, because once you begin to perceive you are introducing that experience into your system, which means again a dualistic style of relationship. You cannot even know it, because as long as there is a watcher to tell you that these are your experiences, you are still separating those energies away from you" (*Fremantle and Trungpa,* 11).

I compare such 'visions' to the perception of an afterimage when the eyes are suddenly closed after staring at a brilliant red point. You 'see' a complementary green point, even though no such point exists outside of yourself. The more intensely you try to see this illusory point, the more quickly it will vanish. A relaxed, passive mode of seeing is required.

The consciousness of the voyager on the after-death plane becomes less and less keen and adamant, yet liberation is possible at any point. The next bardo covers the period of seeking rebirth, or reentry into the cycle of birth and death. The dead person is now reminded: "Although the projections of the bardo of dharmata appeared until yesterday,you did not recognize them, so you had to wander here. Now, if you are able to meditate undistractedly, rest in the pure, naked mind, luminosity-emptiness, which your guru has shown you, relaxed in a state of non-grasping and non-action. You will attain liberation and not enter a womb" (*Fremantle and Trungpa,* 73).

This phase is marked by feelings of limitless perception and superworldly powers; of extreme torture and persecution; and finally by visions of human beings making love, at which time "it is very important to take great care with the method of closing the entrance of the womb. There are two methods: stoppping the person who is entering, and closing the womb-entrance which is

Slowly the body dissolves into the light, becomes the light. Only clear light remains.

being entered" (*Fremantle and Trungpa,* 82). And at this moment the reincarnation is envisioned as male or female.

Trungpa reminds us that the three after-death states can be seen not only in terms of peaceful and wrathful deities, but also in terms of the six realms which make up the whole of Buddhist samsaric existence. Those realms can also be understood as the range of states of consciousness in which we may find ourselves in normal daily life. For these worlds the Chinese and Japanese use the character 道, pronounced *dao* or *do,* literally meaning 'ways'. A 'way' lacks the sense of permanence that is suggested, for example, by the word 'world'. It too is an intermediate state.

In Tibetan Buddhism the ways are usually portrayed by the Wheel of Life, which is divided into six sectors and held in the mouth and claws of the god of death. The contents resemble the six bardos listed above, although the boundaries between them are probably not as clear as the graphics of this wheel of time/life/death would suggest. The circle represents the whole chain of being; it spans the whole spectrum of psychological dispositions to which a human being may be subjected.

The *Bardo Thödol* describes the six realms of phenomenal existence in this way: "O son of noble family, together with the wisdom lights, the lights of the impure, illusory six realms will shine: the soft white lights of the *gods,* the soft red light of the *jealous gods,* the soft blue light of the *human beings,* the soft green light of the *animals,* the soft yellow light of the *hungry ghosts* and the soft smoky light of the *hell-beings* … If you are afraid of the pure wisdom lights and attracted to the impure lights of the six realms, you will take on the body of a creature of the six realms, and will grow weary, for there is never any escape from the great ocean of the misery of samsara" (*Fremantle and Trungpa,* 52). One's karma, the sum total of one's previous thoughts and actions, determines the realm of existence one is drawn to and finally reborn into.

The motor of this merry-go-round world of samsara can be found at the hub of the wheel of existence where a cock, a pig and a snake appear, representing greed, anger and lust, respectively. The stopping of all samsaric life, necessary for liberation, is often symbolized by the image of the god of death holding a male/female couple apart under his feet. (This is discussed as an element of Tantric art in the Appendix.)

The Silent Orgasm

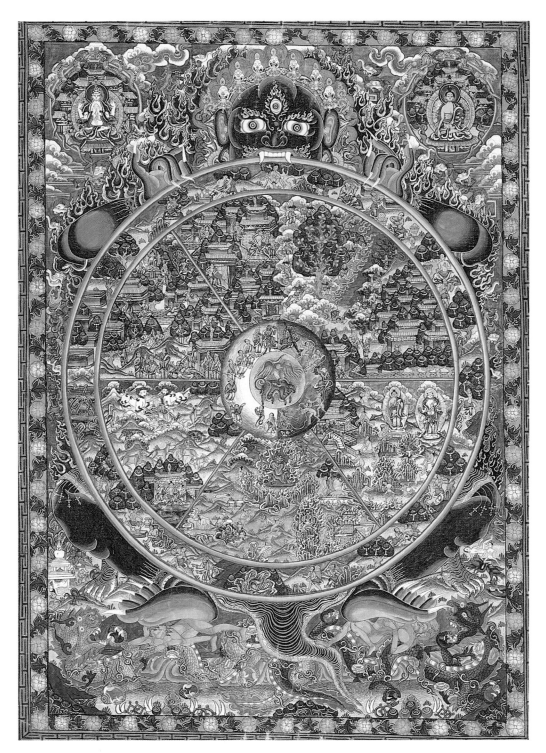

Wheel of life
Showing the six realms of samsaric existence in the claws of Yama, the God of Death, whose two feet separate a
male-female couple (43 x 59 cm)

What surprised me most when I first encountered a picture of the wheel of life (or wheel of rebirth) was that the goal of human life is not portrayed as going up to Heaven and so avoiding Hell down below, the goal I had been indoctrinated with by my Christian peers. In this Eastern vision of existence, life as a god, as a human being or as an animal seems equally unattractive. They are equally subject to impermanence and suffering, that is, subject to birth and death. Ordinary death only changes the form, but is not capable of breaking the continuity of samsaric life. The goal is to be liberated from all intermediate states of existence, beatific or terrifying.

The book of the dead is equally a book of life, a book for the living. Trungpa also calls it a book of birth because "the details presented here are very much what happens in our daily living situation, they are not just psychedelic experiences or visions that appear after death... The whole thing is based on another way of looking at the psychological picture of ourselves in terms of a practical meditative situation. Nobody is going to save us, everything is left purely to the individual, the commitment to who we are" (*Fremantle and Trungpa,*2).

In 1964 Leary edited the *Tibetan Book of the Dead* as a guide for the living, specifically for experimentation with psychedelic drugs, then the newest source of vision. It is now widely appreciated in the West that meditative techniques using breathing, chanting and/or visualization can serve to achieve states of transparent consciousness. What psychedelic drugs have in common with those techniques is that they bring about subtle chemical changes in the human body. But a great part of the value of this interpretation of the text is that it strips away the exotic unfamiliar symbolism and substitutes more comprehensible (if perhaps less accurate) Western psychological jargon.

Parts of the book of the dead were recited during a 'soma' retreat in which I participated during the 1970s at Osho's Ashram in Poona. The schedule of daily meditations centered around forceful 'breath of fire' breathing in different body positions for each of the seven chakras, and 'armor of light' techniques of visualization. The purpose of this two-week retreat was to have out-of-body experiences, and at the end, a simulated death experience. From my sketchy notes about the latter, I can today extract

only that I became aware of the fact that everything in life is but a meeting followed by a departure, that there is a communion of consciousnesses and a transformation into what has been communicated. I wrote, "The only thing really necessary is total awareness at the most vital stage of transformation, at death". What I felt was a strong sense of oneness with everything—birds, trees, grass, shit, and any other person.

Today the art of dying or reincarnating has been replaced by means of prolonging life with the aid of machines and drugs. Asked about the use of painkilling drugs before death, Lama Lodö gives an alarming reply: "When the body is in a drugged condition, the mind, veiled with stupidity, cannot concentrate and is easily drawn into the animal realm" (*Lodö*, 16).

Even more lamentable is that our modern cultures have lost their initiation rites. Their reinvention and reintroduction in modern terms—as has been pioneered with the use of psychedelic drugs, special breathing, primal therapy and other aids—is of utmost urgency for human beings who want to become their own masters. "To those who [have] passed through the secret experiencing of pre-mortem death, right dying is initiation, conferring, as does the initiary death-rite, the power to control consciously the process of death and regeneration" (Evans-Wentz, xiv).

Yoga Model
Consciousness of the Seven Chakras

Significantly enough for the evolution of human consciousness, many psychotherapists and other Westerners have lately rediscovered a wireless or invisible anatomy of the human body which is central to ancient yogic and Tantric teachings. This consists of the channels of energy, or nadis, and the wheels or vortexes of energy, the chakras of the so-called subtle body. Correspondences to the alignment of the physical nervous system and the position of the most important human glands, respectively, have been suggested only quite recently. Hiroshi Motoyama has brought together enough relevant research to be able to claim that the chakras and nadis do influence the physiological body, that there seems to be a connection between autonomic nervous plexuses and the chakras, and that mental concentration on the chakras can produce beneficial therapeutic effects. (*Motoyama*, 1978, 1981. See figure on page 32.)

It should be pointed out that neither ancient yogic nor Tantric manuscripts suggest that the subtle or yogic body made up of

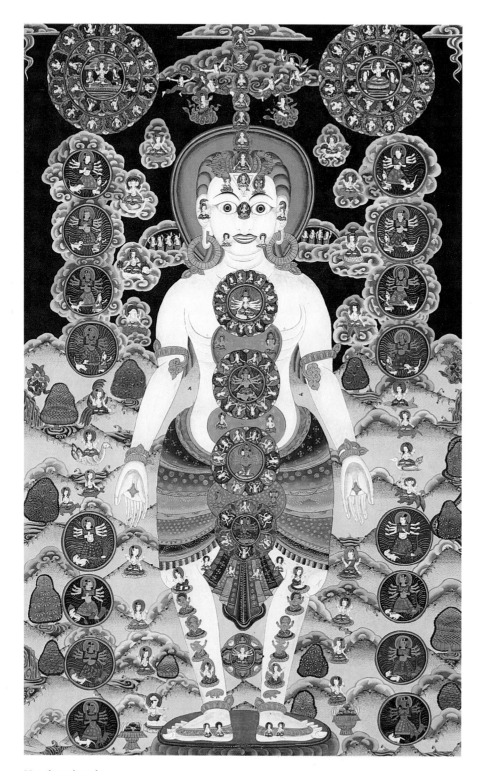

Nepalese thangka
Thangka indicating location and symbolism of the chakras, or vortexes of energy, in the
subtle body of a yogin (63 x 101 cm)

energy channels and vortexes has any objective existence comparable to that of the ordinary body with its organs and ducts. Bharati calls the nadi-chakra system simply "a heuristic device aiding meditation". The actual number of nadis claimed to exist in this mystic human physiology varies according to different branches of yoga and Tantra. Eliade gives figures ranging from 72,000 to 300,000. In drawings which outline these energy conduits in relation to the human body, it is interesting that they are shown to run within as well as outside and around the body (see figure on page 34). Likewise, the number of chakras, or energy centers, varies somewhat in the historical literature. The Hindu yogic tradition has generally worked with seven chakras.

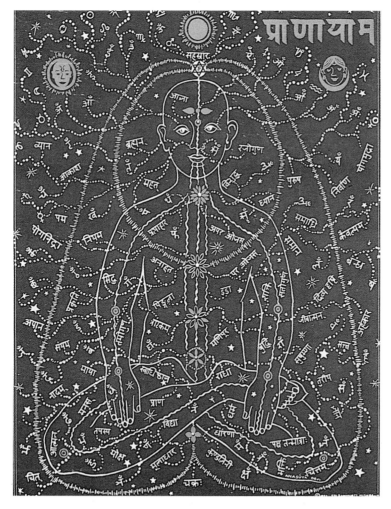

The nadis or energy conduits, and the cacras or energy vortexes, on a popular yoga map of the subtle body.

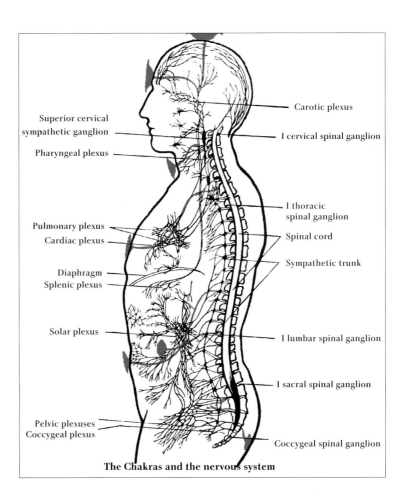

Superior cervical sympathetic ganglion

Pharyngeal plexus

Pulmonary plexus
Cardiac plexus

Diaphragm
Splenic plexus

Solar plexus

Pelvic plexuses
Coccygeal plexus

Carotic plexus

I cervical spinal ganglion

I thoracic spinal ganglion

Spinal cord

Sympathetic trunk

I lumbar spinal ganglion

I sacral spinal ganglion

Coccygeal spinal ganglion

The Chakras and the nervous system

The seven chakras in relation to the physiological nervous system. *From Leadbeater, The Chakras.*

All we can say about their actual location is that they are in or near certain areas of the gross body. The first chakra lies below the spine, the second lies around the genitals, the third around the navel, the fourth around the heart, the fifth around the throat, the sixth on the forehead above the point between the eyes, and the seventh around the crown of the head (see figure on this page).

All schools of yoga and Tantra accept the existence of three main vertical conduits of energy: the *pingala* on the right side of the body, the *ida* on the left, and the *susumna* along the spine. The right pingala conduit is also known as the sun channel, and the left ida conduit as the moon channel, reflecting the difference in the quality of their energies. They are also conceived of as Shiva and Shakti, the basic Hindu polarity of the cosmic male (static) and female (kinetic) principles, respectively (see figure page 35).

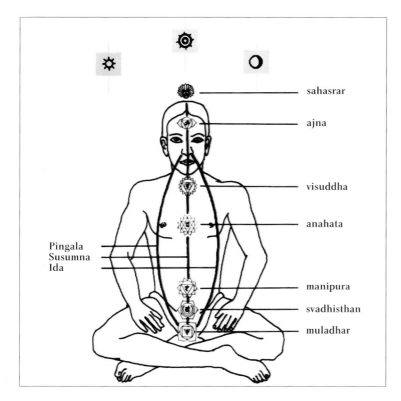

sahasrar

ajna

visuddha

anahata

Pingala
Susumna
Ida

manipura

svadhisthan

muladhar

The seven chakras and the three most important nadis, or energy conduits in the subtle body: the pingala or moon channel (right), the ida or sun channel (left), and the susumna (center). From Khanna, Yantra. The chacras are drawn in the form of yantras in the traditional Hindu fashion. In some drawings, the pingala and ida are shown crossing from one side of the body to the other between the chakras, and thus spiralling around the susumna through the upper body; this image strongly resembles the caduceus of Mercury, the symbol of Western medicine, with two snakes spiraling around a central staff from the bottom to top.

We should not forget that we face in this mystical physiology a cosmicized human body. The entire spiritual discipline of yoga and Tantra revolves around the effort to unify these opposite forces in a 'middle way', called suṣumna. In another respect, it consists of unifying a second basic polarity, that of Shiva and Shakti at the crown chakra, by reversing the basic flow of vital or sexual energy—the kundalini—to make it flow upward. In sum, what is targeted is the experiential transcendence of all phenomenal pairs of polar opposites within one's own body. This is implied, for example, in the term *ha-tha yoga,* which translates literally as 'sun-moon union'.

The rediscovery, or verification, of this mystical energy structure of the subtle body in our time is not surprising since ancient and new breathing techniques to make one aware of these centers are probably similar to the holotropic breathing techniques Grof uses in our time. Grof characterizes the chakras in terms of energetic blockages experienced by various patients and the manifestation of those blockages as tensions, emotions and visions. Such empirical rediscovery of the chakras and utilization of them for

therapeutic purposes is both natural and quite significant (*Grof,* 1988).

In contrast, the imagery usually used to describe the chakras in books on yoga or tantra will remain largely academic knowledge to the enquirer, and provide little or no help in the experiential exploration of this energetic layering of one's existence. Such descriptions and charts of correspondences may be found in the works of Woodroffe, Varenne, Mookerjee or Khanna.

To convey the enormous difference between a reading of the ancient symbology and an actual experiential understanding of the chakras, I quote a description of the heart chakra (the central chakra, with three chakras below and three above it) from Tantric scripture, and then report three instances of personal experience of the energy of my heart chakra. From Mookerjee's The Tantric Way (p. 155):

"Anahata (unstruck) Chakra, in the region of the heart (cardiac plexus), has twelve letters—k, kh, g, gh, n, ch, chh, j, jh, n, t, th—inscribed on golden petals. In the middle are two interpenetrating triangles of a smoky color enclosing another triangle 'lustrous as ten million flashes of lightning', with a Bana-linga inside the triangle. This chakra is associated with the element air, and above the two triangles is its presiding deity, the three-eyed Isa with Kakini Sakti (red in color). Its bija mantra is Yam and it is principally associated with the sense of touch." (See figure this page).

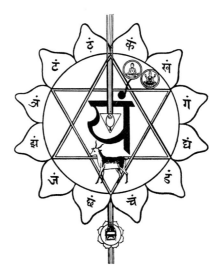

Hindu symbolism of the yantra of the heart chakra.
From Arthur Avalon,
The Serpent Power.

Even with the keys to the above mantric, yantric and anthropomorphic deity symbolism provided by Leadbeater (p. 96-121) for the understanding of this chakra, I doubt that anyone would be able to use that description on one's own for meditative purposes or for the decoding of an actual chakra experience. Some living guide would be required. The iconography and symbolism of the heart chakra is remarkably similar in all of the sources I have consulted, which might encourage us to suspect that they all refer back to one original source or—and this I doubt—that the actual heart chakra experience has always been identical with all human beings.

I had my first heart chakra experience in 1975 during a week-long encounter-group workshop in Poona. Three days into it, with people mostly younger than I, I felt a concrete wall slowly growing around me. I simply lost contact with the outside world and with myself, too. It was the first group I had ever joined. I was just perplexed by the fights, catharses and loving of the other participants. I saw no way of being able to join any of it. In an evening darshan with Osho on the fourth day, he asked how the group was going for me and I told him, "I simply can't strip physically and psychologically as easily as the American participants can." "Strip, strip," he answered, and he told the group leader, "Next day you put him in the center of the room, slowly strip everything off him, and don't leave him any privacy." Then he added, oddly, "And you all shall profit from it."

That is exactly what happened next morning; I was stripped slowly, touched all over, pulled on my penis and teased and tickled. Well, I thought, keeping my cool, another American party game … But after a time something began happening inside me. I became more and more angry; first I just defended myself, but slowly I was overcome by an uncontrollable rage. I actually felt ready to kill, and I told the group leader about it. But the show went on: the thirteen other members of the group attacked me from behind large mattresses. They heaped the mattresses on top of me and sat on them. It was a strange feeling being squeezed under these mattresses, a feeling like being in the uterus.

The fight must have lasted the best part of an hour. There came a point when I was exhausted and broke down; there I lay on a mattress with everyone surrounding me. I fell into a kind of trance and started crying and babbling like a small baby. I

The powerful real sun-moon polarity in outer nature lead ancient man to conceive of his own inner body/mind polarity in terms of sun and moon energies.

suddenly was a little baby. The trance became deeper. The group leader assisted my breathing by putting first his hands and then his knees on my breast. He asked where I was. I answered, "I can't believe it, I can see my own heart". I swear I did see it, pulsating and pumping red blood. Then my attention moved away from it to the center of the breast. At that point 'I' disappeared and for the first time in my life 'was'. All that remained was the whole universe in the form of a dark-blue starry night sky with one central red spot. The overall sensation was one of being bigger than the universe or at one with it, of liberation from my separate existence, from death. Whilst this overcame me, as I lay with closed eyes, the group leader had me very slowly describe the scenario to the others, those who had fought me. At one point the group leader asked me what I would do if I could stay in this situation forever, and something from inside me said: "I would love everyone."

I do not remember what effect this all had on the other participants. I felt deep gratitude towards them because they had all helped me to arrive at this breakthrough. When I came back to my normal senses, I left the room naked, swinging my orange loincloth like a flag of joy, aiming to go to town to share my joy with everyone. Fortunately I was stopped by one of the ashram guards.

Osho refused to give me any explanation of this event for years, until one evening at darshan he described it in nearly identical detail, not to me, but to someone who had just arrived. I was sitting ten feet away. He called the experience the Inner Sky, and that became the sannyasin name of the newcomer. As for me, I felt like I was on fire for some two years afterwards, until it dawned on me that an experience like that, for which I would have gladly exchanged the whole of human history, would not come again in the same form. It had to be forgotten. Only then would another glimpse of one's true self become possible. The main obstacle to the next glimpse is one's own desire for the old one to reoccur.

Whether or not Osho foresaw the whole event at the darshan during the group-work is of no concern to me. The device he chose worked. It may clarify the event to briefly describe the life context in which it occurred. About six months earlier I had gone through a midlife crisis, a case of having the rug pulled out from under my feet. I could no longer function. I had intense dreams about death which permeated my days, too. I drowned it all in al-

cohol. I abstained from consulting a 'shrink' to be pasted back together again. Instead I consulted Osho, whose sannyassin I had become a year before. He laughed at the description of my current psychological state and simply said: "Now we can start working; take an encounter and a primal group." In other words, I was ready; I had done my homework.

There were other results on a more mundane level. After the above experience I simply forgot about alcohol. In addition, my death dreams stopped. I had died. The existential realization of death (called in Zen the 'big death') is not identical to the event of dying. But above all, from that moment on my life has been pervaded by non-attachment to objects, inner or outer, or to social position. One does not hanker after a small corner store if one owns, indeed, is the whole city.

I also realized that only one who has had such a taste of the self will be able to look outside afterwards and find the same taste in the trees, the animals, the earth itself. One's actions will come into tune with nature, or to use a contemporary expression, will be truly ecologically conscious. All the intellectual knowledge in the world about the interdependence of life forms will never create the same insight. Only a personal, integral experience will lead to real change in one's vision of the universe and one's interpersonal relations. The increasing exploitation and degradation of the environment in our century bears witness to the ineffectiveness of scientific theory.

My cards lie open on the table. That is my understanding of a heart chakra experience. In the first place, it has little similarity with the iconography of the canonical yogic model described above. Secondly, I suspect that the concrete experience will be as different from individual to individual as their fingerprints are. Nature abhors xerox copies.

To underpin this hypothesis, here is another variation of the heart chakra experience. It happened to a 24-year-old Japanese woman during one of a sequence of primal therapy sessions which I administered in 1990 and 1991. After intense breathing and orgasm, she first experienced an episode of walking on the sea with no fear whatsoever of drowning. She encountred a small fishing boat with her former lover in it, and made peace with him simply by holding hands. Suddenly she was elevated towards the starry sky, and then all the stars rushed into her heart center. She ulti-

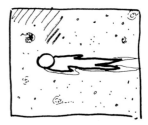
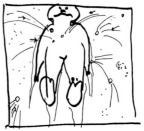

A woman's sketches of her heart chakra experience in mandalic sex therapy.

mately disappeared and contained the whole universe, she was the whole. See her four drawings of the second episode, made immediately after the session (figure on page 39).

What her 'experience' and mine have in common is a complete disappearance of the sense of a separate self, and a first sense of truly being. Our identities as ourselves were lost. The self could not be found anywhere. One somehow merges with the whole. How it is possible to remember such an episode will remain a mystery and a paradox.

In addition, neither of our experiences were prompted by any special technique designed to awaken this particular chakra. They did occur in contexts which were carefully prepared to encourage open or transparent awareness. Yet they were unprescribed, spontaneous happenings, with such strong effects that we can be comfortable in calling them gifts or revelations.

It is nevertheless useful to consider methods which have been devised for the specific purpose of arousing an awareness of the chakras. I have practiced three such special meditation techniques:

1. Chanting of traditional mantras while concentrating on the locations of the respective chakras.

2. Audiotape-guided 'chakra breathing' using sounds, rapid breathing and uncontrolled spontaneous body movements; or 'chakra sounds' using taped music and self-produced sounds to guide awareness through the chakras (tapes prepared under the guidance of Osho).

3. The 'breath of fire', a strenuous combination of intense breathing exercises and physical postures (described in detail in the discussion of astral projection in Chapter Four).

Then again, there are mystic traditions, such as Zen Buddhism, which neither mention the chakras in their scriptures nor use them in their meditation practices. Chakra meditations are part of the gradual path to enlightenment, not the sudden or spontaneous path.

Even though the ultimate goal of all schools of yoga is the same—namely to unite the individual with the whole in my language, or the soul with God in their language—teachings about the chakras of the subtle body belong to the Laya or Kundalini branch of yoga. The overall purpose of the teachings is the arousing of the kundalini (the serpent fire or serpent power),

which in the normal human being lies dormant at the base of the spine, and its elevation to the higher chakras and hence ever higher levels of consciousness. According to Hindu yogis, this requires sustained effort, patience and, above all, the guidance of an experienced master. Nearly all written treatises on the subject contain a solemn warning never to embark on any efforts of one's own to arouse these tremendous energies, but to search for qualified tuition.

While the guidance of a master is desirable on any path, I find this warning not applicable to the modern Westerner. Try reading any or all of the treatises on the chakras available in Western languages, and do what you may—I doubt that it is possible to harm yourself. At worst, you might just imagine something in your own practice. Such esoteric knowledge would just become a hindrance on one's path.

Motoyama, as mentioned above, has brought together a great deal of Indian yogic information on the chakras and also described both the traditional meditation techniques for opening them and his own experiences with such openings. He generally accepts the yogic assertion that the chakras act more or less as 'bridges' or 'centers of interchange' between the three bodies of the human being traditionally accepted by yoga. These are the physical or gross body bound to the five senses; the astral body containing all our desires and emotions; and the causal or spiritual body, the most refined aspect of existence. For the Hindu yogin, naturally, it is all one continuum, one unifed whole, rather than a sum of three separate bodies. For me, such a tripartite division of human existence is far too intellectual to be of any value in the search for oneself. It somehow resembles the Judeo-Christian distinction between body, soul and spirit, which, after thousands of years, has not advanced human consciousness very much.

Perhaps the least tradition-bound and most experiential interpretation of the chakras was offered by Rajneesh in his Divine Melody—Discourses on Songs of Kabir. I will conclude with a brief outline of his approach. He compares the seven chakras to the seven colors of a rainbow: none can be denied, all must be unified into a whole to produce the beauty of a rainbow. On the other hand, he compares the opening of the seven chakras with seven types of orgasm, or seven types of searching for and experiencing oneness.

The first chakra, muladhar, the root chakra, is marked by a consciousness obsessed with food and hoarding. Here matter unifies with matter. "The child is born. His first functioning in the world is through eating ... Matter wants to have an organic unity with other matter: matter is pulled by matter, attracted by matter. This is the first love—food. Food gives the first orgasm to the child" (*Rajneesh*, 1978, 108). The glutton lives at this lowest level of consciousness for a lifetime.

The second chakra, svadhisthan, is marked by a consciousness of power, of domination. "Once the physical needs of the child are fulfilled, a new need arises that is a vital need: to dominate. That too is again an effort to bring a unity—the unity between the dominated and the dominator ... A person who is food-obsessed is more closed than a person who is power-obsessed—at least he moves towards others" (*ibid.*, 110). The politician lives according to a consciousness of this second center for a lifetime.

The third chakra, manipura, is marked by a consciousness of sex. Here the union of the outer male and outer female introduces a sense of sharing. "In food you simply absorb; you don't share. In domination, you destroy; you don't create. Sex is the highest possibility on the lower plane—you share, you share your energy, and you become creative. As far as animal existence is concerned, sex is the highest value. And people are stuck somewhere with these three" (*ibid.*, 58).

The fourth chakra, anahata, the heart chakra, is marked by a consciousness of love. It lies exactly at the middle of the ladder of the chakras. Here the union is between the three lower and three higher chakras. "Below the heart, a man is an animal; above the heart, he becomes divine. Only in the heart is a man human ... Humanity has dawned in him, the first rays of the sun have entered in him ... Love has nothing to do with the male-female polarity. Love is beyond opposites—hence, the unity is deeper (*ibid.*, 58,113).

The fifth chakra, visuddha, the throat chakra, is marked by a consciousness of prayer. Here the union is between outer and inner. "When the devotee bows down before his deity, the inner is bowing towards the outer. When someone goes and sings a song to the sun or to the moon, the inner is singing a song to the outer. And remember, you have witnessed only one thing: you have witnessed the devotee singing a song to the deity. You

have not seen another thing…: the deity singing a song to the devotee—that too happens, but that is very subtle. That you will come to know only when you have experienced prayer" (*ibid.*, 115—6).

The sixth chakra, ajna, the third-eye chakra is marked by the consciousness of Tantra. Here the union is of reason and intuition, of inner male and inner female. "At the third, man and woman met at the physical plane, outside. At the sixth, again the masculine and the feminine meet, but no more on the outside—in the inside. The third is the center of sex, the sixth is the center of Tantra… Half of your being is feminine and half of your being is masculine. And at your third eye, there happens a meeting. This third eye is very symbolic—that means your left and right eyes dissolve into one eye.. " (*ibid.*, 116).

The seventh chakra, sahasrar, the chakra of the thousand-petalled lotus, is the chakra of "samadhi—ultimate ecstasy, total orgasm. Now part and the whole meet, the soul and God meet, you and all meet … you disappear into total orgasm" (*ibid.*, 118). The opening of the seventh chakra constitutes the ultimate sense of oneness, the merging with the cosmic whole. It is the 'experience' of The Fourth in the Vedanta model of consciousness; of the Great Clear Light, the liberation from the wheel of rebirth and 'redeath' in the Tibetan Book of the Dead. Beware, these are only words for it; it can not be described, it is not even an experience at all, since there is no room left for any duality between experience and an experiencer as such. The mystics have described it as the moment when a drop dissolves in the ocean, or the ocean dissolves into the drop.

Durkheim, a lifelong interpreter of Eastern spirituality, characterized Western religions as those referring to "the body that one has", as opposed to the religions of the Far East which refer to "the body that one is". The Western system of belief results in a conceptual duality of a dead body versus an animated soul, the Eastern in an a-priori union of body and consciousness. This basic distinction could alternatively be summarized by two pregnant sayings from the respective traditions: "The flesh is weak and the spirit is strong", says Christianity, which sees the body as something of an obstacle to spiritual salvation. At the most extreme there have even been sects which punished the flesh by

Hierarchic Model
Seven sheaths of polarized energy

flagellation or mutilalation to overcome the temptations of the body. In contrast, a statement by the Japanese Zen master Ha-kuin: "This very place the lotus paradise,this very body the Buddha." The Far East readily accepts the human body as a temple to be entered to discover the mystery of life; the body is the very medium for, rather than a hindrance to transcendence and transformation.

The concept of original sin in the Judeo-Christian tradition reflects the same condemnatory attitude toward the body; there is some deep stain in being incarnated into a body, which has to be removed by the rite of baptism. This contrasts strongly with the Far Eastern tradition where small children are viewed as next to divine. For instance, in Bali, an enclave of ancient Hindu culture, the newborn child is believed to have come down from heaven and thus revered as holy. The baby is always carried and not allowed to touch the impure ground until the first birthday, 210 days after birth by the Balinese calendar.

The central idea of this book, to which we return again and again both in this discussion of models of consciousness and in the later discussion of practical techniques, is that experience is much more effective than belief. Only through meditation, by di-rect experience using body and consciousness as a unit, can con-sciousness be made transparent and ultimately be transcended. Splitting one's world into believer and belief, or engaging in phil-osophy and rational thinking cannot by themselves transform a human being.

At various places in his writings, Ken Wilber reiterates that the perennial philosophy in all its traditions sees being and consciousness in terms of a hierarchy of six or seven levels. Here is his enumeration of the hierarchy: 1. physical or material, 2. emotional/sexual, 3. mental, 4. higher mental or psychic, 5. subtle or archetypal, 6. causal or unmanifest, and 7. ultimate or unqualified. (*Wilber*, 1985, 255). The academic approach to this set of ideas would be to consider each level as an independent field of inquiry and discover the respective characteristics, but then we would be left with a mere classification of lower levels which are obvious and higher levels which are unverifiable, and without a model for direct experimentation and experience.

A most powerful tool to achieve direct experience of the above seven levels or sheaths of one's being is the meditation technique

of witnessing the breath, as transmitted by the Anapanasati Sutra (sutra on full awareness of breathing). This relatively simple technique is said to have been used and taught by Gautama Buddha himself and is taught today in many places in association with vipassana or insight meditation. The danger of practicing this technique is that you will never be the same again. Not only do you enter an existential laboratory, but you also become the animal which is experimented on. With Wilber's academic understanding you have nothing to win; with actual practice of anapanasati yoga, nothing to lose.

Each of the seven sheaths has its own polarity of life force. It seems that life is only possible if there is this tension between two poles. I shall here use Rajneesh's comments on this polarity either by direct quote or by paraphrase.

The first body is the physical one, and the first polarity one discovers and focuses one's attention on is that of the incoming and outgoing breath; here the medium is obviously air. One realizes that one pole cannot exist on its own—the body needs both for its survival. There is also no question of one being good and the other bad. This reminder sounds trivial at this level but will have already become very important at the polarity of the second body.

Physical Body

The alchemy of anapanasati yoga lies in nothing but the unqualified, choiceless watching of polarity. "The moment you become aware of it, you transcend the (physical) body. If you transcend your first body, then you become aware of the second... The breath coming in and the breath going out are two things, and if you become a witness, you are then neither. Now the third force has come into being" (*Rajneesh*, 1972, 192). The higher sheaths are experientially revealed as one becomes conscious of the polarity of the lower ones and thus transcends them. There is no value in teaching anyone the next level of experience or the whole sequence beforehand. The danger is that one might only imagine and not actually experience.

The second body is the etheric one. Its basic polarity of vital force consists of love and hate. Influence is the material of the vital energy in this body. One can watch how liking rapidly changes into disliking inside oneself even if there is no-one else in the same room. It is our education, our religious conditioning which makes us believe love equals 'good' and hate equals 'bad'. Deeper insight through meditation will show that we simply cannot pre-

Etheric Body

vent hate, even for our so-called loved ones, even if we try—just as we cannot stop the physical body breathing out because of some concept of the inbreath being good and the outbreath being bad.

I clearly remember once, after the third day into this meditation and after I had overcome all the physical pain connected with sitting, I developed a strong feeling of hate for some fellow meditator which lasted for about 45 minutes. I could have killed him. But after this period of time the energy of hate changed into one of utter love and compassion for him. "We are suppressing our love for our enemies and we are suppressing our hatred for our friends. We are allowing only one movement, but because it comes back again, we are at ease. It returns, so we are at ease. But it is discontinuous. It is never continuous. It cannot be" (*ibid.*, 193).

Astral Body

With the witnessing of the second sheath of consciousness, you transcend it, and become conscious of the third, which is usually referred to as the astral body. The energy medium which can be experienced at this level is that of magnetism, expressing itself in the polarity of power and weakness, of self-confidence and self-doubt, of hope and despair, or of courage and cowardice. "When the magnetic force is in you, coming to you, you feel great. When it has gone from you, you are just nobody; and this is going on, just like day and night. The circle revolves. So even a person like Napoleon has his impotent moments. A very cowardly person has his moments of bravery" (*ibid.*, 194). In my experience, the cycle of change of magnetism, even in my ordinary life, is much longer than the cycle of love-hate in the second body. For me it takes from one-and-a-half to two days before one "breath" of magnetism changes into its opposite.

Mental Body

The fourth sheath of consciousness is the mental. The polarity here is that of a thought entering you and pulling out again. Thus, the medium here is thinking.There are always strong correlations between the polarities of the higher bodies and that of the first, the polarity of breathing in and out. "When you breath out, these are moments of impotency. No original thought can be born in these moments. So in moments when some original thought is there, the breathing will even stop" (*ibid.*, 195).

The connection made here between breathing and creativity happening in the gap between two thoughts might seem strange

The Silent Orgasm

to us, but only because our education pays next to no attention to the actual change in breathing in our different activities. Our present culture has very little interest in the fact that our breathing is completely different in acts of love and acts of hate. Quite to the contrary, in the Far East all the arts of self-development, such as yoga, tantra, taichi or qigong to mention some main ones, pay great attention to breathing. It is accepted by all of these inner alchemies that air is only the outer medium of breathing; hidden deeply within it is prana, the basic polar energy of life. I believe that something can be understood about this even without practice.

Osho, an Indian by birth, summed up the whole secret of the Tao in the last of a long set of discourses on Laotse, by speaking on the mystery of breathing as the first and last act in one's life. "The child doesn't know how to breathe, nobody has taught him. This is going to be his first act, so this cannot be his act … This first breath is taken by the whole. And if the first breath is taken by the whole then everything else which depends on breathing cannot be your act … all that is going to happen after this first breath till you die, till the last breath, is going to be the activity of the whole. The whole will live within you" (*Rajneesh*, 1977, 357—8).

In life one is engaged in many activities connected with thirst and hunger, physical movement, sex, thinking, love, and aesthetics. A full life might also include meditation. All meditation techniques pay attention again to breathing, to the very first act in life, but with a distinction: now it must be done with consciousness. "Such a man while dying will see his breath has left him and will be aware, watching it. He will die watchfully, and one who dies watching, never dies. He has come to know the deathless. Through breathing he has discovered the vital principle of life. Breathing was just the outer layer of it" (*ibid.*, 379—80).

Once you are a witness to the fourth body, the fifth one, the spiritual, will manifest itself to you. The experience of the polarities described so far, up to the fourth body, is easily accessible to anyone because the individual living entity continues to exist. A quantum leap is necessary for the experience of the fifth, for the basic energy medium here is life itself, manifesting as a polarity of living and dying. Like incoming and outgoing breath, life is something that happens to you one moment and then pulls away from you the next.

Spiritual Body

"When you become aware of this, then you know that you cannot die, because death is not an inherent phenomenon; neither is life. These both, life and death, are outward phenomena happening to you. *You* never have been alive, never have been dead. You are something that completely transcends both; but this feeling of transcendence can only come when you become aware of the life force and the death force in the fifth body" (*ibid.*, 196).

Becoming conscious of death as only one aspect of a bigger life/death polarity has many existential consequences. Suicide, for instance, only makes sense as long as one has not become aware of death as something which is constantly occurring to one. The denial of death, or better, the unawareness of death as one's constant companion, and the acceptance of the life pole only, make it possible for the human being to commit suicide, or as a substitute for it, kill other human beings. Animals cannot do this since they are not aware of life.

Cosmic Body

Only after the equanimous and detached acceptance of both poles of the fifth body, life and death, will the sixth sheath of consciousness surface. The sixth body is the cosmic one. The polarity here is that of creation and destruction—not of the self as an individual or egoic entity, but of the self as the cosmos as a whole. Thus the medium here is the very creative and destructive energy of the universe.

Having reached this level, one feels in communion with the whole universe and its cycles of evolution and dissolution. "A star is born: it is *your* birth that is coming; and the star is going out: that is *your* going out. So they say in Hindu mythology that one creation is one breath of Brahma—only one breath! It is the cosmic force breathing. When he breathes in, the creation comes into existence—a star is born, stars come out of chaos, everything comes into existence. When his breath goes out, everything goes out, everything ceases—a star dies, Existence goes into Non-Existence." (*ibid.*, 198).

Nirvanic Body

The seventh sheath of consciousness is known as the nirvanic one, the body of enlightenment. Here of course, language is hardly of any service. Perhaps being and non-being could stand for its unique polarity. "In the seventh creation is always of something else; it is not of you. Creation will be of something else, and destruction is of something else, not of you. Being is of you, and Non-being is of you" (*ibid.*, 201). The point now is again to accept

both. For communicative purposes, however, "one has to choose Being or Non-Being—either the language of negation or the language of positivity" (*ibid.*, 202).

In the many popular Indian drawings of the subtle energy body of a yogin, the sitting figure is usally crowned on either side by the sun and the moon (see figures on page 33 and 34). The sun and the moon indicate the polarity of life force, of prana, in the seven bodies or seven sheaths of consciousness. Also, invariably shown in the drawings are the seven chakras with lines of energy flow, extending even beyond the surface of the body. And above the crown chakra is another sun, symbolizing the end of the journey into oneself, the ultimate unity behind all polar tensions in ordinary consciousness. This is congruent with the Great Clear Light mentioned in the Tibetan Book of the Dead.

I believe that the same polarity of life energy in the various layers of human consciousness is represented by the two yoginis, Dakini and Varnini, standing at either side of Chinnamasta, a manifestation of the Hindu goddess Kali. This representation of the full-breasted and decapitated goddess is usually interpreted as a symbol of the universal power of creation and destruction. Transcending the world of desire, she stands triumphantly upon the copulating figures of Rati and Kama, the goddess of sexual pleasure and the god of love, symbolizing of course human procreation.

My interpretation of this image goes further. To me it says something about the approach to, and content of meditation— what is required is the state of no-mind, represented here by literally cutting one's own head off. The right and left attendants symbolize to me the basic polar quality of the life force which one can experience by going more deeply into the seven bodies. Chinnamasta dances triumphantly on a couple in sexual union. Thus, she—being in meditation—has transcended the cycle of birth and death. Meditation constitutes the ultimate union of and beyond all phenomenal polarity. This is represented by the single figure of a Buddha in meditation on the top of the whole cosmic drama underneath. This drama is pictorially set in flames because it is subject to constant death and rebirth. I shall come back to this icon of Chinnamasta at the end of the Appendix.

Exactly why this map of the journey into the inmost sheath of one's being resulted in a hierarchy of seven layers in the Indian

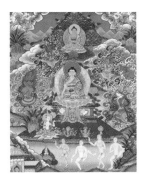

See figure on page 198.

tradition will remain forever unknown. All hierarchies are ulti-
mately no more than human constructs, not facts of nature. We
can only say that these seven levels of the complexity of human
consciousness have caught human attention; admittedly, we have
little to say about the transitions from one sheath to the next, and
the gaps between them.

The seven levels remind us of the chakras of the yogic model,
yet they are in a different order. As stated at the beginning of this
subsection, the hierarchy of the seven levels or sheaths is some-
thing which, with the proper technique, such as Anapanasati
Yoga, can be used to verify for oneself through experience the
truth of a layering of one's being. We have proceeded from the
grossest and most separate to the finest and most ineffably whole
aspects of consciousness and being.

The scheme also reflects processes used in various recently
devised meditational therapies as means to lure the modern hu-
man being out of the mind with which we mainly identify our-
selves. The techniques and vocabularies may vary, but the path
they follow and the goal they target is singular. Usually they begin
by forcing the human being from the mind into the body, then
from the mind into the heart, and further from the mind into no-
mind, with the ultimate goal being to transcend—to include and
to go beyond—being and non-being.

Zen Model

*From unconsciousness
via witnessing to
awareness*

True masters do not teach religious belief or doctrine. They are
not priests or professors. They share their life experience, their
being; they do not burden you with any knowledge. The only
thing they are devoted to is the growth of the friends who choose
to be with them. For that purpose they constantly invent new de-
vices and techniques to wake them up. This might include lying:
therefore they are socially shunned. A Mother Theresa can be aw-
arded a Nobel Prize; no master is likely to receive such recogni-
tion from society at large.

We have to admit that our daily activity or work is to a large
extent performed unconsciously, in the sense that we are usually
not conscious of what we are doing and who is doing it. We are
drowned in our work, indeed, we want to be drowned in it, be-
cause deep down we are afraid to face ourselves just like a normal
Japanese salaryman is afraid of a holiday. Masters say that in the
normal, so-called waking state we are 99-percent unconscious;

there is only a flickering of consciousness present. In this state the human being is in a way one, not split; but this sense of oneness is the result of unconsciousness.

"From ordinary unconscious activity to awareness there is a gap which can be filled by witnessing", said Osho, describing a two-step approach to awakening. "So witnessing becomes a technique, a method towards awareness. It is not awareness. But as compared to ordinary activity, unconscious activity, it is a higher step. Activity becomes conscious…" "Witnessing comes as a consequence of consciousness. You cannot practice witnessing; you can only practice consciousness… So consciousness is a method to achieve witnessing. And in the second step witnessing will become a method to achieve awareness" (1972, 207, 209).

Consciousness in fact is still marked by duality, by the mind, by division into subject and object. Your mind contains all of your past, your conditioning, your thoughts, and hence brings the past into the present. Whereas witnessing is about the present only and has the power to pull you into the present. There is no room for the past. Just sit silently and, for example, listen to the

sounds of the birds; you cannot listen to sounds in the past. Whatever method of meditation is practiced, witnessing is the essence of the practice. It is, as Osho said, "the technique of all techniques".

What is the difference between consciousness and awareness? "Consciousness is a quality of your mind, but not your total mind. Your mind can be conscious and unconscious. But when you transcend your mind, then there is no unconsciousness and no corresponding consciousness—but only awareness… Awareness (consciousness becoming conscious of itself) is the end of spiritual progress; unawareness is the beginning" (*ibid.*, 208—9)

Meditation, or the state of pure awareness, is not to be confused with concentration or contemplation, which are activities of the mind with practical values of their own. In concentration you focus your mind on a particular inner or outer object; thus even a dog barking a mile away can disturb you. In contrast, meditation is "choiceless awareness", to use Krishnamurti's eloquent term. Nothing can disturb you in meditation. You widen the conscious more and more, you accept everything inside and outside of you, until one day only awareness is left. That, however, is beyond deliberate effort. It is a gift, a revelation.

Ryoanji. "Temple of Heavenly Peace" in Kyoto, Japan, from the middle of the 15th century. A dry landscape garden made just of raked sand and a few rocks, in its rare winter appearance, attached to the main building of a Zen temple, quasi a built metaphor on the Buddhist experience of emptiness with and beyond all form.

The Silent Orgasm

Witnesssing is something like magic; it is the ultimate alchemy
to turn the lower metals into gold. You are angry; do not repress
your anger; just become a witness to it: I am angry, I am angry, I
am anger now. The miracle is that anger and witnessing cannot
exist together. Anger disappears. For anger to exist unconscious-
ness is a prerequisite, as it is for killing. Preaching to people not
to kill by way of the Ten Commandments has turned out to be
very ineffective over the last few millenia. Moses should have
taught his people methods of witnessing if he had wanted them to
stop killing. It is equally immature and ineffective to preach that
people must love each other.

One of the simplest witnessing techniques in existence was
used by the historical Buddha; it reportedly led to his enlighten-
ment. This is the technique, mentioned earlier, of anapanasati
yoga, "the yoga of incoming and outgoing breath awareness."
Buddha used breathing, among the most unconscious activities of
the human being, to create awareness. There is nothing to be
done with breath; just watching it in utter passivity is the tech-
nique. You watch it going in, then there is a gap, then you watch
it going out, then there is another gap. This method became prac-
tically synonymous with meditation as such all over southern and
eastern Asia.

But do not expect a Sunday ride to enlightenment if you
choose this method. It is very arduous. I remember a two-week

retreat after which I was proud to report that I was able to witness my breath for two to three seconds. Then thoughts would intrude and interrupt my watching, and off I went into daydreaming, thinking. Every other meditator reports the same limited progress, at least at the start. It seems to me that this sort of sitting meditation, or zazen in Japanese, is no longer necessarily the most adequate method. Some 2500 years have passed since Buddha lived. The human being has changed internally since that time, and so has the world around her. Zazen, above all, needs commitment and time; a two-week or weekend retreat might just be good for your nerves and your sanity. It can, however, become powerful if it is combined with cathartic techniques by which one can unburden oneself before one sits down and watches.

Pure awareness usually leaves no visual or audial traces. It cannot be seen or transmitted from one person to another. But over the centuries the enlightened masters have tried again and again to communicate something of it. In Japan the Zen arts are part of that effort. Thus the way of archery arose, the way of flower arranging, the way of tea, and the way of painting. These ways or arts might be seen as precursors of the recently developed Western practice of art therapy. They are nothing more or less than techniques to bring more consciousness into very normal human activities, such as making tea or writing a Sino-Japanese ideogram. (In another book I have analyzed how this is done in the tea ceremony; *Nitschke* 1991, 166—75.) To my understanding, the goal of all of them is to eventually bring together utmost effort and utmost relaxation, utmost attention and utmost passivity; then there is the inner explosion, the taste of no-mind, the taste of one's original self, but—and here lies the difference from non-art meditation techniques—with a visual trace left behind.

This state happens when utmost effort is given up, indeed, gives itself up in total surrender. In this sense it is identical to Buddha's great eye-opener. He had to give up six years of intensive meditation, he with all his efforts had to disappear, for awareness to shine.

I practiced the way of painting, apprenticing myself to a calligraphy master in Tokyo, Suzuki Kou, for seven years. Near the end of that period he asked me to enter an all-Japan exhibition of calligraphy, even though I was a foreigner. I was given one year to prepare a submission. I gently refused but he finally coaxed me

into it. The practice exhausted me physically and financially. There seemed enough and not enough time: there were only two characters to be painted, and yet the more I tried, the worse the results seemed to become. I did not need the master to correct my products; I knew instinctively that they were hardly fit to bless society in a public exhibition. He patiently showed me again and again how to do it. Several times I gave up, but he used unusual tricks to get me painting again.

One fine day the deadline for delivery was very close and I had made 5 paintings. Each required about two hours of preparing the ink, etc. and two seconds for the actual painting. Again I failed. None of the results were of any value besides documenting my own ambition and paranoia. So I decided to throw in the towel for good. There was, however, one sheet left, with some sprinkles of ink on it and thus worthless. I poured some straight water into the inkstone and swore at the master, myself and calligraphy and did a final painting for myself, not for any exhibition. The brush danced with me over the paper. I was so relieved, so high, so refreshed. I was simply blissed out. I did not know why. Moments later I looked at the painting, and I knew immediately that this was it. This painting was exactly what I had wanted to do for an entire year, but it only happened when I got out of my own way. I signed it with my Japanese name. Strictly speaking, I should not have signed it at all because 'I' was not there when it happened; all the earlier products I could have signed, for I was very much there when I wrote them.

This episode was not yet over. I rolled up the two-meter-long painting and handed it over, still rolled, to the master at our next meeting. He unrolled and looked at only about 30 cm of it, rolled it up again, and gave it to his daughter to have framed for the exhibition. He did not look at the whole of it. To me he simply said: "I knew you could do it", and smiled. He must have made up his mind by the aura with which I had walked into the class on that occasion. It dawned on me that only secondarily was he interested in my painting. His primary interest was in me. From that moment on I knew that he was not only one of the most accomplished calligraphers of his time. He was also a true master. As for me, I did not pick up a paintbrush for the next seven years.

My calligraphy experience confirmed to me that there is something like 'objective art', art as a visual trace of ego-transcendence

The Ox-Herding Pictures,
illustrating a Zen parable.
Woodcuts by Tokuriki
Tomikichiro, used by kind
permission of the artist.

1. Searching for the bull

2. Discovering the
footprints

3. Seeing the bull

4. Catching the bull

5. Taming the bull

6. Riding the bull

7. The bull transcended

8. Both bull and self
transcended

9. Returning to the source

10. Back in the world

or of no-mind. It might also be termed transpersonal art. What was brought home to me through my own experience was not only the existence of such art, but also the fact that there are ways to train the artist for it, to coax him into it. Furthermore, while before my own mini-satori in calligraphy I could not see in other calligraphers' paintings which were ego products and which were not, I can now see when others leave such traces of this state of no-mind.

To leave such traces one has to become a hollow bamboo. Art then becomes anonymous or transpersonal. It is the art of the 'gap', of a moment of meditation. Ananda Coomaraswamy is known for having pointed out the existence of 'objective art' in the traditions of the medieval West and the Orient. "Anonymity of the artist belongs to a type of culture dominated by the longing to be liberated from oneself. All the force of this philosophy is directed against the delusion 'I am the doer'. 'I' am not in fact the doer, but the instrument; human individuality is not an end but only a means ... To wish that it may be made known that 'I was the author' is the thought of a man not yet adult" (*Coomaraswamy*, 41). Osho goes a step further in describing creativity: "Action is not creativity, inaction is not creativity. Creativity is a very paradoxical state of consciousness and being; it is action through inaction,

Lotos flowers, result of art-therapy in Poona in 1970's

it is what Laotse calls wei-wu-wei. It is not a doing, it is an allowing. It is becoming a passage so the whole can flow through you. It is becoming a hollow bamboo, just a hollow bamboo" (1980, p. 178).

These are mighty words, but they acquire meaning after an experience of such a state. It should be remembered that none of the Zen arts are easy; they demand far greater commitment and endurance than a Western academy of art does. It has been said that for the Zen arts one must first acquire an unfailing technique and then abandon oneself to intuition, to the gap. It is intriguing that the foremost scientific thinker of our century, Albert Einstein, asserted along the same lines that "A scientific theory can be verified by experience, but no way leads from experience to the creation of a theory" (quoted by Charon, p. 60). This places the scientist on a par with the artist whose creations are based on individual intuition, rather than on logical deduction or inference from observed data. Charon goes on to claim, "Science itself makes its greatest progress whenever it denies facts of experience; for those are never facts in an absolute sense, but always only interpretations of observations" (*ibid.*, p. 60).

The arduous path of the Zen arts is best transmitted by the ox-herding pictures, an ancient Chinese picture story using the metaphor of a shepherd searching for his lost bull. Ever new versions of this story have been recorded right up to our own time,

Art-therapy in Poona in the 1970's; melting with nature.

The Silent Orgasm

and some of the most mature human beings from China and Japan have added their commentaries. This allegory sheds a wealth of light upon such questions as the meaning of art, life and education. (*Nitschke, 1989*).

Naturally the bull represents one's true nature. The intuiting of the sought is what creates the search in the first place. Such is the essence of the story. In the figure on page 56, pictures 1 through 7 show the various stages of confusion, search, fighting and endurance. For the present discussion, picture 8 is of particular relevance. It is captioned, "Both Bull and Self Transcended". One comment states, "Whip, rope, person, and bull—all merge in No-thing. This heaven is so vast, no message can stain it". Yes, the picture of this stage of the search for the bull consists of an empty circle. The circle has often been used in East Asia as a symbol of oneness, no-thing-ness, no-mind. This state symbolized by the circle is not one of inactivity or unconsciousness, but of consciousness having become conscious of itself—of pure awareness, to return to the term used at the beginning of this chapter. The seeker has become the sought. He has ultimately come back home. The circle is complete.

It is of great significance for the understanding of Zen Buddhism and the Zen arts, for the grasping of their vision of human growth, that the picture story does not end with the empty circle. The two further steps which await us represent the ideal of the boddhisatva, the one who has attained the wisdom of transcendence and then comes back into the world, to be creative and to serve and inspire others. Picture 9, "Returning to the Origin and Source", shows just a picture of nature. Once you have been through such a search, such therapy, once you have unburdened yourself of all repressions, all you see is nature as it is, not as a projection of your own. To paraphrase Blake, once the doors of perception are cleansed, everything appears as it is, naturally. (He said "beautiful".) Picture 10 depicts the shepherd going back into the ordinary world. Hence the last two pictures are in praise of the natural and the ordinary in life. The Western hero stands in the spotlight, the Eastern hero is invisible, in-distinguishable from the ordinary person. (Our present-day mind has become so pervasively mad, that to be normal might indeed look abnormal.) But the returnee carries a bottle of wine in his bundle. He is not serious any longer, he is playful.

In Kyoto in the late 1970s I viewed a large exhibition of brush-and-ink paintings by Japanese Zen masters together with a friend. Most of the paintings were quite simple, showing a few blades of grass, a frog, an insect or a couple of calligraphy strokes, nothing very serious or heavy. When we emerged, my friend, an American painter, commented, "This is not painting, this is enlightenment".

We encounter similar traces in other arts, such as poetry. Here is the best-known trace left by Basho.

> *furui ike ya* *The old pond there,*
> *kawazu tobikomu* *a frog jumps in*
> *mizu no oto.* *the sound of water.*

Hand movements by Osho (then known as Bhagwan Shree Rajneesh) during a darshan in 1981.

The elegance of these traces is beyond time. I think it was Hölderlin who remarked that the ultimate grace on earth is found at either end of the spectrum of consciousness: in the realm of the unconscious, such as the swift dance of a long-legged crane, and in the realm of the fully conscious, as in the walk or the hand movements of an enlightened being. Every finger seems to be filled with awareness. The few well-known and standardized hand postures found on a dead Buddhist sculpture are but a faint shadow of the grace resulting from full awareness in a living being.

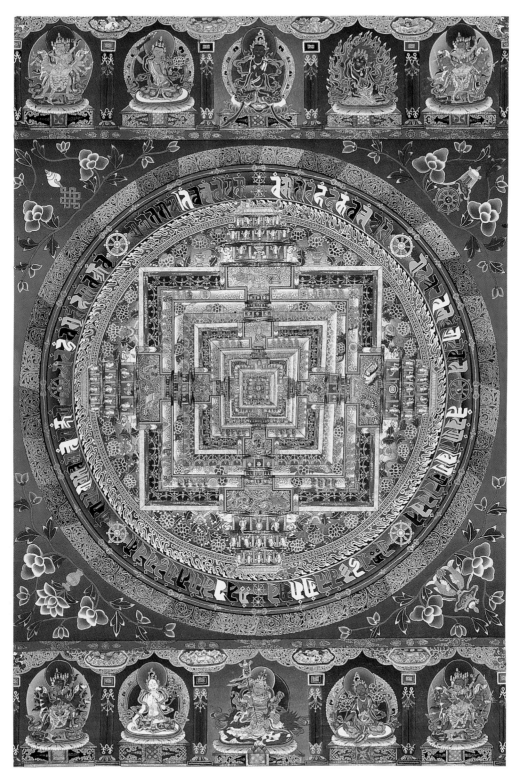

Vajrayana mandala
Newari thangka from 1989 based on a Tibetan pattern (63 x 91 cm)

Western Models
of Consciousness

What the five models of consciousness presented in the last chapter all have in common is that they are the result of the collective effort of the Indian genius over a couple of millenia, even if one admits the crystallizing power of such figures as a Buddha or a Patanjali in history. The next models differ in that respect. They are very much tied to the life work of specific, in this case, Western individuals. In addition, they are works of, and about mind.

Models furnished by Western religion or philosophy or science compare, in depth of insight and degree of utility, to ancient Eastern models as a bullock cart does to a space shuttle. In the East, thousands of years of persistently asking "Who am I?" and experimenting with meditation have produced an immense body of knowledge, techniques and literature. The Western approaches which have emerged in the past century or so are limited, because psychology, the science of consciousness, has mainly been seen as an end unto itself, whereas in the East its primary role is to go beyond the psyche. Psychology in the West would be out of business if it accepted no-mind, the Eastern concept of pure awareness or transconsciousness, as a reality. It is nevertheless useful to examine some contemporary Western models, for they are part of the intellectual baggage on which so many of us rely to one degree or another, and in various respects they may be well suited to our actual needs at this moment in time.

This is not the place to attempt a unified, modern Western-Eastern theory of consciousness. Such a 'general theory' would range from the nature of sensation, perception and emotion, through various types of transpersonal awareness, covering the entire domain of psychology and parasychology as well as mystical traditions and experiences. It would be far beyond the framework of this book, far beyond my goals of sharing some insights and commenting on the current literature of transpersonal consciousness.

I read Stanislav Grof's pioneering book Beyond the Brain (1985) about a decade after my primal therapy and heart chakra experiences and felt that I must write something to show that the same

Transpersonal Model
Grof's cartography of the human psyche

nonordinary states of consciousness that he documented in experiments with hallucinogenic drugs can be obtained without drugs, just by using the breath. In the meantime, in 1988, he did so himself in *The Adventure of Self-Discovery*. There he reports his experiences with patients using an intense breathing or hyperventilation which he calls "holotropic" breathing. "The entire spectrum of experiences observed in psychedelic sessions can be induced by various forms of nondrug experiential psychotherapies, such as exploratory hypnosis, primal therapy, neo-Reichian work, Gestalt practice, nude marathon and aqua-energetics, and different varieties of rebirthing" (*Grof*, 1988, p. XII). His work strengthens my belief that intensive breathing and hallucinogenic drugs effect similar biochemical changes in the human blood.

The specific purpose of this book is to introduce, in Chapter Six, yet another method for inducing the same spectrum of transparent states of consciousness that are reportedly obtained by the techniques to which Grof refers.

Grof sees the results of his vast research on the scope of human consciousness as a contribution to the creation of a new scientific paradigm based on holistic or holonomic principles. He presents the gist of these principles at various places, e.g., "These experiences clearly suggest that, in a yet unexplained way, each of us contains the information about the entire universe or all of existence, has potential experiential access to all its parts, and in a sense is the whole cosmic network ..." (*Grof*, 1985, p. 44). Or, "One must assume that consciousness has—at least in principle, if not always in actuality—access to all forms of the explicate and implicate order" (*ibid.*, p. 90).

The predicament he is in as a scientist is expressed by his insecurity, his use of words like "suggest" and "one must assume". He is aware that transpersonal experiences especially contradict the very foundation and principles of Western mechanistic science, the science which he sees as dominated by the "Newton-Cartesian paradigm", following an argument set forth in the works of Fritjof Capra. My feeling is that Grof is setting up a strawman, namely the paradigm of Western science which is crumbling anyway, in order to be able to shoot at it with his research results and those of his like-minded colleagues. I think it will be relatively easy to convince scientists. The final models of consciousness by Wilber, Bohm and Charon will prove my point.

The Silent Orgasm

The real culprits in the retardation of consciousness in the traditional West are not the sciences—they are relatively innocent—but the religions. I refer to the roots of Western culture in orthodox Judaism, Christianity and Islam. It has been and still is these religions which form and perpetuate our immature concept of consciousness. They are responsible for the fact that the majority of humankind today show the spiritual awareness of a twelve-year-old child even at the age of eighty. The religions have one great advantage over the sciences. Their main work of indoctrination is done between the ages of five and twelve; they have finished their main job by the time we start teaching science to the child. Judging from my own experience and that of my closest friends who all enjoyed Christian educations, it is very, very arduous to start the search for oneself later in life with these injected religious prejudices. For before you had ever asked any questions in your early years, all the anwers were not only supplied, but engraved upon you. This includes the answers about sex, marriage, death, heaven, hell, soul and god. This is the crime of religions against humanity: they steal from us the chance of a clean start for a true and spontaneous self-inquiry.

To climb the highest peaks of human consciousness will be nearly impossible with the ballast of useless belief-garbage forced into you before you could say no. There is no possibility for an 'adventure of self-discovery' if you have been indoctrinated to believe in something written in some ancient Holy Book. It has been said that belief means not knowing; I say it means not wanting to know.

Nor can the 'global destruction', both by war and environmental rape, which Grof warns against, be laid at the feet of Western science, as he claims. It is far more a consequence of the deep religious indoctrination of a mind-matter, body-soul, man-god duality. Why not exploit matter, nature or the body? After all, they are different from one's soul and from god, who are eternal! As long as we have these beliefs and the religions which perpetuate them, there will be no end to wars and the exploitation of the very earth which we are.

I do not remember the word 'consciousness' even once appearing in the course of my Christian education. Yes, there was lots of talk about 'conscience', which is nothing but the conditioning one receives by one's parents or one's culture at large.

To follow one's conscience one behaves like a parrot, one just repeats what one has been taught; there is no need to be conscious. Indeed, consciousness would do away with much of conscience as sunlight does away with the night. In contrast, I can see no barrier in any ancient Far Eastern religion to embracing all of Grof's consciousness research, and even guiding him towards the next logical step, namely meditation.

A constantly recurring theme in the works of Grof, Bohm, Pribram and Capra is that the discoveries of modern physics resemble the mystical vision of reality as taught by the ancient masters of Hinduism, Buddhism or Daoism, but contradict Newtonian laws and the Cartesian model of the world. Very well then, they continue, let us promulgate a science with a new paradigm, holistic, holographic or ecological, based on the latest insights of physics but somehow legitimized and supported by tenets of esoteric mysticism. But why do we need the confirmation of the ancient mystics of East and West? No Buddha has ever had any quarrel with the science of the day, because science does not deal with the experience of truth. It builds theories, truths which are at best adhoc about the material nature of the universe via its own means, which are empirical and analytical. Research in consciousness does not deal with a material or measurable aspect of the universe. What is all this hankering for acceptance by science, old or new? I do not subscribe to Capra's opinion that "the world-view of science will come closer to the view of the mystics as we go along refining our theories" (*Wilber, ed.*, 1985, p. 226).

A Buddha consciousness will always comprehend the lower one, that of the scientist using conscious mind, using ego; but it will hardly ever be the other way around. And the fight of the Buddhas has always been against priests and what they stood for, the dogmas of the established religions of the times.

The discussion of apparent similarities between quantum physics and mysticism began in earnest with Capra's book The Tao of Physics in 1974. Subsequently his thesis was vehemently criticized as exploiting a mere linguistic similarity between two different contexts of human endeavor to know reality, that of science and that of mysticism. In this dispute, which is far from being finally settled, two things should be kept in mind: first, it may indeed be high time for science, from subatomic physics to psychology, to formulate a new paradigm for itself with its own

particular tools, i.e theories built by conscious mind, by thought. Second, mysticism has always been and still is making statements about reality which come from beyond mind, beyond thought. They come from meditation.

With this said in reaction to Grof's lengthy appeal for a new scientific paradigm there remains the hard core of his research research. There he is a giant. I am deeply indebted to his work for sorting out my own and my clients' experiences toward making our conciousness more transparent. Both of his books cited above, the one based on work with drugs and the other on work with breathing, present the same 'cartography' of the human psyche, distinguishing by content among four levels of conscious-ness. This cartography has been of great help to me in evaluating my own experiences. And yet I take it as a stroke of luck that I did not encounter his work until a decade after my own experiences of transparent states of consciousness, and thus was not directly influenced by his model.

The first level of consciousness which Grof abstracts from his experiments is marked by abstract or aesthetic contents which relate in some way to the physiology of the human sense organs.

The next level Grof calls the biographical or recollective one. Here there emerge from one's various subconscious traumatic episodes which have enough emotional charge and relevance to haunt one for the rest of one's life. Reliving these episodes has an unexpected healing potential. They have to be made conscious before they can evaporate. Nothing can disappear from the un-con- conscious directly.

As a personal example, when during my forties I separated from a three-year relationship, I felt unbearable pain. It stopped suddenly when, after primal breathing, I relived a desparate scene of my life at the age of three or four, when my mother locked me into one room of our apartment and left me alone. The pain of separation from my lover had derived its intensity from the fact that it connected with a greater pain I had suffered in early child-hood. I was surprised beyond any expectation that when I met my ex-lover the next day I felt no more pain, not even attraction to her any longer.

At the third, perinatal level of consciousness are hidden the events occurring from conception throughout one's uterine life up to biological birth, which in itself turns out to be close to an

Going through the birth-canal; sketches made by a woman after a perinatal experience in mandalic sex therapy.

experience of death. At this point, of course, the cartography clashes head on with the mainstream of materialistic medicine and psychology, which flatly denies the possibility of any memory of such events. At these stages of life, their argument goes, there exists no material base, no brain for a memory to be imprinted upon, hence birth and womb experiences are dismissed as hallucinations. With the amount of evidence of such memories now before us, scientists may begin to accept that consciousness is a non-physical aspect of every being. It is not just an epiphenomenon of physiological brain processes.

Grof was able to subdivide the very complex experiences on the perinatal level of consciousness into four major thematic clusters which are related to the four major stages of the biological process from conception to actual birth. He calls these clusters basic perinatal matrices: the first is distinguished by a sense of undisturbed intrauterine life, the second by a sense of the onslaught of the delivery process, the third by that of the struggle of moving through the birth canal, and the last by that of a sudden relief after propulsion into the world (*Grof*, 1985, p. 98—127).

My own experiences confirm his findings that these four stages of perinatal consciousness do not necessarily turn up in that time sequence, nor do all of them have to appear in one individual. It is also possible that one of them turns up again and again. This is not a map of the individual experience of one or many persons, but a cartography, a composite of possible experiences. It is close to the quality of an average; in a room of 100 persons the average height may be 180 cm, even though nobody is actually 180 cm tall. Likewise, the cartography may be conceptually accurate, and yet the journey on the uncharted sea of consciousness may start at different points and follow different paths in different orders for each individual. For instance, I relived existences as plants and animals before I relived my biological birth in this life.

Equally important is that elements of the biographical or perinatal and also transpersonal level of consciousness do not always come up clearly separated but are often experienced in certain dynamic configurations for which Grof coined the term "system of condensed experience". In this context he says, "Perinatal themes and their elements, then, have specific associations with

related experiential material on the transpersonal domain. It is not uncommon for a dynamic constellation to comprise material from several biographical periods, from biological birth, and from certain areas of the transpersonal realm, such as memories of a past incarnation, animal identification, and mythological sequences" (*Grof*, 1985 p. 97).

The fourth level of consciousness, called transpersonal, is divided into two categories of experiences in his later book; those within consensus reality and space-time, and those beyond it. It strikes me as strange that the 'transpersonal' level is drawn so broadly as to include not only recollections of former human lives, or collective human memory (i.e. as people) but also of truly transpersonal ones, such as recollections from animal or vegetal existences. The classification scheme could be made more logically sound, perhaps by adding a 'prenatal personal' category between the perinatal and transpersonal levels of experience. But this is a rather minor flaw.

In this catalogue of states of transpersonal consciousness, Grof has practically subsumed every phenomenon of reality the human being has been known to experience or to imagine having experienced, right up to the ultimate experience of the "supracosmic and metacosmic void", to him "the most enigmatic and paradoxical of all transpersonal experiences" (*Grof*, 1988, p. 147). As a description for this state he draws upon the Heart Sutra which at one place says that "form is emptiness and emptiness is form".

Here I find a serious problem. The 'experience' of the void is by no means on a par with the rest of the states of consciousness Grof has listed in his cartography of the human psyche. The void belongs neither to the realm of the known nor to that of the unknown, but to the realm of the unknowable, in the sense that you have to disappear to 'know' it. It demands a quantum leap. It cannot become part of the consciousness research that Grof is pioneering for it can never be part of any science, whether with the old paradigm or a new one. Transpersonal psychology and therapy have much to contribute to meditation techniques, but they do not even touch on meditation as the 'experience' of the void.

The knowing and describing are so futile here that it is not even quite right to speak of a 'void'. What is being indicated is not absence, but rather awareness without content, a no-man's land of clear light (as Trungpa interprets the Tibetan Book of the

Dead), a jump out of the wheel of existence. In addition, by calling the void *supra* or *meta* cosmic, Grof puts its *experience* on so high a pedestal as to make it appear unreachable. It is not. It is merely not communicable in language. Void is void, whether the scale is meta-cosmic, cosmic, local, or the size of one's head.

It may be that the whole of consciousness research in the West, valuable as it might turn out to be for purposes of healing body and mind, is only another trick of what Ken Wilber called the Atman Project—the age-old human endeavor to find an escape from or substitute for the necessity to disappear as ego in order to be as the whole. Now the new entity to survive is consciousness, ever so subtle, immaterial and transpersonal; before it was the soul, able to survive the ultimate shipwreck which is death.

To bring all these descriptions of what cannot be described back to the human level, I shall hand on a meditation technique here suggested by Osho for the purpose of attaining a "taste" of the void. It is in fact one of the 112 meditation techniques contained in the Vigyana Bhaira Tantra. This is Paul Reps' translation of it:

"At the point of sleep, when sleep has not yet come and the external wakefulness vanishes, at this point being is revealed." (*Reps*, 1961, p. 167)

There is a subtle 'gap' just before you lose consciousness when you fall asleep, and another one before you become fully conscious or awake the next morning. Try to become aware of it. In that gap 'you' are hidden.

I tried the technique, but I always just fell asleep; and I was fully conscious the next morning before I remembered that I wanted to watch for the 'gap' between unconsciousness and consciousness. It seems difficult to succeed with this technique simply by ordinary effort. Only quite recently did Namkhai Norbu reveal an ancient Tibetan technique how to enter this "window of opportunity" just between normal thought activity and the start of dreaming; here according to Dzogchen tradition one has one of the many chances to become aware of the state of natural light, or better, become the natural light, and thus become able to induce lucid dreaming, that is, watching and influencing one's dreams consciously. (*Norbu*, 1992, p. 45—64).

In 1986 the 'gap' became slightly accessible to me in, naturally, an unexpected way. Fate had thrown me into a kafkaesque situation where I was judged guilty of all kinds of 'crimes' I had not committed. The more I defended myself the greater the efforts of my 'judges' to find me guilty. They held absolute power over me, and seemed to me to be motivated by revenge; my innocence would have meant their guilt. Under the circumstances, my entire participation in the investigation, interrogation and defense had to be done from a public phone box between midnight and 1 or 2 o'clock in the morning during winter. Then, up until the time I went to bed around 4 or 5 am, my mind was working with the speed of light to find a solution to my predicament. There was none. This went on for a few days. I sometimes found some sleep in the wee hours out of sheer mental exhaustion. Upon awakening, the whole mind-mess set in again.

Suddenly it happened on two consecutive mornings. I was in the 'gap'. I came out of sleep and was suddenly conscious, but my mind was empty, no content, just awareness was left. All the thousands of radio stations in my mind were on hold. There was only silence, but that did not prevent me from hearing the birds and other noises of the neighborhood. In this 'gap' form is emptiness and emptiness is form, or sound is silence and silence is sound. It came close to Nagarjuna's paradoxical qualification of reality: neither being nor non-being, nor both nor neither. Whatever one might say about the subject will have to be denied the next moment. After a while I could clearly see how my mind switched on again with the insurmountable power of age-old habit. I fought against it, without success. Soon I was back in my mind-mess. But even as a memory, the taste of the 'gap' will stay with me forever.

Through the trick of an unsolvable kafkaesque dilemma in real life, I was put into the same position that the koan is designed to produce in Zen practice. The koan given by a Zen master to a disciple is a riddle which is unsolvable and yet must be solved. It might be called an artificially created dilemma. The best-known example is the problem, "What is the sound of one hand clapping?" One soon finds that any answer is wrong, and yet the master may keep you working on it for months or even years. But if you are intense enough and lucky, one day all your brain cells might short-circuit and your mind simply stop. You would then have an 'experience' of yourself without mind, of no-mind, of the

void. You cannot make a concept out of it since it is a pheno-
menon not of mind, but of no-mind.

After the 'experience' of the gap, whatever you say will have
little relevance to the content of the koan. It will be paradoxical,
but will somehow carry the flavor of the void, at least for those
who can see. A good example is the poem recorded centuries ago
by a Japanese nun named Chiyono who had been meditating for
many years without finding enlightenment. On a full-moon night
she was carrying water in an old pail when she saw the moon re-
flected on the water. Suddenly the pail broke, the water rushed
out, and the reflection of the moon was gone. This little shock
triggered her enlightenment.

"This way and that way I tried to keep the pail together, hop-
ing the weak bamboo would never break. Suddenly the bottom fell
out. No more water; no more moon in the water—emptiness in
my hand" (cited in *Rajneesh*, No Water, No Moon, 1975).

All I can say is that after the resolution of my 'life-koan' I felt
like touching the feet of my adversaries, as Zen disciples do to
thank the master for being so tough with them.

Another sort of 'gap', an unexpected hole in the fabric which
trips one into meditation, was used by Osho during his frequent
spoken discourses. He had an odd style of speaking, and on one
occasion (on 28th of August 1987, videotaped as *The Invitation*) he
explained that there are two aspects of his discourses. One is the
content, and this is the less interesting; it might as well be jokes,
since he is not an orator and there is nothing in his mind that he
wants to convince others of. The other aspect is the 'gaps' or
pauses which he inserts into his discourses at the most unex-
pected points so that the listener's mind is occasionally made to
stop. Some longtime friends of his would consciously drop them-
selves into these 'gaps' and later be unable to recall any of the
content of the discourse. I find this way of 'non-listening' to be an
easy and quite powerful meditation technique. The best way to do
it is to use videotapes of his discourses; nothing of the trick is left
in the printed transcripts of his talks.

The greatest value of Grof's cartography of human conscious-
ness seems to lie in the support, the confirmation and rationaliz-
ation which it provides, for people have experiences similar to
those which he documents. What is surprising is that, despite the
authentic and pioneering research he performed, Grof sometimes

comes to conclusions which negate his own belief in it. He often distinguishes between two modes of consciousness in the human being, "the hylotropic mode—ordinary waking consciousness experienced from one moment to another—and the holotropic mode—nonordinary states of consciousness that mediate access to all other aspects of existence" (*Grof* 1988, 41). He also says that this paradoxical or dualistic model could be compared to that of the wave-particle paradox of subatomic reality. At another point he admits that in the holotropic mode "the experience of fundamental oneness with the rest of creation increases the tolerance and patience toward others, lowers the level of aggression, and improves the capacity for synergy and cooperation" (*Grof* 1988, 272).

My point is that if the 'experience of fundamental oneness' does not do away with the entire dualistic model of human consciousness, then there has not yet been an experience of oneness. The experience of fundamental oneness *is* the transcendence. What else are we waiting for? Consciousness ought to be made more and more transparent, without the perpetuation of dualistic description.

Here I see the difference between two outstanding bodies of work in consciousness research and meditation which have recently been done in two places: in and out of Esalen and in and out of Poona (the ashram of Osho). In Esalen you could find one half of the most brilliant collection of superegos-as-therapists of our time and in Poona the other half, but with a difference: we had in our midst a model, an enlightenened being against whom we could measure our experiences, a being in whom we could and did encounter a no-mind side by side with a brilliant mind.

Finally, a warning against an obsessive hankering after those experiences of transparent consciousness which are often referred to as 'spiritual experiences'. For me this term is a contradiction. There is nothing spiritual about the reliving of a birth or death. The 'experience' of the void is a spiritual one, but then it is not an experience. What we do with various meditation techniques is come to own more and more of what has always been ours anyway. There is theoretically no end to this expansion. We are capable of becoming conscious of any pebble in space or any event in time. The experiences which come your way have to be lived through and then laid aside. To know yourself, it is not actually necessary to have any such experiences at all.

Evolutionary Model

Gebser, Wilber and epochs of unfolding consciousness

Of the various Western scientific models of human consciousness I have chosen a new one presented by Ken Wilber in his book Up from Eden, because it brilliantly subsumes the research on the subject which has recently been furnished via anthropology, psychology, philosophy and their combinations. Against the experiential perspective which is emphasized here, Wilber's model remains 100% academic. That is, it is not based on direct personal in-sight or realization of so far unknown layers of consciousness, but on out-sight, the interpretation of data supplied by others.

Wilber himself says that his "transpersonal view of human evolution" is not a simple empirical-analytical reading of human evolution but a hermeneutical or interpretative one, "set in a developmental logic derived from phenomenological inquiry into the deep structures of consciousness development" (*Wilber* 1981, 33).

However deep the structures of consciousness which Wilber brings to the surface, his theory of the development of human consciousness will remain a meal painted on a wall. You may look

Involution and evolution. Reproduced from Wilber, Up from Eden.

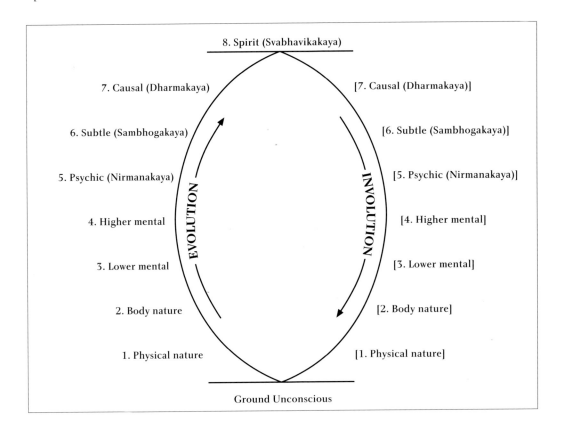

The Silent Orgasm

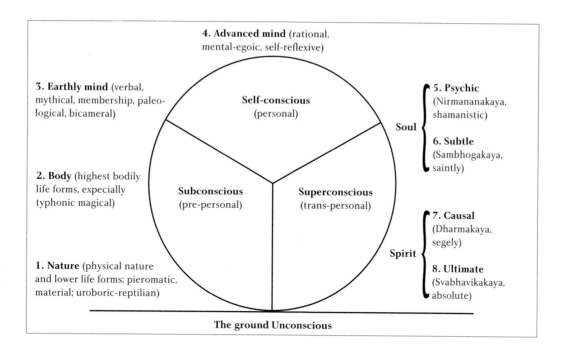

4. Advanced mind (rational, mental-egoic, self-reflexive)

3. Earthly mind (verbal, mythical, membership, paleo-logical, bicameral)

Self-conscious (personal)

5. Psychic (Nirmananakaya, shamanistic)

6. Subtle (Sambhogakaya, saintly)

Soul

2. Body (highest bodily life forms, expecially typhonic magical)

Subconscious (pre-personal)

Superconscious (trans-personal)

7. Causal (Dharmakaya, segely)

8. Ultimate (Svabhavikakaya, absolute)

Spirit

1. Nature (physical nature and lower life forms; pieromatic, material; uroboric-reptilian)

The ground Unconscious

The Great Chain of Being, reproduced from Wilber, Up from Eden.

at it and admire its brilliance of execution, but such contemplation cannot satisfy your hunger for first-hand transformational experience, the standard by which the models of consciousness presented here will be evaluated.

Wilber's central hypothesis resembles the ancient Indian mythico-philosophical vision of the universe as a dual simultaneous process of expansion and reabsorption, or evolution and involution. One important element has been added: Jean Gebser's thesis, published in 1949 and 1953, of the historic unfolding of human consciousness through five successive structures (called by Gebser archaic, magical, mythical, mental and integral). This joint production suggests that the Western mind is trying to catch up through scientific means with what was apparently intuited by Indian sages several thousand years ago.

Wilber's hypothesis is summarised near the end of the book, with some diagrams, two of which are reproduced here (figures on pages 74 and 75). The first shows the movements from Spirit to Physical Nature and back, i.e. the processes of increasing and decreasing dualism, as involution and evolution. "Involution is the *enfolding* or in-turning of the higher structures into successively lower ones, and evolution is the subsequent *unfolding* into actuality of this enfolded potential… In short, once involution is com-

plete, evolution begins… It is not that the higher actually *comes from* the lower as a cause from an effect. The lower can never produce the higher. It is rather that the higher *comes from* the Ursprung [origin] where it already exists as potential … and the higher reaches existence only by passing through [the lower]" (*Wilber* 1986, 302).

This scheme can be applied equally to the evolution of the entire human species or to a single human life from conception to death, as is clear from the second diagram, the "Great Chain of Being." Wilber states, "Evolution *is* holistic, because 'to evolve' is simply to remember that which is dis-membered, to unify that which was separated, to re-collect that which was dispersed.

Evolution is a re-membering, or putting back together, of that which was separated and alienated during involution. And evolution, as successive remembering or joining together in higher unity, simply continues until there is *only* Unity and *everything* has been remembered as Spirit by Spirit" (*Wilber* 1986, 305). (How unfortunate the term *Spirit* is with all its Judeo-Christian connotation. What is its meaning? Remember Laotse: "The Dao that can be named is not the eternal Dao.").

Among the levels of the historical evolution of consciousness which Wilber isolates the first has the human being still in unison with nature, embedded in it, lost in it, he still is nature. This first level is called "archaic" by Gebser, and "uro-boric" by Wilber.

At the next level, called "magic" by Gebser and "typhonic" by Wilber, is the first emergence of a self differentiated from nature. This level is oriented mainly to body/emotion.

At the third level, labelled "mythical" by Gebser and "membership" by Wilber, the sense of a separate self is strengthened by the development of an early verbal mind and membership formations.

At the fourth level, called "mental" by Gebser and "egoic" by Wilber, the human being evolves as a full-fledged mental ego which not only sees itself in opposition to the body, but even suppresses it. While Gebser relates the magical structure of consciousness to "emotion", and the mythical one to "imagination", he sees "abstraction" as the main characteristic of the mental structure (*Gebser*, Vol. 2, p. 148).

At the fifth and last level, called "integral" by Gebser, consciousness is characterized by "the restoration of the unharmed original condition with the enriching integration of all previous

achievement" (*Gebser,* Vol. 2, p. 167). This to Gebser means that the previous levels of consciousness have become "transparent" to the human being. He believes this "integrating diaphanization" is the central feature of the consciousness to come.

The model of the epochs of consciousness elucidates the successive ways in which the divine was conceived quite well. The magically structured consciousness was characterized by the creation of *idols* and *rituals.* The mythically structured consciousness was marked by *deities* (polytheism) and *mysteries;* and the mentally structured by *God* (monotheism) and *ceremonies.* The integral structure entered by the human being in our times is oriented towards *consciousness* and its *diaphanization.* Parallel to this evolution runs a change of focus from the Great Mother to the Great Goddess to God the Father and now Godhead or the Void, the ultimate in transparency. On the intellectual level, then, the overall scheme helps us recognize which religions are regressive in their messages and techniques and which push towards greater transparency.

Human beings first became conscious of nature as something separate from the self, rather than embedding the self, during the magical epoch. Consciousness of a separate human soul began during the mythical epoch. At the climax of the mental epoch, god was declared dead and man free; that is to say, man's rational mind, his spirit, replaced his soul. If we now speak of transpersonal or transparent consciousness, we should remember not to reject or condemn the previous levels of insight, as one does not reject one's childhood; we have merely transcended them.

Wilber sees humankind as a whole in our age slowly breaking free from primary identification with thought processes and beginning to enter transpersonal or super-conscious realms, which he divides into four successive stages, following Buddhist terminology.

There is another basic thesis from Gebser (besides the five-stage historical unfolding of consciousness) which deeply informs Wilber's scheme of human evolution. It is epitomized in the first and last sentences of Gebser's Ursprung und Gegenwart (Origin and Presence): "Der Ursprung ist immer gegenwärtig… Doch nur wer um den Ursprung weiß, hat Gegenwart und lebt und stirbt im Ganzen." "Origin is always present … Only he who knows of the origin has presence and lives and dies whole." Though this may be

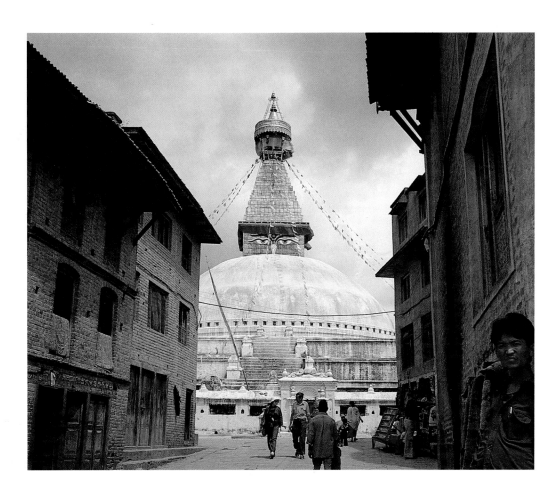

Stupa at Bodnath near
Kathmandu, built between
the 5th and 8th century AD.
Beyond being a burial
mound for a relic of a
Buddha it is a huge three-
dimensional built mandala
representing the structure
of the the micro-cosmos and
the human micro-cosmos
in their processes of ema-
nation and reabsorption.

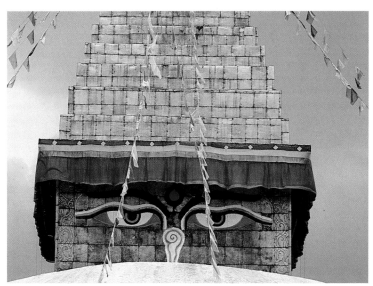

The Silent Orgasm

nothing more than the quintessence of the perennial philosophy, it is nonetheless expressed in an aesthetic form comparable to Laotse. Unfortunately the English 'origin' (or 'source') lacks some of the connotation of Ursprung, which etymologically implies 'original jump'—something like a sudden, internal 'Big Bang' of consciousness.

According to Wilber, all that we human beings ever want intuitively is this wholeness which he calls "Atman consciousness"; but all we have ever really done, through the various stages of development as a separate self, is find substitutes for it, in what he calls the eternally ongoing "Atman project". "All a person wants is Wholeness, but all he does is fear and resist it (since that would entail the "death" of his separate self). And there is the dilemma, the double bind in the face of eternity" (*Wilber* 1986, 13).

It is a clearly paradoxical view of human culture through the ages. Each successive level of consciousness is seen as a transformation and integration of the earlier ones, with ever greater potential for wholeness, ever more transparency of consciousness. But then culture is seen in retrospect as nothing more than traces of the human flight from reality. "Culture, truly, is what a separate self does with death—the self that is doomed only to die, and knows it and spends its entire life (consciously or unconciously) trying to deny it, both by constructing and manipulating a subjective life and by erecting 'permanent' and 'timeless' cultural objects as outward and visible signs of a hoped-for immortality…" (*Wilber* 1986, 15).

Wilber has rendered us the service of underpinning this interpretation of human culture from Eden onward with exhaustive evidence and rigorous interpretative skill. This is the main value of his view of human evolution, which is basically the view of the perennial philosophy applied historically. Of course, any interpretation of human culture from whatever angle is ultimately only an intellectual or academic pursuit. As noted earlier, it offers no nourishment to those who hunger for the experience of transformation.

Even on the intellectual plane, this evolutionary model cannot be taken as a prophetic roadmap which could help us read where human consciousness stands today and which way it might move from now on. After all, a Buddha realized transpersonal consciousness about 2500 years ago, and he never claimed to have

The stupa as symbol of enlightenment painted in a thangka

been the first enlightened being, nor the last. Only Western religions contain childish 'first and only' claims, such as 'the only begotten son of God' or 'the only prophet'. This sort of dogma has retarded human spiritual evolution tremendously, and still does. The East has been far more generous in its vision of enlightenment; it has accepted the existence of hundreds, indeed, thousands of Buddhas, of human beings who have reached their goal and will reach it in the future.

The positivistic belief in the progress of human consciousness, which consciously or unconsciously is implicit in the constructs of both Gebser and Wilber, is to my mind a defect of vision. Are there more enlightened beings living now than 2500 or 5000 years ago? Has the chance for a human being to realize enlightenment increased over the millennia?

The ancient Hindu concept of cosmic evolution and involution is indeed similar to the model proposed by Wilber, and yet it differs in one important aspect: its purpose is not intellectual, but didactic. Part and parcel of the old Hindu model were maps, man-

Tantric scheme of cosmic evolution and involution by internalizing the symbolism of a mandala. Reproduced from Khanna, Yantra.

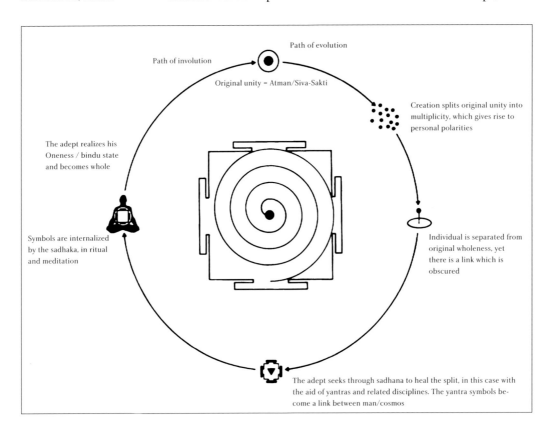

Path of evolution

Path of involution

Original unity = Atman/Siva-Sakti

Creation splits original unity into multiplicity, which gives rise to personal polarities

The adept realizes his Oneness / bindu state and becomes whole

Symbols are internalized by the sadhaka, in ritual and meditation

Individual is separated from original wholeness, yet there is a link which is obscured

The adept seeks through sadhana to heal the split, in this case with the aid of yantras and related disciplines. The yantra symbols become a link between man/cosmos

dalas and yantras, designed to transmit the message of the original unity and its successive disintegration in cosmic evolution. Methods of visualization and identification were invented for the seeker to relive, to be reabsorbed into *bindu,* the original unity, the 'Ursprung'. Khanna's diagram of this simultaneous dual process of the universe, reproduced here, has indeed much in common with Wilber's in figure on page 74, although the terms involution and evolution are reversed.

In the wake of Tucci's seminal book on the mandala, published in 1961, mandalas and yantras have been understood in the West mainly as geometric diagrams symbolizing the universe in the process of emanation and reabsorption. The movement from the central point, the bindu, to the outside visually portrays the evolutionary mode of the universe, and the reverse movement portrays involution, the mode of dissolution of the self into the original wholeness. See the yantra in figure on page 80.

Khanna elaborates: "Involution is a compulsion into the spiritual. It implies moving against the current of life. In subjective terms it means thirsting for a higher state of consciousness, suppressing the 'lower' by ascending the ladder of multiplicity into unity, a spiritual itinerary which takes the form of a return to the state of cosmic foetalization, the a *priori* state before experience begins ... A yantra thus maps the road of eternal return, and the way to inner wholeness When he has internalized all the symbols of the cosmos and his body 'becomes the yantra', the adept is no longer alienated from the truth that the symbols illustrate, but is transformed into the truth he seeks." (*Khanna,* 80). The stages of the inner journey to original wholeness are traced in detail (foretelling the holographic model of consciousness discussed below). Khanna concludes, "each phase of the cosmic cycle is a dynamic whole, and while the Whole contains all the parts, all the parts assimilate the Whole ... Every part in creation must also be of the nature of the Whole" (*ibid.,* 78—9).

The content of Wilber's theory of the Atman Project clearly seems to be contained in the symbolism of the yantra. "As primal unity first divides into two, so our consciousness emerging from the precreative to the post-birth state divides into two parts: one who as a silent seer observes in detachment (the Atman), the other who as the phenomenal ego yields to the creative play of

life. These two basic levels of consciousness are radically different but co-extensive … The Atman has no boundaries, no limitation. It retains its wholeness and purity throughout eternity. It is total. Under the spell of the creative play of the Supreme Energy, man mistakes the phenomenal ego for reality and identifies it with Atman. The phenomenal ego shatters our perception of our inner wholeness and makes us see life as an accumulation of disjointed images" (*ibid.*, 79—80).

Wilber's works contain much repackaging of ancient Hindu and Buddhist tenets in the wrappings of Gebser's evolutionary theory of consciousness and trendy 'transpersonal' language. Yet there is much to admire in the brilliance and clarity of his hermeneutical discourse on the evolution of human consciousness.

Holographic Model
Charon, neo-gnosticism and the consciousness of matter

One of the most influential models of reality advanced during the ongoing birth pangs of the paradigm shift in Western science has been the holographic model. In 1947 Dennis Gabor, drawing on Leibniz, developed a calculus to describe holography, a three-dimensional type of photography. In 1965 the first hologram was produced by firing a laser beam through a plate with a recorded light pattern. In 1969 the neurosurgeon Karl Pribram proposed the hologram as a new model for brain processes, and in 1971 the physicist David Bohm proposed that the entire universe is structured on principles of holography, or to use his word, holomovement. The pros and cons of this new view of the world are gradually emerging in the hard and soft sciences and are far from being settled in a conclusive manner. The best overview at this point is The Holographic Paradigm and Other Paradoxes, edited by Wilber.

A hologram, as is by now well known, is two-dimensional and yet the image on it is visible in three dimensions as it is tilted. What is more remarkable is that each minute part of the picture contains the entire picture in condensed form. If a hologram is broken, any piece will serve to replace the whole of it, though in slightly blurred form. "The part is in the whole and the whole is in each part … The key point is simply that the *part* has access to the *whole*" (*Wilber ed.*, p. 2).

Pribram discovered through clinical experiments on humans and animals that if brain tissue is selectively damaged or removed, none of the particular contents of memory is completely lost, and

others are fully retained. The difficulty of eliminating bits of memory information led him to conclude that sensory input is spread over the whole brain, as in a hologram. He also hypothesized that, like a hologram, each part of the brain contains the information of the whole.

At about the same time, Bohm's work in particle physics led him to propose that the entire universe is hologram-like, with each part containing the whole and vice versa. And, hey presto, the scientific and intellectual communities of the world, drawing on news from both brain science and theoretical physics, were presented with a plausible new interpretation of reality: the human brain as a micro-hologram integrally embedded in the macro-hologram of the universe. It was a holistic vision so grand as to be commensurate with the age-old claim of the original and eternal oneness of the universe made by the mystical tradition.

Bohm went a step further. For him the hologram analogue was too static in character, because a hologram is just one frozen frame, a snapshot of reality, and reality is in constant movement. He invented the concept of *holomovement*, a dynamic version of the hologram, as a rough model for the universe. In *Wholeness and the Implicate Order* Bohm defines holomovement as "undivided Wholeness in Flowing Movement. This view implies that flow is, in some sense, prior to that of 'things' that can be seen to form and dissolve in this flow. There is a universal flux that cannot be defined explicitly but which can be known only implicitly, as indicated by the explicitly definable forms and shapes, some stable and some unstable, that can be abstracted from the universal flux. In this flow, mind and matter are not separate substances. Rather, they are different aspects of one whole and unbroken movement" (*Bohm*, 11).

Bohm believes that there is an *explicate* order of the universe where we experience separate objects and events, and an *implicate* order which is the undivided unity of the whole; and the implicate realm of wholeness is *enfolded* in each explicate part. To him, "the holomovement's basic movement is folding and unfolding" (*Wilber ed.*, 51). He suggests "that this implicate order implies a reality immensely beyond what we call matter. Matter is simply a ripple in this background" (*ibid.*, 56). "The connections of the whole have nothing to do with locality in space and time but have to do with an entirely different quality, namely enfoldment" (*ibid.*, 49).

Bohm also pays particular attention to the identity of consciousness within his new grand scheme of reality. "Consciousness basically is the implicate order as all matter is, and therefore, it's not that consciousness is one thing and matter is another, but rather consciousness is a material process and consciousness is itself in the implicate order, as all matter, and that consciousness manifests in some explicate order as does matter in general ... Consciousness is possibly a more subtle form of matter and movement, a more subtle aspect of the holomove- ment" (*Wilber ed.,* 62). In other words, "we are of the holomovement; we can't interact with it ... Consciousness is a feature of the holomovement, and therefore the content of consciousness refers to the whole of the holomovent" (*ibid.,* 91).

Although Bohm considers it "foolish" to look to the mystical tradition to validate his case, he clearly seems to share the mystical worldview which holds that the separateness of a person or an object is ultimately only an abstraction of the human mind (in his terms, an appearance in the explicate order of manifestation). He accepts thoughts as such merely as "ripples" on the whole of consciousness-energy. We take these ripples for reality because we can objectively perceive them. If we rid ourselves of those ripples, of thought, "then we have an emptiness which makes consciousness somehow a vehicle or an instrument for the operation of this totality—of intelligence, compassion, truth" (*ibid.,* 98). For him this non-manifest consciousness is the pure awareness which has been discussed above as part of a practical model described by mystics.

The question is how to approach this pure awareness beyond thought, and he is surprisingly clear about it for a scientist. He speaks like an Eastern mystic, intuitively perhaps, or as part of his acknowledged influence from J. Krishnamurti: "it is only when thought actually is not there that it would be possible to perceive what is beyond thought. When thought is there, attempting to capture what's beyond cannot work" (*ibid.,* 66).

As the most direct way to actualize this joint revolution of physics and consciousness research, which postulates consciousness and the material world as having essentially the same nature, he suggests transcending thoughts completely to *be* emptiness. I point out that this is only possible by meditation. Only meditation can transform consciousness with content, that is, mind,

The Silent Orgasm

into pure awareness, emptiness. I do not feel qualified to criticize the intriguing holomovement analogy of Bohm's model, but I must question his rigor and thoroughness. Why merely suggest and not personally attempt the meditation which would be necessary to experience a first-hand verification of his model? Is there another way? Why does he not follow his own hypothesis, and stretch across the full spectrum of human potential, from the scientist via the artist to the mystic? Are we once again facing the fear of disappearance of the self, of ego-death, in other words, another modern version of Wilber's Atman Poject? An important thing to remember, however, is that this new paradigm came from a physicist, from science.

The writings of Pribram and Bohm on the holistic nature of the universe and the identity of consciousness and matter seem to add up to only a model. Another physicist, Jean Charon of France, formulated similar concepts into a theory, in his book *L'esprit, cet inconnu* (1977). (The German translation is entitled *Der Geist der Materie* or *The Consciousness of Matter*.).

Charon counts himself among the neognostic physicists, a movement for a new orientation in scientific thought which began during the 1970s in Princeton and Pasadena. Their forebears, the gnostics of the first century AD, maintained that scientific knowledge, not just belief, was the key to understanding reality. They speculated that there are minute particles they called "äons" which, as carriers of consciousness, determine matter and evolution.

Charon claims to have found the äon, in the form of the electron. "The electron forms an independent little universe whose space is totally isolated from the surrounding space. Nothing can leave or enter this space, it can be called a *closed space*" (*Charon*, 83). He goes on to theorize that "our consciousness, our I, as a whole is contained in each single electron of our body" (*ibid.*, 139). These fascinating claims warrant a look at some of the details of his theory.

Initially, Charon divides the space-time complex of the universe into two parts coexisting side by side, the space-time of matter and the space-time of consciousness. He believes the latter has escaped scientific recognition because it is hidden away inside tiny particles of matter. Later he describes the physical characteristics of black holes and finds that "The electron dis-

plays a structure which makes it appear as a micro-black hole; that is, it has a geometry which contains a space-time similar to that of the black hole, a space-time of consciousness" (*ibid.*, 73). After elucidating the characteristics of the electron mathematically, he concludes "the micro-universe of the electron encloses a space whose information content *cannot decrease* (evolution with never-decreasing negentropy)" (*ibid.*, 100).

This means that the matter which took part in the building of a living and thinking structure, and had the qualities of consciousness of that structure during its relatively short life, cannot simply revert back to the diffuse minimal psyche after the death of this structure. The once-gained information, the once-gained consciousness, can *never again* be lost (*ibid.*, 100). Therefore "the level of consciousness of the universe as *a whole* rises progressively: this happens by elementary matter undergoing many successive *life experiences;* those elementary particles might belong to the mineral realm for a more or less short period of time, then again to the living and thinking one, but cannot lose the once-acquired treasure of information gathered during successive life experiences" (*ibid.*, 102).

As a closed microcosm in the midst of the space-time of matter, the electron can, according to Charon, manifest its qualities and capabilities via four possible means of interrelation with the outside world or the consciousness of another electron. He calls these interrelations "reflection" when happening within the electron itself, "cognition" and "action" when related to the space-time of normal matter, and "love" when related to communication with other electrons. He says, "in contrast to reflection and action, the other two capabilities of the electron, *cognition* and *love*, effect an *increase* of negentropy in the space of the electron, that is, an enlargement of the information contained within it" (*ibid.*, 181).

Concerning love, he elaborates, "One can claim that love is the simplest and most effective process to increase the negentropy of the universe … Strictly speaking, love has something of a *telepathic* process; for it enables the direct communication between two consciousnesses" (*ibid.*, 183, 185). (I have found in my own work with primal therapy, as described in the next chapter, that love is a precondition for the therapist to be able to read the patient's mind and to guide him or her on the journey inward.)

Among the consequences of Charon's theory is a challenge of the traditional anthropocentric approach to consciousness: "Instead of saying 'I think' you should rather say 'it thinks' as you say 'it rains'. For what thinks in you are the billions of electrons which *only* can enclose a space-time in which consciousness phenomena can take place" (*ibid.*, 193).

Concerning evolution he states: "The goal of the whole ladder of the cosmos is to increase maximally the negentropy of the universe as a whole—and that includes its order, its effect (in the sense of physics), its consciousness." (*ibid.*, 193). That process in evolution takes the electron not as the goal but "merely as a means to discover this goal of evolution. The electrons which constitute us do not know this goal either. If the thinking electrons had already recognized the ultimate goal of evolution, then *we would also know it*" (*ibid.*, 231).

To Charon the drama of the spirit of consciousness is not separate from the drama of matter in evolution. At the end of the book he concludes: "The progress of consciousness takes place simultanously on the level of the whole and of the individual; but there will never be a 'mixture' of the individual experiences and achievements in the course of the total elevation of the the level of consciousness; for each äon has its own *individual history* of consciousness, and it remains 'itself' with its own past and its own memory which distinguishes it from all others. Still it gains an acceleration of its spiritual progress only by the fact that it joins its 'personality' with that of the others ever more intensely. Only by this unition the äon becomes truly itself. In an incomparable manner the folk of the äons has been able to achieve that for which we look so often in vain: unity in multiplicity" (*ibid.*, 257).

Granting for the moment that all this is so—that each of the electrons in my body contains all the information accumulated during my present life and all former existences they were part of in the course of evolution; that it is them who think, who think me; and that I can take comfort in the fact that there is really no death since my consciousness, i.e. my electrons, cannot be destroyed but will live on after death in billions of other configurations in which the levels of intelligence will increase—would all that allow me any access to that enormous information that I constitute? Is there any chance of consciousness becoming more transparent, of awareness becoming aware of itself before the end of evolution?

Charon is not suggesting any method for that; it seems he is not even interested in the problem. His implication that my vague flash of empathy with, for example, some blade of grass reaching towards the sun through the morning dew, is due to the memory of one or two electrons within me who at some point belonged to blades of grass, doesn't offer much in terms of a technique of mediation, of making consciousness more transparent. (He does call a person with such memory flashes a *sage*.) His theory suggests that ultimately I am only what I am thinking, or what in Vedanta terminology is my waking consciousness. My waking consciousness is equal to the consciousness of the electrons contained in me. In addition, each of the electrons contains its own information gathered in the course of evolution; that information could be called the content of my unconsciousness.

Two things seem clear: firstly, there is no place in Charon's theory for consciousness without content (pure awareness); secondly, I will never have access to this information in my unconsciousness. (What then is the special value in having become human? Or are we to dismiss Buddhist scripture, which holds that being born human is the first of the seven great fortunes of man?) To me, Charon's theory of the äons presents little more than a rational explanation of consciousness as an epiphenomenon of matter, of the physical characteristics of subatomic particles. Perhaps it would be appropriate to call his book "Consciousness as Matter", rather than "Consciousness of Matter".

Wilber has disagreed quite distinctly with the holographic or holomovement model of consciousness, for reasons which would seem to apply to Charon's neognostic theory as well. Affirming Huston Smith's dictum that "all existence is graded, and with it, cognition", he tends to accept the gradation of the perennial philosophy, such as the seven levels of the ancient Indian "chain of being" (listed above in the discussion of The Hierarchical Model). Wilber qualifies that simple hierarchy with the idea that the seventh level of being is both the ultimate stage, the goal of evolution, and equally and paradoxically always present at each stage of that evolution. It is both transcendent and immanent, as it were. "Every stage of evolution transcends but includes its predecessor … Each higher level cannot be fully explained in terms of a lower level. Each higher level has capacities and characteristics not found in lower levels." (*Wilber ed.,* 257; similar assertions are

made about the levels or epochs of the evolution of consciousness in Up from Eden.).

His basic critique of "pop mysticism, the new physics or the holographic craze" is that they "collapse" that hierarchy. He holds that each level has developed its own unique quality of discourse to come to a deeper understanding of itself and to communicate this understanding to others. Thus, empirical-analytical discourse belongs to the gross material reality of level one, as of necessity the paradox is adequate when the human mind tries to make statements about the pure awareness of level seven. Wilber sees contemporary science as having discovered the interdependence of physical matter and energy on its own level and with its own means (empirical-analytical), and having reached the reductionist conclusion that, since all reality is ultimately made of subatomic particles, all reality from the simply physical up to the level of pure awareness can be explained by the same means.

After all, the comprehension of the physics of holography and holomovement is a result of thinking, of conscious mind, unlike the comprehension of reality by the mystic, which is a result of meditation, of a transmental state of consciousness. To put the issue more pointedly, the approach of theoretical physics to the question of consciousness could be compared to trying to explain the distress of your lover by placing his or her tears under an electron microscope; or doing the same with the paper on witch the works of Sophocles are written in order to understand Greek tragedy.

After his sharp critique of Pribram's and Bohm's holographic model of reality, Wilber reaches one of the same conclusions as Bohm, namely an encouragement to engage in meditative practice. He realizes that merely by studying this new paradigm one will not actually transcend anything, not make one's consciousness any more transparent. This time not I but he concludes in the last sentence of his book on the holographic paradigm, "The only way you actually know the trans-mental is to actually transform". It was the next sentence—on how one might transform—that I was waiting for.

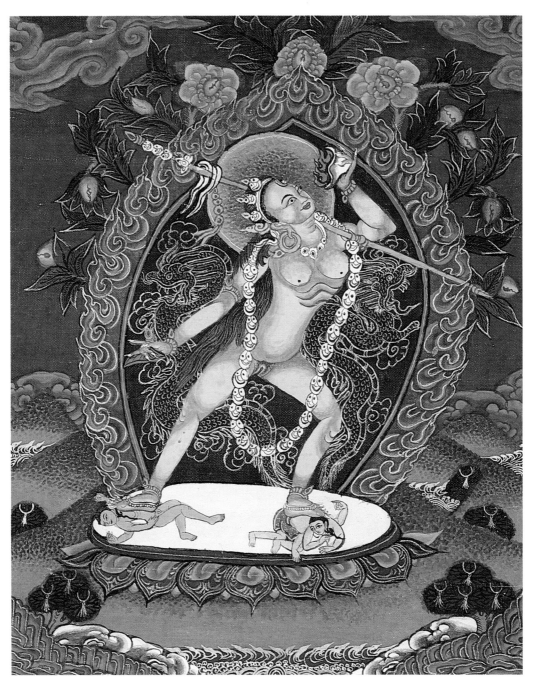

Vajrayogini alone, standing on a primordial couple (21 x 26,5 cm)

Hunting Technique: Transpersonal Therapy

In my experience no technique of transcending ordinary consciousness can be learned from books. Imagination based on other persons' descriptions will become a substitute for any real experience. Only one's own experience can have the effect of healing and making whole. One person's truth can easily become another's lie. I relate some of the results of my own efforts only to lure the reader into trying the same techniques, not into expecting identical results.

Three types of meditation to induce transpersonal states of consciousness are dealt with in this chapter; while their techniques differ, their scope may be regarded as similar. The first type utilizes hypnotherapy, the second hallucinogenic drugs, and the third various sorts of modified breathing. Of course any of the many techniques of meditation invented throughout human history might trigger similar states. There is one form of experience which is known to trigger such states but which cannot be called a technique as such, since it cannot be practised, and that is a life-threatening or near-death situation. This being the case, the practicable techniques of meditation might be considered to be artificial or simulated versions of the actual experience of death of the self or the ego.

Nothing less than this ego-death will afford you a real taste of immortality. And there is no other suffering than not knowing yourself, your own immortality; all other human suffering derives from this basis. The reason why masters have never been popular within the societies they lived in (although they are society's biggest assets) is that masters kill; they teach or assist the death of the self which is so central to social identity.

There is a classic anecdote about a Zen master who actually 'kills' one of his disciples: Early in the morning the disciple was striking the temple bell to awaken the other monks. He was distracted by the sight of a beautiful maiden coming down the mountain path, and the sound of the bell became odd. At that moment the abbot, standing behind the disciple, struck him on the head with his staff, and he fell down dead. Later the disciple's

parents came to thank the abbot for his compassion. Here is one interpretation of the story (Osho's): In the first place, the master had no business standing behind the disciple; he did so because he had sensed the disciple's imminent death. Sexual imagery is often the last thing which appears just before the moment of death, closing the circle as it were, since one is born as a result of sex. Thus, the maiden whom the monk saw was a hallucination. The abbot struck him to make him aware, for full awareness at the moment of death is enlightenment.

Dehypnotherapy

Waking up from the hypnosis of ordinary waking consciousness

Hypnotherapy is well known as an effective tool for encouraging relaxation and the recollection of long-forgotten or repressed episodes of a person's life. It is often used to discover and relieve childhood traumas which remain in the unconscious and affect behavior in normal life. From all reports and from my personal experience, it is clear that hypnotherapy is an easy, safe and effective way to make consciousness more transparent, even to the point of recalling various transpersonal experiences.

During hypnotherapy sessions with patients, some psychiatrists and therapists have stumbled upon the phenomenon of vividly recollected prenatal experiences, including some which can only be construed as belonging to earlier lives. One prominent psychiatrist, Brian L. Weiss, wrote a book, *Many Lives, Many Masters*, about a case which took its own course and turned into a dramatic example of past-life therapy. The present lives of both patient and doctor were transformed, and Weiss' conventional scientific outlook was exploded by his personal contact with transpersonal material. The story of the patient's recollection of numerous past lives and her transmission of voices from distant spacetimes basically rings true. But there is one glaring flaw: the point where the hypnotized patient reports, "There is no water. The year is 1863 BC. The area is barren, hot and sandy" (*Weiss*, 27) "BC" is quite incredible by itself; did the ancient Egyptians calculate their time by the Christian calendar? This is just too much to swallow. In addition, precise dating is virtually never an element of past-life memories, even of figures like Gautama Buddha.

A method which Weiss used also deserves comment. At one point he asks the patient to listen to a tape of herself talking in trance at the previous hypnotherapy session. She made him turn

it off because "it was too weird and made her uncomfortable" (*Weiss*, 91) Such discomfort should be predictable to anyone who really understands what is happening. Compared to the power of *being* the subject of the relived episode, merely *knowing* about it by hearing or reading is stale at best. This is an essential point. In my experience, both of receiving and administering hypnotherapy, the patient always has full memory of whatever has come up under hypnosis. But making an unconscious event conscious is not enough to effect a true insight or change. The total, defense-less reliving of, or living through the episode *is* the meaning. The reason it came up is that it was never fully lived through in the first place; it does not symbolize anything else. The job of hypno-therapy is not to interpret past-life episodes, but to help the patient connect with them and experience them consciously.

One of the simplest forms of hypnosis is what is known as the 'guided dream.' It can be equally effective for an individual or a group. The patients are asked to relax each part of the body from toes to scalp, soft music is played, and the leader or therapist sug-gests a certain storyline. Crucial parts of the story are left without clear content; here the individual's unconscious will automati-cally supply precise content, each in his or her unique way. Usually, by some magic, the unconscious will only supply material which is crucial in the individual's life history, as if it wants to communicate a vital message to the conscious mind.

An example of a storyline which I have often used: "You are ly-ing on a beautiful beach enjoying the sand, the waves and the blue sky. After a while you get up and walk along a path which leads to a forest; you enter the forest; the path becomes darker and darker; it finally ends at a clearing where there is an old house that is practically in ruins. You hesitantly enter the very dark interior, full of spider webs; in the kitchen you see the date on a huge old calendar and you are surprised. Entering a back room, you see a very old person whom you vaguely recognize, ly-ing on a bed; you are afraid, but still you approach the bed, and the person begs you to bring your ear close to their mouth. You are startled by the message given to you. Then the person gives you a small package nicely wrapped as a going-away gift. You feel that you must leave, and you go back through the dark forest and return to the beach, where you lie down again and relax. Suddenly you remember the gift; you carefully unwrap it, and it is a great

surprise to have received such a thing." So ends the guided dream, and after a while you take your clients out of their hypnotic state. It is important that the story is narrated very, very slowly, taking perhaps as much as twenty minutes.

If the atmosphere is conducive, afterwards everyone can sit in a circle and share their ideas of who the old person was for them, what date was on the calendar, what the old person said, and what present the package contained. These moments of sharing messages from the unconscious, with tears often flowing, can be extraordinarily charged and moving—and interesting. One young Japanese woman opened the package and found pellets of herbal medicine which she instinctively felt would poison her if she took them. Her unconscious extended the guided dream: she ran back to the old person to hand back the strange medicine, and the latter swallowed it and was miraculously cured of all her ailments and became young again.

From the principles of hypnotherapy and self-hypnosis, Osho developed a technique he called dehypnotherapy. The purpose is to awaken from the hypnosis to which we are subject in our ordinary waking state. Dehypnotherapy is based on the thesis that the program or software of your adult biocomputer is fairly well established by the age of four. Up to then you respond with freshness, without preprogrammed behavior to each new life situation. Those unique responses later harden to certain strategies, or games, which constitute the behavior of the particular adult personality. Naturally, those learned games hardly fit the adult life situation any longer, but they nevertheless control you in the most important decisions you take, such as the choice of a partner and how you respond to problems in the relationship.

Through dehypnotherapy you can obtain first-hand insight into the strategies which you developed before the age of four, admittedly often for reasons of survival, but which tend to control your life ever after. That knowledge can liberate, but it will not necessarily do so. Additional effort and awarenes are required on your part. In the next situation when you are about to re-act unconsciously with your stagnant old strategy, you may re-member that it does not fit any longer and that alternative modes of conscious re-sponse are available to you. There and then you have to make a conscious decision to explore a new strategy fitting the new situation. It takes an effort on your part. Otherwise

you just fall back into the same rut like a stuck gramophone needle.

Dehypnotherapy can go deeper; it can bring you in touch with contents of your dormant consciousness which belong to collective or even cosmic levels. Here an example from my own experience at Osho's ashram in Poona: After 45 minutes of deep-relaxation suggestion in a Dehypnotherapy group, the leader drew the attention of those who had not entered deep sleep (that hazard always lurks in hypnotherapy) to their navel chakra, about two fingers' width below the navel. He then suggested remembering that "there is no fear". After the suggestion he took us out of the hypnosis and invited us to stroll alone in the garden or the surrounding park.

What I went through for the next hour or so is difficult to frame into words, since I have nothing similar to go by from my own experience or from the documented experience of others. I walked past trees whose leaves seemed to be on fire; bushes, leaves and grasses were wild energy patterns. Nature appeared as if it were painted by van Gogh at the end of his life. (Perhaps he constantly lived in a state where fear is completely absent.) I sat down by a river and noticed a dragonfly landing on a rock near me. As I gazed at the dragonfly I simultaneously saw myself through the eyes of the little creature as well. Seeing and being seen had just become the same act. I looked at some dog turds close to me and again the same thing occurred; I saw myself through the eyes of the turds. I had never had such a sense of union, and had never heard of someone else having it. On the walk back to the ashram I saw a cyclist peddling towards me, and again I simultaneously saw myself through his eyes. A very strange sensation, indeed.

Such an experience was apparently known in ancient India. "In the heaven of [the Vedic God] Indra, there is said to be a network of pearls, so arranged that if you look at one, you see all the others reflected in it. In the same way, each object in the world is not merely itself, but involves every other object and, in fact, is everything else" (*Rig Veda*, quoted by *Grof* 1985, 75—6).

Is it fear, a very deep fear within us which ultimately makes us perceive ourselves set apart from everyone and everything else? Is it fear which creates the illusion of separateness in space and the appearance of solidity of objects? Behind all fear stands the fear

of extinction, of death. Yet I did not die, nor did the world around me disappear. Only fear had died.

Back at the therapy room there was a final episode of unexpected beauty. I sat in meditation for a long while, as if floating in a bell of upward-streaming energy, with no pain in my body and no content in my mind, but wide awake. I did nothing to make it happen; this is why I call meditation a gift. It was just that some obstacle had been cleared away, and that was fear.

Even if that sense of union was only a faint approximation of the state described earlier as cosmic consciousness (under the hierarchic model), then the model and the experience are as far apart as the word *apple* is from its actual taste and sensation of nourishment.

Another kind of dehypnotherapy was referred to in Poona as *yogic sleep*. What is done at the start of a typical hypnotherapy session, namely the inducing of deeper and deeper relaxation of body and mind, could be triggered by listening passively to our master's daily discourse. The trick was to not argue in the mind with what is heard, but simply to listen to the sounds of his voice without any internal resistance. It was easy to then fall into a state resembling a hypnotic trance.

Having entered such a trance one morning, I suddenly 'awoke' and was terrified that I had gone deaf. It seemed like I could not hear a thing. Then I realized that I was very clearly hearing Osho's voice and the singing of the parrots on the roof. Indeed, I had never heard those sounds so clearly. And yet at the same time I was still engulfed in total silence. What had happened was that my mind had ceased its inner chatter. I was fully present with anything, as and when it happened.

I looked at some friends sitting nearby and I could instantly read from their faces all their psychological patterns and life situations. They or I or all of us had become transparent. This was a new sensation. Finally I decided to close my eyes and look at my own patterns, my own life, and I was struck by what I saw—nothing but a few moments when love had overcome me. The rest of my life was blank, empty, as if it had not existed. Somehow there was nothing frightening about it. It was a sensation of an empty, all-pervading presence.

After the discourse I met a close friend who took one look at my face, said I looked mad and walked away. I spent the rest of the

day alone in my room overwhelmed by that silence of my mind which miraculously brought me in touch with everything surrounding me as never before. I even had to close the windows, because the presence of the living trees was too much too bear.

It dawned on me afterwards that the idea that meditation is simply an experience of total silence is not accurate. Speaking logically, it seems plausible that pure silence is commensurate with meditation, since it somehow conveys the idea of absolute absence of duality. Experientially, however, meditation is marked by both sound and silence; it is equally beyond both. Similarly, the experience of the Primary Clear Light of the Tibetan Book of the Dead should not be mistaken as merely the opposite of an experience of absolute darkness, for it is with and beyond the polarity of darkness and light. Likewise, in many Indian pictures showing the chakras, there is a sun and a moon above the right and left sides of the body, and then another sun in the center at the very top (see figures on page 33 and 35). That sun beyond the sun and moon, that light beyond the polarity of ordinary light and darkness, is the ultimate target of yoga.

Psychedelic Drugs Therapy
Undrugging oneself by drugs

In an age of double standards for drugs it is difficult to promote their use for purposes of consciousness research or transcending ordinary reality. The manipulation of death with drugs is generally accepted, as can be seen in the intensive care ward of any hospital, but when it comes to manipulating birth with drugs, as we do in abortions, our religious watchdog organizations are up in arms. Few religious organizations protest the postponement of death by drugs or medical machinery as an *interference with the work of God.*

Governments, educators and the mass media have tended to lump psychedelic drugs together with mind-numbing, physically addictive drugs such as heroin or cocaine. As a result, the mention of psychedelic drugs tends to conjure up scenes from the TV screen of police battling drug pushers on inner-city streets, or of ruthless kingpins in the jungles of Asia and South America. We have almost completely forgotten that in almost every ancient culture, including various extant traditions, psychedelic drugs have been employed at the most sacred places and times in order to induce religious states of consciousness and to promote insight into the realities and ideals which anchor their respective worldviews.

Human beings have basic needs on various levels which might be viewed as a hierarchy. The obvious first level is the physical needs of food, shelter, clothing and love. But eventually a full stomach and secure home are not enough in themselves; aesthetics become necessary, one wants to make and listen to music and live in a beautiful home with a garden. These two levels of needs have been more or less fulfilled by the prosperous half of the world, including most of the West. Then comes the level of spiritual needs, when riches and aesthetics are no longer enough. The question of the meaning of life, of who I am, becomes as urgent and all-consuming as the question of food was at the survival level. In this sense, true religion is the ultimate necessity. Only its fake version is the "opiate of the masses".

It was wrong to expect that the most materially and aesthetically advanced countries in the West would have found ways to use psychedelic drugs for new insights into human consciousness. Somehow, the quantum leap of consciousness made possible by material advances has been aborted. The question then arises why become rich in the first place if not as a stepping stone to the transcendence of ordinary consciousness.

In wealthy countries drugs became an escape from reality, an escape into more unconsciousness, rather than an advance into transconsciousness. The revolution of the Flower Children in the 1960s trying to find an alternative to the materialistic American Dream just evaporated like dew in the morning sun. The succeeding Japanese Dream of global commercialism, which is being widely mimicked in the 1990s, is even less likely to produce a more conscious human being, since it is based on antlike slavery of the individual for corporate profit. There is no sizeable counter- movement against mainstream mass culture in Japan. The industrially successful nations have not understood why they have worked so hard to become rich. The hierarchy of human needs and its inner logic of meaningful fulfillment go unrecognized.

There are a few isolated and courageous exceptions to the general misuse of psychedelic drugs in the Western hemisphere. Stanislav Grof and Joan Halifax describe their experiments with drugs in *The Human Encounter with Death* and Grof alone in *Beyond the Brain*. Both books document in great detail their psychedelic therapy on patients dying of incurable diseases, as well as on non-

The Silent Orgasm

patients which allowed them to have a taste of dying before real death under clinically controlled circumstances. Together with their patients they discovered that the psychedelic experiences were an excellent training and preparation for letting go of life in order to gain it. In a sense, Grof and his collaborators had reinvented the essence and meaning of rites of passage using psychedelic drugs and had proven their therapeutic efficacy.

They summarize their results in the following way: "According to our observations, those individuals who have experienced death and rebirth in their sessions show specific changes in their perception of themselves and of the world, in their hierarchies of values, general behavior, and overall world-views." … Individuals talk about experiencing themselves as reborn and purified; a deep sense of being in tune with nature and the universe replaces their previous feelings of alienation. Profound serenity and joy can dominate their mental lives. This is usually accompanied by a general increase in zest and a sense of physical health and good physical functioning" (*Grof, Halifax, 1978, p. 210*). In this sense they had used drugs to undrug themselves of the physical and mental conditioning of their particular culture.

With all the above said I do not wish to imply that psychedelic drugs alone could have effected the quantum leap of consciousness of mankind in the second half of the 20th century. What I meant to say is that despite the sincere and courageous efforts of Aldous Huxley, Leary, Metzner, Alpert and Grof a great chance was missed by not including the use of psychedelic drugs as a technique to induce transpersonal states of consciousness on a large scale, and that it is a great pity that experimentation with them under controlled circumstances has largely been abandoned. Today, drugs and crime have become synonymous in our minds.

The scope of Grof's psychedelic therapy is well documented by his cartography of the human psyche, which he refined further and further in his sequence of books. The reader is referred to these books directly. I have given a summary of it under the Transpersonal Model of Consciousness above. The whole spectrum of this cartography turns out to be similar, if not almost identical, to that arrived at independently by other therapists not employing drugs but intensive forms of breathing, such as used in primal therapy, rebirthing and various other humanistic growth therapies.

This is a discovery of unforeseeable implications for the development of human consciousness in the 21st century. So far, psychedelic drug haves turned out to be too explosive to handle for Western cultures. Drugs are too easily misused for regression into greater unconsciousness rather than applied to an advance into greater consciousness. This cannot be said of breathing.

The danger, however, is that if word gets out that therapies using intense breathing produce transparent states of consciousness identical to those experienced under the influence of psychedelic drugs,—and this will be affirmed by this book as it clearly was also in Grof's last book—I would not be surprised if Western societies also started suppressing, indeed, even outlawing these techniques in the near future, as well. We must not forget that, as Wilber beautifully documented, societies in history have always suppressed Atman consciousness, that is, holistic consciousness, and merely allowed various forms of the Atman Project, its substitute gratification.

A case in point is the persecution of Osho all over the globe. And he has not even advertized or allowed the use of drugs in any of his ashrams. But to buy one new Rolls Royce per week—living in the middle of the desert—turned out to be a most enraging 'drug' on a national scale which made man aware of his own disease of greed for wealth . A couple of tons of LSD distributed nationwide would not have been such an eye-opener.

Encounter and Primal Therapy

Reconnecting with one's unresolved past projected into the present

Encounter and primal therapy use techniques which partly overlap, and with different approaches they achieve results which are often quite similar. Encounter therapy uses social isolation, deprivation of individual privacy, extreme confrontation in a marathon manner, and occasionally various forms of intensive breathing for the purpose of breaking a person's defenses. The premise of primal therapy according to Arthur Janov is that any defense against real feelings is neurotic. With the breaking of all defenses a human being just becomes natural and lives in the here and now.

I came across Janov's and Grof's writings on primal therapy several years after I had undergone encounter and primal therapy myself. They thus exerted a certain influence on my evaluation of my experiences, but their ideas did not cause or influence their occurrence.

To illustrate primal therapy, and to show how easily an encounter technique can bring about a primal result, I shall describe a session which I managed in the US in the early 1980s. I lived in a large communal home with seven other people, one of whom, a man in his late twenties, exhibited uncommon behavior and was socially excluded by the others. He lived in two worlds. One was his own room, which had heavy dark curtains, a lot of pillows and a reddish decor; in short, a man-made womb. Here he would retreat to be in peace. Whenever he came out of his room, into the other world, there was trouble. He would slam the doors, pound the refrigerator and behave aggressively toward nearly everyone. He was a very tall, strong person. The domestic tension was heightened when he was found to have stolen some underwear belonging to an older female housemate off the clothesline. When he asked me for a private primal therapy session, I initially refused in order to observe him a little longer and wait for an opportune moment. I talked to him whenever I could and felt deep compassion for him and his neurotic behavior, which was as much a mystery to him as to me. He told me that a couple of years earlier he had shot someone in another country. That did not interest me very much, partly because he was aware of it, but also because it was surely an effect and not the cause of his malaise.

As usual in my primal sessions, I had no preconceived strategy for helping him. I felt more like a detective than a healer. There was the clue of the woman's underwear, and I chose to begin with the encounter technique of a meeting with the woman. I asked her to be as aggressive and provocative as possible. Nobody else was at home. I put the two a cushion's width apart, confronting each other with eye contact. She laid into him verbally, and he remained cool and controlled. After half an hour or so he grew slightly irritated, but never very aggressive. I observed his body movements but could not detect any cues as to how to proceed. The one thing that struck me was his use of the same phrase, apparently unconsciously, at three different points in the conversation: "There is never any room for me." It came up once, for example, when he recalled occasions when everyone else in the house would go to the woods or the beach by car and there would suddenly be no room for him in any of the vehiles. So he felt excluded and rejected.

When I sensed she had done her job, I asked the woman to leave the house and I put him into primal breathing for about ten minutes. I then placed my hand lightly over his heart chakra and asked him to whisper "There is no room for me". This broke his defenses in no time; it opened the door for him to feel his primal split. He started crying intensely like a little child. I asked him where he was and how it felt. He related that he felt he was in a cold box, unfriendly and small, and that there was a little window on top where people gazed in. He hated it. That feeling-scene would last for a while and then he would suddenly shift to an opposite environment, warm, pleasant, reddish, dark, listening to gentle drumbeats. He loved it there. He floated back and forth from the cold, hostile space to the warm, friendly one several times. The intensity of the feelings he lived through must have been overwhelming, since it took about twenty minutes to get him out of the primal trance at the end of the session.

He had zoomed in on the most painful scenes in his early life, what Janov calls the Major Primal Scenes, "when an event takes place that is so intrinsically shattering that the young child cannot defend himself and must split away from the experience. This event produces an irreparable rupture that will last until it is relived again in all its intensity" (Janov, 1970, 30).

Over tea afterwards I made no effort to give him an interpretation of what had happened. It was clear to him. He already knew intellectually by having been told that he was adopted just after birth; he had met his real mother for the first time a year or two earlier. She had been advised by some soothsayer to get rid of the fetus, and at the time had made up her mind to do so. It may well have been when he was still in the womb that he got the message that "there is no space for me" in the outside world. He was put in a respirator when he was born (probably prematurely). The basic information had been related to him already, but it was only now that he knew what that knowledge felt like. He realized that even now he was living in the polarized world of a benign womb and a hostile respirator.

His neurotic pursuit of an older woman was his way of searching for the mother and the love he had never known, for the most primal needs of a child. Janov explains that "Any behavior in the present which is based on past-denied (unconscious) feelings is symbolic. That is, the person is trying through some present con-

frontation to fulfill an old need" … "Primal Therapy works because the patient finally has a chance to feel what he has been acting out in a myriad of ways throughout his life … The disease, I submit, is the denial of feeling, and the remedy is to feel" (Janov, 1970, 50, 385). Because of life's circumstances I never had the chance to meet the man again. I can only hope that having once reconnected deeply with his very early pains, he remained aware of them so that they no longer manipulated him unconsciously.

Primal therapy uses a very simple technique, an intensive form of breathing or hyperventilation. Many psychotherapists have noticed that deep breathing is an alchemy for connecting with our deep feelings and primal pains; shallow breathing works as a defense mechanism which helps suppress them. Primal therapy uses a forced deep inhalation through the nose, followed by a natural exhalation through the nose and mouth. There are the unpleasant side effects of cramps in the legs and arms, and later a strong pressure in the head. After ten or fifteen minutes one falls into a trance-like state, which has been termed a conscious coma. When the breathing is stopped, at the request of the therapist or when the patient cannot take it any longer, content from the unconscious comes to the surface and is verbalized. When nothing more comes up, the primal breathing is restarted. The eyes are kept closed throughout; the patient is turned completely inward, although he can easily communicate with the therapist. After the session, he can easily recollect the entire content.

There are other methods which can be successfully combined with hyperventilation, including deprivation of sleep for one or more nights, bodywork, the right music at the right moment, and cathartic meditation (described later). The individual primal therapy I underwent at Poona began with four days of isolation from normal routines and the writing of an emotional autobiography emphasizing earliest memories, followed by a week of daily sessions of about two to three hours.

The self-healing potential of the human psychosomatic system is very mysterious. It seems to have a built-in auto-focus system which after intensive breathing automatically zooms in on the most important traumas which may have occurred decades, even lives ago. Then, by consciously reliving them, it relieves itself of them. In a way, the system repairs itself so it can live more fully in the here and now.

To provide some concrete sense of what happens to someone who goes through primal therapy, I shall summarize my own experience in Poona in 1977. I began with no precise knowledge of what might happen, neither from books nor from people. I was just very scared, because I had often heard screams coming from the little windows of the heavily padded primal therapy chambers, as if people were being tortured. It had been two years since Osho had suggested that I do the therapy, and out of fear I had postponed the adventure again and again. Finally I developed severe chest pains while passing through a period of jealousy so strong that it brought me to the edge of killing. (I had just heard what a rewarding time my lover had had in a tantric sex workshop…) My psychological and physical pains were so intense that I was ready to do anything to get rid of them, even individual primal therapy. Now I am detached enough from those events to share parts of the meticulous diary I kept of every episode (the parts which have not been eaten by Indian rats in the meantime).

First day:
Ten to fifteen minutes of primal breathing. When one of the two therapists touches my heart chakra I am just overwhelmed by a concrete feeling of love. I am absorbed by it and cry intensely. After a while this feeling turns into one of helplessness, a word I keep repeating. After further breathing I come up with sentences such as "I am not a metal box", "I am not a tin soldier", and in my mind's eye I see my mother forcing me into the kind of trousers I just hated as a boy. I pound the floor with my legs.

I am made to relate to the therapists my recent jealousy fight with my lover. After further breathing, I start speaking to her, "If I can't be honest to you, leave", which soon afterwards turns into "Stay, please" and "I love you ". Being made to recall her face, I start calling her name louder and louder till I just break down. Her loving eyes appear to me as the most beautiful feeling there could possibly be.

Slowly her face disappears and a row of skulls appears looking at me. Asked what they are I respond they mean death to me. They seem to point at me with unseen arms.

This scene persists a long time, then slowly my knees start trembling; so does my pelvis. Asked why, I respond by saying that I don't know what this trembling is. I am just made to feel it not to

try to explain it. The trembling increases and takes over my whole body. I suddenly look into the eyes of a doctor with certain shining instruments like forceps and scissors in his hands; I am just coming out of a vagina; I shout, infinite fear grasps me; I try to go back, I yell and shout even more. The doctor fumbles around at my navel; I am born. I tell these happenings to the therapists and assert that it was really not hurting at all, just such a shock and surprise and that I was only afraid of the doctor's scissors.

Soon afterwards I have some visions of my mother's face and of sucking her breasts and I say: "Strange, my mother is rather loving."

During Kundalini Meditation in the evening and Dynamic Meditation the next morning, my mind is filled with images of wild sex which I can't remember happening before during those meditations. Something has been opened deep inside me.

Second day:

The therapist plays tough this morning. I hide under the sheets. She says: "You look like a mummy all wrapped up but completely focused in the head." I respond: "Should I strip?" After some more holotropic breathing I undergo the next birth primal; I work myself out of the huge vagina of a female with a huge belly; no pain is involved (figure 1).

Figure 1

The therapist asks me what I am experiencing. I say it is strange that I am out but still the women's belly is so big. But then emerges another head out of the vagina. Slowly I recognize that it is the head of Osho, without a body, only a head and an umbilical cord. I start laughing when I see myself as a tiny child, the woman who had turned into the body of the therapist, and Osho relaxing on one of the therapist's legs (figure 2).

Figure 2

After some more breathing I start making movements with my arms as if I am drowning in some blackish water. I shout for my life. At the edge of the pond stands K.M. [an Indian sannyasin friend] who teases me with a fishing rod. He doesn't help me to get out (figure 3). So I drown, but there is no pain. Then I see myself hanging on some huge iron hook on an iron chain. Asked why I am shouting I answer "I don't want to die." The therapist retorts:

Figure 3

Figure 4

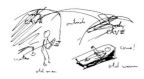

Figure 5

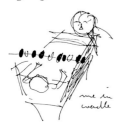

Figure 6

"Some intellectual crap." She teases me by saying that my lover might just now be making love to someone else. That gets me into a sequence of shouts of "No, no, no". Asked where this feeling of no sits, I point towards my stomach area. The image coming up during the no-shouting is me defending myself against a huge spear directed towards my stomach manipulated again by K.M.; I continue to shout 'no', and the spear is slowly moved towards my breast. I try to push it away with my arms, and the whole scene slowly fades away. I realize that the face of the doctor who gave birth to me yesterday and the face of K. M. as he tried to stab me today are the same (figure 4).

I do some more primal breathing, then I start to make some strange gestures with my arms as if I were swimming in some warm dark-reddish liquid, which is mostly on top of me. I suddenly realize it is a space like a womb I am swimming in; I push off it with my hands. Now I start pulling my knees towards my breast and put my arms around them forcefully; and I force my head towards my knees. Bending my head I am overcome with the strange sensation of hanging in the womb upside down with my head below. A feeling of fear overcomes me that I might drop out. So I hold tight to the naval cord and secure myself. This feeling of danger sometimes disappears when the womb I am in takes a horizontal position.

This sensation of danger and no-danger alternates about three times. I start repeating "I want to get out". I chose the moment of a horizontal position when I start pushing violently with my legs, and I use my arms and hands on the wall of the canal, too. Shouting "out, out, out", finally I am out.

During the process of working myself out of the womb I am simultanously engulfed in a vision of a very old man with a very wrinkled face in a rock cave. I recognize him as myself. He has Chinese or Japanese features. He takes a last drink of water and then folds his hands as in an Indian greeting. I do the same in reality. He then lays himself in a coffin-like bed beside a very old woman who opens her arms to welcome him. I feel I am dying (figure 5).

After new primal breathing I feel like a little baby lying under heavy covers in a cradle with my arms on top of it. I object to the what I feel are ridiculous colored rollers on top of me, whilst my mother looks on from the bottom of the bed (figure 6).

The Silent Orgasm

The therapist makes me sit up and open my eyes. She asks what this feeling was. I say it was a kind of anger and slowly come to realize that it was spite. Then we work on this feeling of rejecting love, but really wanting it. In this game, perhaps the most marked one in my particular arsenal of trips, whenever I concentrate on *love me,* I break down in tears, seeing my mother's and lover's faces, and I feel how much and how urgently I need this love, really more than any food. Whenever I concentrate my attention on *don't love me,* I have a sensation of anger, hate, and spite in my very jaws. The face coming up is my former wife's face. I feel ashamed and dirty because of this refusal.

During the Kundalini Meditation at 5 pm I undergo another birth primal. I suppress my wish to shout as I come out of the vagina since other people are around. In the third stage of the meditation I engage in wild sex with both of the female therapists in my fantasy.

Third day:
I bought a Teddy Bear last afternoon in town and he is now sitting beside me in the massage room; I wanted to have a friend in the room. My general feeling after some breathing is one of fear. When the therapist askes me fear of what, I answer "Of both of you". Their suggestion is: "Go into that fear".

I slowly pull my knees to my chest, touching my feet with my hands to defend my stomach area; for a figure like K.M. tries to pierce my bowels with a huge trident. I shout: "No, no!" I sit up in order to better fend off the trident with my hands shouting: "Stop!" (figure 7).

Figure 7

Going back to primal breathing I sit up folding my arms around my knees feeling like being in an agreeable dark-red womb; the trident is now directed towards my neck and there is a hole underneath me, open towards the sky, and a couple of unrecognizable faces peep in from outside. I try to hold tight to the umbilical cord since I am afraid of falling out. Looking down towards the opening I say: "I want to get out" (figure 8).

The therapists encourage me; I bend down to the floor with my head in order to get out but out of fear I resist. (I had always been terrified of doing headstands or any position in which the head is down. I went through eight years of hell in school because such positions were required twice a week in physical education

Figure 8

Figure 9

Figure 10

Figure 11

Figure 12

Figure 13

classes.) I try again and again, going down to the floor with my head, then some hand pushes me by the neck and I roll over: *I am out* (figure 9).

The therapists pull me back onto the mattresses. I tremble and cry. I feel the fresh air and spaciousness around me; it feels so good. Asked what I feel, I say just the air. Deep gratitude arises in me; I say thank you, thank you. Asked thank you to whom, I answer: "To both of you."

I touch my heart chakra like a treasure box; asked about this treasure box, I answer that it contains absolutely everything and everyone I love in the form of a medieval picture with many faces; then I describe all the faces (figure 10). I am made to speak about my feelings toward my father, mother, former wife, my lover and persons I consider enemies. Finally, I speak about the therapist who ran the encounter I had taken two years ago. I feel very warm towards him. A vision of the heart chakra appears slightly different from one I had once before—a small glowing red ball with the real heart beside it located in dark blue surroundings (figure 11).

This image slowly changes into one of a warm white luminosity to which I am attracted. Then Osho in his chair appears in it ever so faintly and starts levitating. Finally, what is left is a clear bright light into which I am absorbed. I cry. (Figure 12, compare to figure 4).

After more breathing I make movements with my hands as if I wanted to get rid of something in front of my eyes. "I want to get away from it". The therapist asks: "What?" "These eyes—the eyes of a hawk." My hands form themselves into paws; I feel the claws coming out, a hawk sitting over its prey on top of a rock and tearing it into pieces (figure 13).

I take a cushion between my legs, stamp on it with my feet and tear it into pieces with my hands. At that moment I can clearly see the hawk's eyes and its beak. Asked what the feelings is, I answer:

The Silent Orgasm

"Killing". "Whom?" "You, you bitch." I shout that repeatedly as long as her face is in my mind's eye.

"Who else do you want to kill?" I see my father's face, I sit up with my nails out ready to kill him, taking him by the neck with my claws. Then come protesting shouts of "No,no,no." Asked "No to what?" No to Latin, Greek, mathematics. I make another attempt to kill him, but I am too exhausted. At this point I suddenly feel great warmth for him. This alternation between utmost hate and love repeats itself several times.

With my eyes open we discuss the god and the hawk in me. It becomes clear to me that I always suppress the hawk in myself and only wish to appear to others in the image of a good guy.

Figure 14

On the way out of the ashram I feel very fresh and rejuvenated, but it still bothers me that I have carried this Oedipus complex for forty years. During the Kundalini Meditation my body wants to go into the position of someone being crucified by being hung under the arms. The head hangs down to be chopped off next moment (figure 14). Late at night I do a meditation of just staring into my face in a mirror. I discover to my surprise that the hawk's eyes from this morning turn up in my own eyes. They feel alright to me now (figure 15).

Figure 15

Fourth day:

The hawk—the feeling of anger, hate and the wish to kill—haunted me again during the Dynamic Meditation this morning.

The feeling even increases when, first of all, one of the therapists makes me assume the bioenergetic position of riding. My legs shake and I scream. Then the other therapist enters and abuses me. She makes me push the wall, first from the front, then from the back with my arms over my head. I drip sweat. The next position is sitting and pushing the wall with my back. They ask: "Whom are you pushing?" I say "My lover." I start apologizing to her etc. At this point, and with more verbal abuse, both therapists disappear, slamming the door. They make me wear a halo constructed of some chicken wire and silver paper for the rest of the day so that I don't forget that I always want to play the good guy and the saint.

Back in my hotel I am hot with anger and ready to kill. I start stuffing myself with food. I also realize that this feeling of aggression is very close to or mixed up with sensations of sex, anonymous sex, sex without facing one's partner. Much of the evening

I spend writing a letter to my lover (which I never post). But I realize that the game I was playing with her was that of spite, a very basic behavioral pattern in my life so far. This I feel points towards a fear of love, of being lost in another person, of disappearing, of ego-death.

Fifth day:

After deep breathing I am pounding the cushions and kill both therapists in my mind's eye. Suddenly the Gestalt changes. I see my father lying in front of me. Like a madman I chop his head off. I accuse him of always having pushed me. Suddenly I realize that he is dead (figure 16). I feel great remorse and break down in tears. I start saying that I had always loved him, his eyes, his hands, and the way he walks. I saw how he walked beside me as a little child holding my hand. It feels so warm and good.

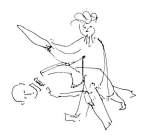

Figure 16

The therapist asks me whether I can see my mother, too. I feel she has never been available to me. Our large apartment appears completely dark to me now, strangely enough because it was really very open and bright. After more intense breathing I make movements with my hands as if I want to open a curtain separating me from my mother. The more I try to reach out, the more the curtain recedes (figure 17). I jump up and call for my mother. She finally appears and takes me on her breasts. It feels so comforting. I roll around looking at her naked body from all angles in great delight.

Figure 17

I do some more primal breathing and start intense shouting again. I struggle, pushing intensely with the legs to get out of my mother's womb; when the doctor cuts the umbilical cord I jump up with an enormous shout.

Suddenly Osho's face appears in front of me with his mouth wide open as if to encourage me; he is shouting, "One more time, this is your meditation technique". I work myself into a convulsion with a lot of mucus coming from my mouth. One therapist helps by putting a finger deep into my throat. It is very painful. In my mind's eye the face of Osho is pulling me on. When it is over the feeling of just breathing the air in this stuffy and stinking massage room is pure joy.

I take up heavy breathing again and pound the mattress shouting that I have had enough, that I am totally exhausted.

They ask how that exhaustion feels and I say it feels like a protection, a defense, an escape from a horrible scene starting to evolve. I am on the table in an operating theatre and the master appears with a huge knife to cut my breast open to take my heart out. I finally let it happen with great shouting (figure 18).

Figure 18

After I come out of the primal trance my first words are of deep gratitude to the therapist. At night doing the mirror-staring meditation again I realized that the hawk is constantly present in my eyes ready to kill. It is the other part of me when I am not in the loving space.

Sixth day:

Already during the Dynamic Meditation in the morning plenty of images of me as a little boy with both of my parents in various loving situations come up. Everything appears so big to me. I realize how much I need their touch and presence, and even now how much every pore of my body needs love and touch. This goes on for a long time, even including another primal birth.

At one point the therapists bury my head under cushions as if to suffocate me. I shout but the strange thing is that at the climax of the shouts, at the center of each shout, I feel a deep silence; it is a beautifully liberating sensation. The rest of the session we spend on discussing why in my life I always seem to have chosen relatively flat-chested Asian women as partners. Then I am asked to try to persuade a woman closely resembling my mother to spend a night with me, as a kind of guinea pig. Someone finally accepted out of pure compassion, but the exercise did not bring me any particular insight.

Figure 19

Seventh day:

After an almost sleepless night I enter the room and begin heavy breathing. When asked, I describe the scene I feel I am in: lying on mattresses holding the two fists of my father who is hanging from the ceiling by his feet (figure 19). I say that this feels heavy, and as the feeling of heaviness increases, the image changes into me lying with a huge cube of iron or stone on my chest (figure 20). I complain that I am suffocating and ask permission to take off my clothes, which feel like a rubber tire around my neck.

Figure 20

Hunting Technique: Transpersonal Therapy

I resume the breathing again and slowly the heaviness disappears. I feel full of energy, energy flowing from the third eye through the throat and heart centers to the solar plexus. I turn into a flow of energy. I surrender completely to this invigorating feeling. It is the clearest sensation I have ever had of the third eye chakra without external stimulation.

End of story. This is the gist of my primal therapy. Certainly it does not read like the memoirs of a hero. But the content probably represents what, with variations, would be present in the typical Westerner raised in a culture oriented mainly to thought and competition, not to love. There were three major lasting results for me:

— The voice of my parents was completely silenced in me. That alone was worth all the pain. I came to understand why both Buddha and Jesus made the 'killing' of the parents a precondition for becoming a disciple. The thousands of 'do this' and 'don't do that' commands from parents and teachers have to be evaporated.

— I was released from the lure of East Asia, where I had chosen to live for more than a decade, by reliving my last death in some Chinese or Japanese context. That there is no way of proving this scientifically does not bother me at all, because no scientific proof would have the same liberating effect. Here again, only experience (and never knowledge alone) liberates.

— The painful vision of having my heart torn right out of my chest freed me for good from romantic love, the usual selfish, chemical type of love which, in practice, is always bound up, through jealousy and possessiveness, with its opposite—hate. Only then does a non-egotistic love arise, which is so total and all-embracing that love appears as the very glue of the universe. The first love resides in the physical heart, the latter in the metaphysical heart chakra. Unfortunately we only have one word for both types of love; fortunately the unconscious does not speak English, but uses powerful images instead.

Astral Projection
Consciousness travelling in space and time tunnels

Some parts of human consciousness can leave the physical body to travel forward and backward in space and time. This has been reported in clinical accounts of near-death experiences, dreams and hypnosis—occurring involuntarily or semi-involuntarily in most cases—as well as in accounts of certain spiritual practices and drug-induced trances. These voyages beyond consensual three-

The Silent Orgasm

dimensional reality (on what is popularly known as the astral plane, using a theosophical term) leave a profound change in one's sense of space-time, for during the travel the *one- distinct-event-after-the-other* of time and the *one-thing-beside-the-other* of space fuse into one huge coincident spectrum of here-and-now.

While a substantial body of literature exists, my perspective on *astral travel* comes mainly from my own experiencing and witnessing of it. I do not subscribe, for example, to Robert A. Monroe's model of astral projection via a second, distinct, nonphysical body. Some contemporary researchers do share my view that astral experience can be subsumed as a level of transparency within a singular, integrated model of consciousness.

Instances of astral projection often occur unexpectedly, unwilled while dreaming. For example, in a recent early-morning dream I saw one of my outdoor cats hanging head-down from a chair like a piece of cloth, a weird sight almost like a melted object in a Dali painting. About three hours later, after a leisurely morning bath, I went outside to feed the cats and one of them was hanging there from the chair exactly as I had seen it in my dream. It was very sick. Now, either time had collapsed for me and I had a precognition in my dream of something that would happen later in 'real' time; or space had collapsed for me and part of my consciousness moved from the bed where I was dreaming to *see* something in another place. Or perhaps both the time and the space of which I dreamed were beyond normal limits.

In another dream, the night I arrived in a foreign city, I found that I had been shot dead. I saw blood oozing from a small hole on the front of my yellow sweater. I stood up to go for help, and when I reached the door of the room I stopped and looked back and saw myself still lying there. I felt confused about whether I was standing or lying down. It occurred to me that since I was no longer in my body, I did not have to open the door, I could just walk through it, and I did so. I was relieved to see someone coming down the corridor whom I could ask for help, but to my dismay I ran right through him. Realizing that I had no way of making myself either heard or seen, I was both frustrated and amused, and I started laughing, which woke me up. There is frequently a comic overtone to out-of-body sensations, both in dreaming and in near-death experiences. Which is to say they tend to be joyful rather than frightening experiences.

In between the space-time transcendence of the involuntary dream and that of the willed trance state is the experience which occurs during the normal mode of waking consciousness. One summer evening, for example, I walked down the lane between my house and the train station to meet a guest. A hydrangea bush in full bloom bulged invitingly over a neighbour's fence, and for a moment I considered taking a flower or two as a centerpiece for our dinner. But I do not like to cut flowers, and these were already a part of my local world, so I went on. Five minutes later I returned with my friend and, lo and behold, one beautiful flower lay broken off on the path. Can a flower break itself off out of compassion? (Not yet reported, even in *The Secret Life of Plants*.) Was it coincidence? Or was it, as I believe, a fairly routine example of precognition?

Besides the random, involuntary out-of-body experiences of the sleeping and waking world, it is possible to induce such states of transpersonal awareness purposefully, through meditation techniques. At Poona in the late 1970s I participated in a three-week meditation workshop designed specifically to obtain a taste of astral projection. It was called Soma, after the famous magic mushroom of the Vedas, but no drugs were used. The preparation for the out-of-body experience consisted of two intensive weeks of guided meditations, focused on the chakras and on envisioned or imagined light.

It has been noted that the greatest barrier to astral travel is fear—fear of death, since leaving the body is usually identified with death; fear of not being able to reenter the body; and a general fear of the unknown (*Monroe*, 205). For me, the prolonged Soma meditations allowed the self to be sensed as gradually less and less bounded, less separate from the environment, less of a definite, solid physical body. Thus the potential of astral projection seemed less like a separation from my body, and more like a trip into some unexplored recesses of my own consciousness. In other words, my fear of death was removed from the situation.

One of the meditations used in the Soma group was the Breath of Fire, a powerful technique which combines special body techniques and difficult breathing, concentrating in turn on each of the seven chakras. Before describing the final week of the workshop, I will outline the seven stages of the Breath of Fire (see illustrations on page 115—116).

Figures 1—7
Body postures of the 'breath of fire', a meditation technique which concentrates on the seven cakras with seven different types of forced breathing and body movements.

The Silent Orgasm

Concentration on the sex center:
Sit with legs crossed and both arms and thumbs up. Exhale deeply and forcefully, slowly increasing the speed. At the end, inhale, squeeze, exhale forcefully, repeat, then relax.

Figure 1

Concentration on the navel center:
Lying on the back, lift head, arms and legs about six inches; exhale twice forcefully from the stomach, rest briefly; repeat until exhausted.

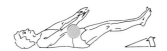

Figure 2

Concentration on the solar plexus:
Kneel and sit on legs; exhale forcefully and bend the spine to the rhythm of the breath.

Figure 3

Concentration on the heart center:
Sit with legs crossed and hands locked at shoulder level; exhale forcefully from the chest.

Figure 4

Concentration on the throat center:
Sit with legs crossed and hands resting on feet; exhale deeply twice through the mouth, then inhale twice through the nose, all rather quickly.

Figure 5

Figure 6

Concentration on the third eye center:
Take three positions in sequence—arms stretched to the side with hands up, arms slightly higher, stretched with thumbs up, and arms stretched overhead. Breathing is from the upper chest, flat, quick and fluttering.

Figure 7

Concentration on the crown center:
Sit with legs crossed, arms stretched overhead, and hands folded with index fingers up. Breathe deeply and quickly from the belly.

After two weeks I eagerly volunteered to attempt astral travel. I was asked to select two helpers I felt very comfortable with. I lay down with one of them sitting behind my head and the other at my feet, and the three of us fell into an integrated rhythm of very subtle breathing, as if we were one body. The group leader asked me to make a clear decision as to where I wished to travel, in space or in time. I chose to travel back in time as far as possible. Then by suggestion, ever so slowly, she coaxed me out of the body. I embarked on what I might describe as a trip through the Darwinian or Hindu evolution of the species, in three dimensions and brilliant color. Strangely enough, this trip moved backwards through time, and even more strangely it occurred twice. Aside from excruciating pains at the top of my spine which I could not relieve by slight body movements, I felt a sense of immense freedom all the way through.

Initially I felt myself to be a cow, grazing, advancing step by step over the grass, some birds hopping around close by. I felt like a cow feels from inside. There was an overpowering sensation of undisturbed silence of being 100-percent present, with no interference from any noise of the mind. Next came a feeling of being an eagle-like bird, cruising high in the sky, with the sound of the

air rushing and a beautiful panorama of the land below. That feeling changed into one of being a catfish, plowing through muddy water; it felt hard to breathe, and I started crying. The sequence ended with the appearance of a bush with thousands of red flowers, overlooking some mountainous setting. Yes, I felt the flowers could look and feel; I was the flowers. I was tickled by bees and fondled by the fresh wind and loved by the rays of the sun. The bush saw a human being meditating, sitting in its shadow, who then became one with it and all its flowers. I felt that I was simultaneously the whole bush and just one of its flowers. The other flowers I suddenly perceived as all the beings who had now gathered in Poona at the ashram.

After perhaps thirty minutes or an hour I became aware that efforts were being made to call me back. There was the excruciating spinal pain again, and I had no desire to return. My body was carefully turned over onto the stomach; it was freezing cold, only the backbone was burning hot. The leader cooled my spine with a sponge dipped in warm water. There came a moment when I realised that I was back. The experience of astral projection left me with an indescribable high feeling that lasted for weeks, in one sense for years. (The after-effect was very different from the few experiences I have had of unguided 'trips' with hallucinogenic drugs, which were followed either by depression or by nothing unusual.)

The everyday word for well-being in Japanese is gen-ki, written with the character for 'origin' followed by the character for *energy*. Here one is reminded of Gebser's dictum that "origin is always present". We only tend not to allow its presence and therefore one is not wholly well. Of course, the average Japanese person is not aware of the deeper meaning of this expression.

The truth of my story cannot be demonstrated to skeptics or anyone else, not even to myself. I did not receive scientific proof of other forms of existence. What I received from astral projection is rather a first-hand feel of the strange truth that the deeper my awareness of my identity, i.e. the greater the transparency of my consciousness, the more energy is available to me. Eventually someone will improve on Einstein's celebrated equation of energy, mass and the speed of light, which is only a formula about a dead universe. What is missing from the equation is the factor of consciousness. The theory of relativity is a product of an his-

torical age marked by mental constructs, dualistic visions of un-living matter overseen by an undying creator.

Energy is directly proportional to the extent or the transparency of consciousness. Osho has presented a model describing three apparent layers of the consciousness-energy conglomerate; it is really one thing, but we can discover it in three stages. The first layer we use in our daily lives, as we work, up to the point of total exhaustion. A second layer will then be available in the case of an emergency; if life is threatened it is possible to flee or fight using the reserve layer of energy. There is a third layer still present when even the reserves are exhausted, and it is this layer which is tapped by meditation. The strange sensation one has when entering the third layer is that both one's energy and the transparency of one's consciousness are infinite. Therefore even a millisecond of meditation, of being the ever-present origin, has genuine energizing and a transforming quality.

Scientific proof that you have been a samurai or a serf, or that your present body is highly likely to include electrons which once were part of a pharaoh's existence and thus, as Charon would have it, contains all his life's wisdom, leaves you as dead as you were before you were offered that evidence. Here lies the difference between being engaged in the sciences or in meditation. In meditation the experimenter is the guinea pig. After scientific experiments you know more, after meditation you are more.

Naturally you cannot employ an expert inner pilot who can steer a predetermined course through the wild and boundless ocean of your consciousness. What might be designed as an astral projection in space, and start out as such, could turn into a sequence of perinatal experiences or take other unexpected turns. Once you enter into the submerged part of the iceberg that is your consciousness or even the immense ocean it floats in, you relinquish all control of what should be brought to the surface and what not; there, all is interconnected and of the same substance.

An example of how wild such a projection can be is the following record of a woman who is coaxed out of her body by suggestion immediately after mandalic sex (see figures on page 119—120). After a 'lift-off' from a house in Kyoto and a bird's-eye view of the scenery from above (1, 2, 3), she climbs through the clouds on a rope of creepers (4, 5), gazes at the moon and considers going to

The Silent Orgasm

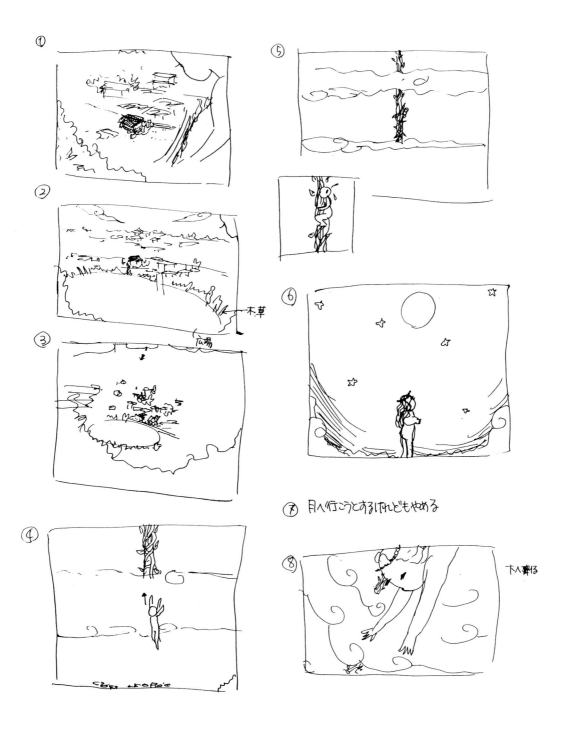

Figures 1—15
Sequence of visions after mandalic sex therapy.

Hunting Technique: Transpersonal Therapy 119

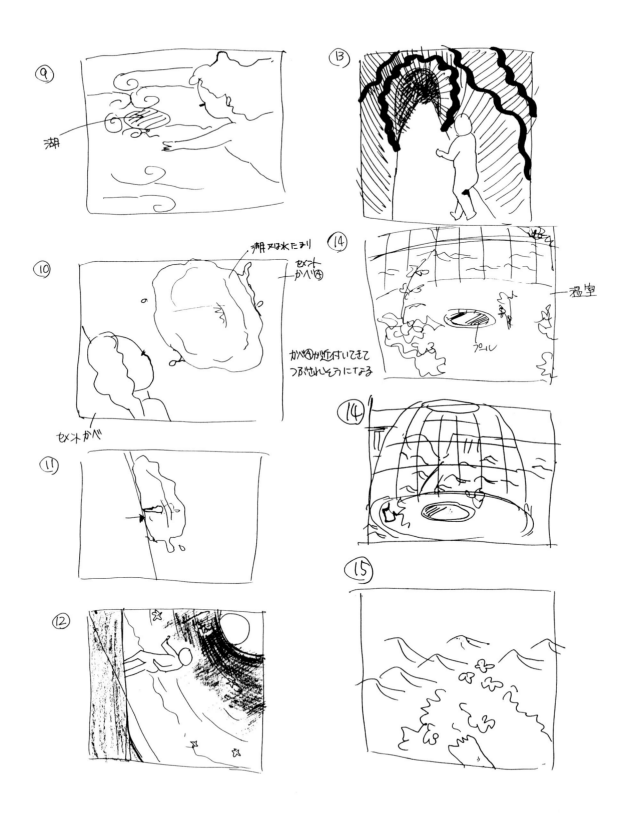

it (6), but decides to come down again (7, 8). On the way down she spots a lake (9), which turns into a plate of water (10) and then crashes her against a concrete wall (11); she then walks on the wall of the concrete tunnel with the moon at the end (12). This tunnel turns into a reddish birth channel (13) and she suddenly finds herself in a huge, hot house in the middle of the desert with a pool at its center (14).

This sequence of sketches documents the fleeting quality of the visions produced by the unconscious. One image quickly melts into the next. This is quite contrary to the powerful static 'stills' Grof reproduces in his respective books on transpersonal therapy with psychedelic drugs and with holotropic breathing. First, I feel these stills are manipulated by being forced into a mandalic circular form; second, by their overexecution in finsh and detail, they provoke the impression of basically static visions, as in carefully composed oil paintings. In my experience the scenes are elusive flashes, more like a film sequence than a photograph.

Summary

A transparency model of consciousness

The purpose of transpersonal therapy is to bring biographical and perinatal episodes from one's own unperceived consciousness, as well as contents from the transpersonal consciousness to the surface. In line with the psychoanalytic theory of the unconscious, transpersonal techniques, especially primal therapy, have found that until submerged episodes surface they tend to distort our perceptions and influence our actions in the present world. The result is our daily neurotic behavior, in which we react more to events in the distant past than those of the here-and-now.

A few of the techniques used in transpersonal therapy have been introduced in this chapter, not to provide any sort of comprehensive survey but to illustrate the genre. Obviously the emphasis has been on techniques with which I myself have experimented. In general, transpersonal therapies hold much potential for helping to rediscover, relive and release the unresolved past and its burdens, which tend to be constantly projected into the present; they help us live and act in the present and reconnect with our natural creativity and inborn intelligence. Still, they are no more than techniques, and as such they require enormous personal effort, regardless of which of the many gates to the submerged content of consciousness is used. That is to say therapy is not meditation.

Meditation is beyond consciousness with content, beyond experience, certainly beyond that part of experience which is mental. There is no gate to meditation because there is no-one left to pass through, nor is any 'effort' necessary for meditation because there is noone left to make it. Nor is meditation something unknown which must first be learned; thus it is not difficult. My own guide emphasized that "Meditation is not something new; you have come with it into the world. Mind is something new, meditation is your nature. It is your nature, it is your very being. How can it be difficult?" (*Rajneesh* 1989, XI).

Some of the experiences encountered in primal or other therapy, or in kundalini yoga or chakra opening meditations are very attractive. They may be invigorating, healing and beautiful. But whoever has been with a living master will know that he will snatch such experiences away from you as if they were children's toys unsuitable for an adult. He will push you on and on. "The ultimate in the journey is the point when there is no experience left—neither silence nor blissfulness nor nothingness. There is nothing as an object for you but only your subjectivity. The mirror is empty. It is not reflecting anything. It is you" (*ibid.*, 26).

There are schools of meditation, such as zazen in Zen Buddhism, which do not bother to look at or interpret the accumulated garbage of the *unconscious*. If you are asked to interpret your own dreams and you open your mouth to do it, the master might just hit you over the head to wake you up. The Zen approach is to try to go through the whole of submerged consciousness in a flash like lightning, to reach satori which is the first glimpse of reality.

In the same spirit of elucidation which is common to therapy, meditation and satori, I believe it is helpful to regard consciousness in terms of transparency. I therefore propose yet another model of consciousness, which begins with Freudian theory and also builds on Grof's research. My model distinguishes four levels of a continuous and unified consciousness, which may better be called four grades of transparency.

A good metaphor for the Transparency Model is an iceberg situated amid the ocean and the atmosphere as originally suggested by Sigmund Freud. Viewed holistically, it consists of (1) a small tip visible above the surface of the ocean, (2) the larger part

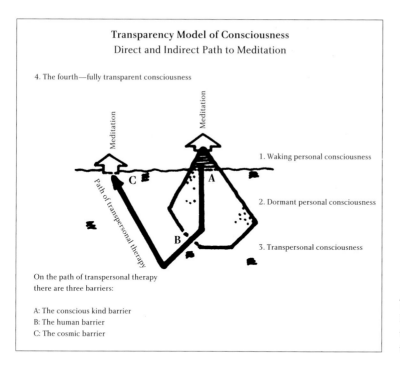

The transparency model of human consciousness with the direct and indirect path to mediation

below the surface, (3) the immense ocean in which it floats, and (4) the humid air above the ocean. The four parts are all the same substance, water, but each presents a different degree of transparency to our perception (see figure above).

I call the first three aspects *waking personal consciousness*, *dormant personal consciousness*, and *transpersonal consciousness*. The fourth level, likened to the air with water vapor in it, defies any linguistic description. Let us call it simply The Fourth, following the lead of the Vedanta. It is consciousness without content, consciousness immanent in and transparent to all the other three levels, pure awareness or fully transparent consciousness, the domain of meditation.

Two paths of meditation are implied by this model. One is indirect, the path of transpersonal therapy in all its forms, advancing through the ice and water of personal and transpersonal awareness, and then evaporating into the air of fully transparent consciousness. The other path is direct, satori-like, vaporizing all tangible awareness in a bolt of illumination, a sudden meltdown of the entire ground of iceberg and ocean.

This model—and of course it is only a model—may serve to convey the idea that consciousness is not just equal to knowledge

in the sense that the more knowledge you acquire the more conscious you become. Furthermore, this model is free from the dualistic view of opposition between consciousness and unconsciousness (or personal and transpersonal consciousness) or between consciousness with content and without content, while still recognizing their apparent existence in terms of perceptual availability—degrees of transparency, integration or intensity, to use Gebser's terminology.

It is just not true that we are not in constant contact with our dormant or transpersonal consciousness; even awake we are not in opposition to it. It is only that our education has not made us aware of it. The truth is that we would not even be alive if we were not also in constant contact with The Fourth, the *Ursprung*. We are The Fourth.

To translate the model into experiential terms: anyone who seriously attempts meditation comes to know that the more one is established in the objective outside world, that is, in its solid material quality, the more unreal one's consciousness will appear to him. Then only the tip of the iceberg is real. Conversely, the more one is established in one's consciousness, that is, the more transparent and integrated one's consciousness is, the less solid, the less real the outside, objective world will appear. It becomes what Hindus call maya, a magic show.

With this model in mind I wish to analyse transpersonal therapy techniques in detail. In general, they basically display a dialectic structure. In order to facilitate relaxation and unqualified watching of whatever comes up, one is first thrown into unknown chaos, such as by drugs, or by hyperactivity, such as wild shaking of one's body in Kundalini Meditation, or by hyperventilation and chaotic breathing such as in Dynamic Meditation, or also by being robbed of all privacy and normal sleep as in encounter therapy. With the exception of hypnotherapy, in the first stage great effort has to be made to break up your defenses and make cracks in your armor.

This first stage can last for just ten minutes or stretch over weeks as in the Mystic Rose Meditation introduced by Osho in the 1980s. This is a three week meditation retreat, with three hours a day. The first week one simply laughs, not because of any joke but for no reason at all. In so many situations the social situation has repressed one's laughter. This one week of belly

laughter will be a deep catharsis to anyone. In the second week one falls into crying more or less naturally; one cries for a week. Since society has repressed your tears even more than your laughter this catharsis will reach even further into you. The third week is taken up by sitting silently, watching and witnessing. After the previous two weeks of catharsis one now has a chance to sit quietly; this quiescence would hardly go so deep without the previous two weeks of preparation. See Rajneesh audio-tape: *The Mystic Rose.*

The three-week Mystic Rose Meditation compressed into an hour is the now classic Dynamic Meditation also invented for modern man by Osho in the early 1970s. Again it reflects the same dialectic structure. First stage (10 minutes): rapid and chaotic breathing with the emphasis on exhalation. Here one is asked to exhaust oneself totally, to build up as much energy as possible. Second stage (10 minutes): explosion of this energy into an un-controlled catharsis; throw out whatever comes up. Third stage (10 minutes): shouting of the mantra *HOO! … HOO!* as loud as possible from your belly while jumping up and down on your heels; this will hammer on your lowest, the sex center. Fourth stage (10 minutes): freeze suddenly in whatever position you might be and simply watch what is happening inside and outside of you. Fifth stage: Just celebrate the mood you are in to gentle dance rhythms.

Thus, in various different forms, the one pole of these meditative therapies consist of hyperventilation, hyperactivity such as wild dancing, jogging, or exhausting mantras to build up energy to go into a deep catharsis through which you throw out your accumulated insanity. The other pole consists of relaxation, silence, motionless stillness to allow you non-judgemental watching and a deep choiceless acceptance. Sometimes this period turns you into a trance-like ego-less state in which your consciousness becomes more and more transparent and you can look into the farthest corners of it but you are simultanously present to communicate with any helper if required. Both poles work in a way similar to a pendulum: the farther you go and exhaust yourself in hyperactivity and hyperventilation, the deeper will be your relaxation. The transition back to ordinary waking consciousness can be eased by a loving hug, some soft music or a celebrative dance as in Dynamic Meditation.

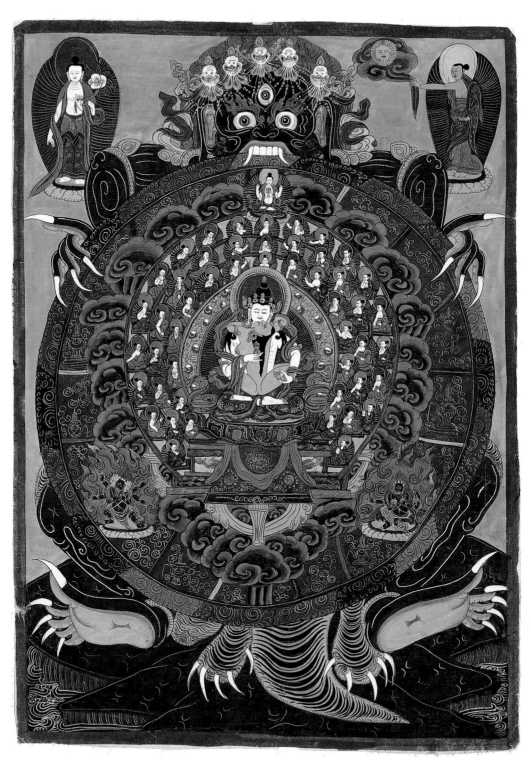

Unio Mystica in the claws of the God of Death (47 x 61 cm)

A last word might be added concerning the guide or helper in such therapeutic meditation techniques. Whereas many of the one-hour meditations just need a guide to explain the structure of the meditation, supervise their execution and make sure that there is no accident or disturbance, the role of the guide or therapist in the encounter or primal therapies is of vital importance.

I cannot conceive of someone doing a primal session by himself. How do you break your own defense system? Nor can I imagine someone who has not undergone a birth-primal or has not pierced into transpersonal areas of his own consciousness helping someone else to do so. Studying it at university is not enough. One must have travelled that path oneself. I feel only then will one be able to muster the love, compassion and resolve to 'push' someone else in the same direction. One will be able to read the other person's mind and heart and not be disturbed by the other person's apparent pain in melting his own iceberg.

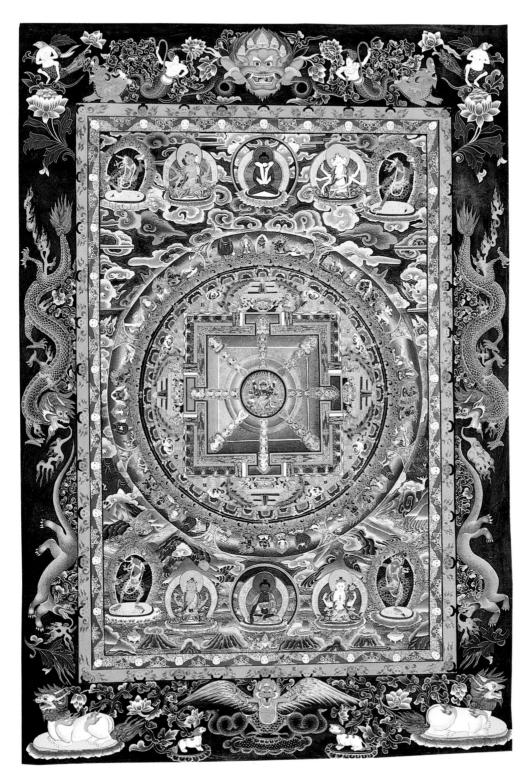

Mandala of Cacrasamvara
'Supreme Bliss', a Vajrayana deity with the rank of a Buddha; 1990 Nepalese copy of Tibetan original (81 x 118 cm)

Orgasm Technique:
Tantric Sex

The therapeutic and meditative techniques presented in Chapter 4 are variations of what can be called the hunting paradigm, or choiceless watching in absolute stillness, when both self and other become alive. The techniques discussed in this chapter fall under the orgasm paradigm, or the use of the mystery of sexual flow and union to achieve transpersonal states of consciousness. It may be that such techniques exist because the the bliss experienced at the moment of orgasm, in which all sense of separateness disappears, became a motivation to attempt to extend the duration of orgasm, or to transform sexual energy into the transcendence of meditation.

The Role of the Chakras or 'Ductless Glands'

There are those who argue, based on experience and not only on theoretical speculation, that the state of meditation can only be created by biological mutation and hence is the result of natural evolution rather than direct personal effort. In a remarkable little book called *The Mystique of Enlightenment*, U. G. Krishnamurti calls meditation a "natural state" without any cause. "Nature, in its own way, throws out, from time to time, some flower, the end-product of human evolution" (*Krishnamurti*, 66). He believes that cultural conditioning discourages us from reaching the natural state, and even historic 'heroes' of consciousness such as Buddha, Socrates or Laotse become stumbling blocks which impede us from blossoming in our *own* unique manners. "The evolutionary process or movement is not interested in using the one that it has perfected as a model for further creation; it has a creation of its own" (*ibid.*, 100).

Krishnamurti (not to be confused with the better known sage J. Krishnamurti of India) refers to the physical changes he underwent in his own process of transmutation as "the calamity". He wishes to convey that the bliss or ecstasy which is usually assumed to be associated with intensive meditation or enlightenment is simply a myth. Experience tells him that the alchemy of physiological transformation is excruciating.

Modern Tantra and Tao of Love
Meditation as result of biological transmutation

Krishnamurti describes his biological mutation in terms of the chakras, which he calls "ductless glands". Although he believes them to be outside the scope of conscious manipulation by human thought, he says, "Unless [the chakras] are activated, any chance of human beings flowering into themselves is lost" (*ibid.*, 98). In other words, this radical commentator, who denies any connection between enlightenment and human effort, who

Diagram of the "small heavenly cycle" of vital energy, reproduced from Mantak Chia: Taoist Secrets of Love.

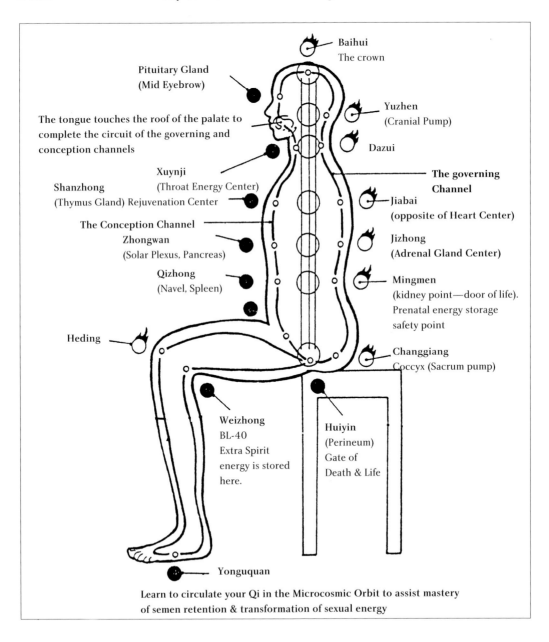

Baihui
The crown

Pituitary Gland
(Mid Eyebrow)

Yuzhen
(Cranial Pump)

The tongue touches the roof of the palate to complete the circuit of the governing and conception channels

Dazui

Xuynji
(Throat Energy Center)

The governing Channel

Shanzhong
(Thymus Gland) Rejuvenation Center

Jiabai
(opposite of Heart Center)

The Conception Channel

Jizhong
(Adrenal Gland Center)

Zhongwan
(Solar Plexus, Pancreas)

Mingmen
(kidney point—door of life).
Prenatal energy storage safety point

Qizhong
(Navel, Spleen)

Heding

Changgiang
Coccyx (Sacrum pump)

Weizhong
BL-40
Extra Spirit energy is stored here.

Huiyin
(Perineum)
Gate of Death & Life

Yonguquan

Learn to circulate your Qi in the Microcosmic Orbit to assist mastery of semen retention & transformation of sexual energy

The Silent Orgasm

believes evolution will never repeat itself, nevertheless emphasizes the role of the chakras in the transformation of consciousness. He takes the traditional Indian view that the chakras hold the key to the mechanism by which nature perfects itself in evolution.

The Role of Kundalini or 'Serpent Power'

Gopi Krishna likewise sees enlightenment as a natural process caused by biological laws. He comes to the conclusions that "mystical consciousness implies essentially a biological transformation of the brain," and "spiritual experience represents the culmination of a regular process of biological evolution" (*Krishna*, 69, 104). But where Krishnamurti claims that any willed interference with this biological evolution is futile, Krishna prescribes Kundalini yoga as the most powerful medicine there is to reach the state of meditation.

Kundalini yoga uses the bio-energy stored in the reproductive system at the lowest chakra, the sex center, and prescribes techniques to guide this energy upwards to the crown chakra in the brain. Having arrived there it creates ecstasy, bliss and clarity of consciousness which then spreads all over the human body enhancing all of its normal faculties. For Krishna the awakening, or uncoiling of the Kundalini, the Serpent Power, on a mass scale would be the only way to rescue the human race from its present course of self-destruction. Believing in the usefulness to evolution of both human effort and his own experience, he has opened various Kundalini research facilities.

The Role of the 'Small Heavenly Orbit of Energy' and 'Inward Orgasm'

Over the last twenty years many well-kept secrets concerning the reversal for spiritual ends of the natural flow of human reproductive energy have been revealed in various books by masters or adepts of the Daoist and Tantric paths, in the East and West. In addition, Tantric and Daoist healing therapies are by now diffused in innumerable schools and workshops in the West.

In the contemporary publicized teachings of the Daoist secrets of love, there are three main underlying principles:

1. At the base of the complex forms of Daoist meditation techniques lies the cultivation of the *small heavenly cycle of energy* or

what Mantak and Maneewan Chia call the "microcosmic orbit of energy" within one's physical body. This energy orbit is created by joining together two main energy channels also used in Chinese medicine. One is the governor conduit, running from a point between the anus and the testes up the spine and over the skull to the top of the palate; there it may be connected by the tip of the tongue with the other channel, the conception conduit, which runs down the front of the body to the starting point of the governor conduit (see figure on page 130). Various techniques of imagination, breathing and manual sexual stimulation, alone or in combination, may be used to arouse and then circulate one's own vital energy in a *big draw* up from the sex center along the spine to the crown chakra, and then down along the front of the body back to the sex center.

To activate this *small heavenly cycle* of energy on one's own is also one of the main goals of qigong, the ancient physical healing practice and foundation of all Chinese martial arts, which has recently seen a tremendous revival in China. The qi in qigong connotes energy in its broadest sense from cosmic creative energy to the spirit received by a human being at birth. In Chinese medicine generally, health is understood as the effective circulation of energy along its various conduits. In qigong in particular, one tries to guide and circulate one's vital energy by three concerted efforts: physical movement, respiration, and conscious thought. Thus, Mantak Chia's energy circulation practices are in the best tradition of ancient qigong exercises.

2. Direct sexual arousal, alone or with a partner, can be employed to transform sexual energy into spiritual energy. Hence sex is viewed as a means not only for procreation and/or physical pleasure and emotional fulfillment, but also for the evolution of consciousness. To achieve the latter goal, a clear distinction is made between normal outward-pouring orgasm which is seen as a form of losing-energy pleasure, as Maneewan Chia calls it, and a cultivated valley orgasm of the Dao of Love which she calls a "gaining-energy pleasure". Since only the latter type of sexual pleasure is deemed appropriate for the transformation of human consciousness, numerous techniques are offered for delaying or preventing the short-lived, outward, energy-losing orgasm. The purpose of these techniques is to trigger an *inward orgasm,* so as not to lose one's vital life-force but recycle it in the described or-

bit. The goal is not only increased and prolonged sexual pleasure, but ultimately the achievement of more transparent states of consciousness.

3. The microcosmic orbiting of energy can also be practiced to great effect with a sexual partner. The techniques offered again include various forms of delaying outward-directed orgasm in both partners, as well as the fusion of their small heavenly cycles of energy into a single interlinked cycle, creating one energy body from two physical bodies (see figure on this page).

The Chias summarize the Daoist secrets of love as follows: "…a continual rolling expansion of the orgasm throughout the whole body, prolonging inward orgasm to a half-hour; one hour, two hours, or longer in a gradual, but ultimately greatly heightened ecstasy. You can enjoy this form of sexual love indefinitely without paying for your pleasure with your life-force" (*Chia* 1984, 258). "The sperm energy is channeled into the warm current of the Microcosmic Orbit. The warm current is transmuted into mental

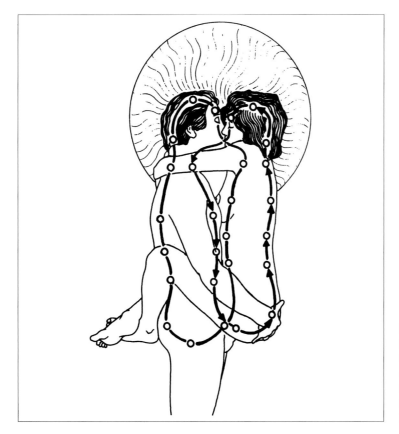

Diagram of the hypothetical fusion of the male and female microcosmic orbits of energy during sexual union; reproduced from Mantak and Maneewan Chia: Healing Love.

power and this power or soul is finally transmuted into the highest manifestation, which is pure spirit. When this spirit is embodied in an Immortal Body, it gains freedom to work in different spiritual planes at will. This is a step beyond the awareness of cosmic oneness" (*Chia* 1986, 171).

The latter quotation is Mantak Chia's description of the last of the seven stages of the transformation of sexual energy to spiritual energy. He admits that he has not yet experienced this final stage, although he finds it well documented "in the thousand volume Daoist canon, including the names of many individuals who reached this state." This raises an important question. Is it honest to claim in a series of books that sexual energy can be used for spiritual ends if one has not had full experience of it oneself? Is it honest to cite the authority of ancient books when the contents cannot be verified (and indeed are not clearly disclosed)? We must wonder whether each of the canonical authors also states that he has taken his knowledge from predecessors whom he has not met.

Nevertheless, the stated principles of Daoist love are clear: activation of the 'small heavenly orbit of energy', practice of a prolonged valley or inward orgasm, and fusion of the male and female orbit into one synergetic body. The targeted goal is also stated clearly: transformation of sexual energy into spiritual energy, i.e. using the very personal activity of sex for transpersonal ends, to create an immortal body. Do we glimpse here the meaning of the elixir of immortality which is often referred to in Chinese medical texts? Only vaguely, for it is never clear whether a classical Chinese allusion to immortality refers to "eternal continuation of physical existence, to a spiritual state of mind, or to access to the other world in this life or after death" (*Akahori*, 73). We must always ask, *what* immortal body?

The Role of High Sex, of Converting Orgasm into Ecstasy

The word 'Tantra' comes from a root which means to stretch or extend; a Tantra is a method for expanding consciousness. The esoteric practices of yoga and meditation, which for millenia have been known as Tantra, typically stress the unified polarity of male and female aspects. Contemporary exoteric interpretations in the West focus on the use of sexual ecstasy to achieve more transparent consciousness. This approach tends to be rather similar to the Daoistic love practices outlined above.

Margo Anand, believing that the complex ritual of Tantrism is unsuited to the modern West, set out to furnish "new and contemporary tools" for experiencing meditation via sexual ecstasy. On the basis of limited training in the classical Tantric tradition and other extensive practice, she developed "high sex", which she sees as a combination of sexology and humanistic and transpersonal psychology (*Anand*, 7). Like the Chia's reworkings of Daoism, Anand's reworking of Tantrism focuses on a three-step process to generate ecstatic states of consciousness.

The first step is to generate and maximize a "streaming reflex" within one's own body, as a particular energy to be used for orgasm. The goal of the techniques provided here is to experience that the origin of the energy for sexual pleasures lies nowhere but in your own body. The second step is to "awaken the ecstatic response" through techniques which integrate a state of absolute relaxation with that of extreme sexual excitement. The principle here, as in the Dao of Love, is to delay ordinary genital orgasmic release and allow an inward orgasm to take hold of the whole of the body over an extended period of time.

The third and final step in Anand's Tantric sequence is to "ride the wave of bliss" or "ride the tiger," either alone or with a partner. Done alone, this prolongs the streaming reflex of orgasm and slowly elevates one's vital energy from the sexual center at the lowest chakra, step by step to the crown chakra, in order to effect an "orgasm of the brain" (see figure on page 136 above). Done together, both persons' energies are moved upwards in synchronized harmony, and one is able to direct the orgasmic feeling to the crown center or practically any other part of the body. Ordinary genital orgasm is replaced by a drawn-out orgasmic ecstasy, and the two separate energy bundles of the partners are unified into a greater synergy (see figure on page 136 below).

Psychohydraulics, a term coined by Alan Watts, is an apt label for both the Daoist techniques of the Chias and the Tantrist techniques of Anand. Here the pumps are, of course, sex. The goal is sexual intercourse without the loss of any energy, or a kind of 'perpetuum mobile of orgasmic ecstasy' fed by one's own or both partners' sexual energy. How this practice can bring about a more transparent consciousness, which we should remember has no gender, remains a mystery.

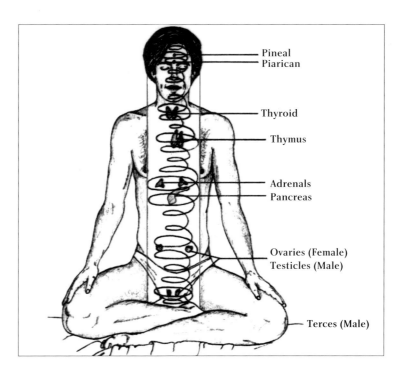

Pineal
Piarican

Thyroid

Thymus

Adrenals
Pancreas

Ovaries (Female)
Testicles (Male)

Terces (Male)

"Riding the Tiger Alone";
diagram of the hypothetical
spiraling of one's vital
energy from the lowest to
the highest chakra. Repro-
duced from Anand, The Art
of Sexual Ecstasy.

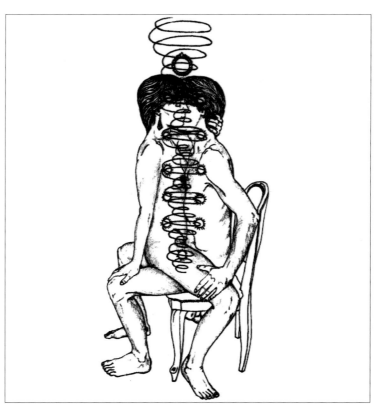

"Riding the Tiger Together";
diagram of the hypothetical
spiraling of both partners'
vital energy upwards during
a valley orgasm. Reproduced
from Anand, The Art of
Sexual Ecstasy.

The Silent Orgasm

The transmission and reinterpretation of the Tantric and Daoist secrets of lovemaking to the modern public is a noble endeavor, likely to bring happiness and fulfillment to many couples. However, I cannot accept the claims that the practices described imply genuine meditation, much less that they could lead to enlightenment or immortality (as Mantak Chia claims). The promised joy or bliss seems very likely to be a dualistic, content-laden state of consciousness.

Spiraling energy patterns and flowery chakra diagrams aside, what the above-cited books describe is nothing but the experience and the flow of sexual energy. Their techniques consist entirely of surface contacts and energy overlaps. Practitioners may be able to synchronize their material and energetic bodies, but the union remains physical. Efforts to achieve metaphysical union in this context would be in vain, since one has never been separate from anything anyway. Meditation would only start with the disappearance of not just the toys of subtle energy experience, but also the experiencer.

Tantric practices are far from easy, and the valley or inward orgasm can be degraded to a very manipulated phenomenon. At worst, lengthening the duration of sexual pleasure could turn into an exercise in egotism. Moreover, the practice could rob orgasm of an essential natural aspect—the explosive, holistic character by which all sense of duality is momentarily transcended. In sum, the control demanded by Tantric or Daoist practice, and the desire for certain states which is likely to be kindled, are the primary obstacles to meditation.

Afterwards, however long the Riding of the Wave of Bliss might be extended, there comes the point of separation of the partners and the return to ordinary consciousness. You come out of the *trip*. And then, what? Without a taste of meditation no transformation will have been achieved. Moreover, experiencing the chakras or the vital energy flow is by no means dependent on sexual arousal or a manipulated orgasm.

I do not doubt that the techniques described in Tantric or Daoist sources could be employed to trigger transpersonal or completely transparent states of consciousness. Unfortunately, through a defect of vision which may arise from social conditioning, the contemporary restatements of these techniques point in the wrong direction: the direction of intensified arousal, retained

semen, and prolonged orgasm. It is all just sex, however refined. I have never heard of anyone becoming enlightened through the practice of extended orgasm alone. Sex has to be transcended, and this even in the simplest sense of *going beyond*. It is significant that none of the books I have found devotes more than a few lines to the moment when sex is transcended, when it is finished, that is, to the gap after orgasm.

Nearly all of the major religions have tried to suppress sex for one reason or another, mainly social ones. With so-called Tantric or Daoist love, it is not sex but orgasm which is suppressed, for a purportedly spiritual reason. Neither suppression serves the goal of fully experiencing the natural state, which is the goal of meditation. If there had been no religious suppression of sex in the first place, there would probably have been no Tantric or Daoist manipulation and perversion of sex either. Suppression and manipulation are just the two sides of an underlying unease (or disease) with nature as it really is.

Glancing back toward the origins of Tantric practice in India, a leading scholar notes, "Control of the seminal fluid is thought to entail control of all passions and the achievement of desirelessness—and of course this notion stems from the common Indian ascetical heritage which postulates that passions jeopardize the advance towards ecstasy. Loss of semen is a pervasive and ancient fear in Indian lore, and it is probably the core of the most powerful anxiety syndrome in Indian culture" (*Bharati*, 294).

The key feature of Tantra is in fact *control*. 'Prevention of seminal emission' is one of a triple set of controls to be exercised by the Tantrika, preceded by the *control of breath* and followed by the *control of mind* so that it does not attach to any inner or outer object. But as long as there is control, there must be a controller, and the duality between controller and controlled remains. How many of us am I? The ego that is supposed to be dissolved has slipped in the back door, for it must be present to exert control if coitus reservatus is practised in any form. Even the slightest experience of meditation brings one to accept that "life is always out of control, the control of the self" (*Feuerstein*, 1990, 226).

One of the oldest treatise on the Tantric tradition is the *Vigyana Bhairava Tantra* ('The technique of knowing one's ultimate reality'), which sets out the 112 classical Indian methods of medi-

tation. The technique used by the Buddha to reach enlightenment is but one of them. Although countless volumes of interpretation have been published, the text itself is very concise, perhaps fifteen printed pages. It is delivered in a very Tantric context: Parvati, the consort of Siva, sits on his lap and asks him to tell her his essential nature. He does not answer directly, but instead tells her 112 ways to find out, to identify herself with bhairava or ultimate reality. The knowledge is probably far older than the earliest surviving edition, from the ninth century.

This encyclopedia lists three methods which directly concern the transformation of the sex act into meditation. I prefer Paul Reps' poetic translation to the probably more exact but very involved scholarly rendering by Singh.

"At the start of sexual union keep attentive
on the fire in the beginning,and,so continuing,
avoid the embers in the end.
When in such embrace your senses are shaken
as leaves, enter this shaking.
Even remembering union,without the embrace,
the transformation." (*Reps,* 166—7)

The first stanza recommends what has been detailed in the Tantric and Daoist practices: do not rush to the end of sex, orgasm; prevent ejaculation, ride the wave as long as possible; do not throw your energy out, form a synergetic circle with your partner in which "each is both," as Alan Watts once expressed it.

The second stanza advises total abandonment to the sex act, the loss of all control. Allow the shaking of your bodies to the point where every cell of each body joins in a dance which involves the cosmos as a whole.

The third stanza suggests that you can also enter this larger energy cycle or cosmic dance alone, once you have tasted it with a partner. Then you are in union with the universe directly, not via the catalyst of a partner; internally you have always been both together, male and female, yin and yang. Then you are freed from the bondage to a partner. Since the joy of unity-consciousness can be realized without a sexual partner, it must be a joy innate to you and not dependent on an external source such as intercourse. (The same truth is expressed in visual terms by Ardhanarisvara, a form of Siva as arch-androgyny, with the right side of his body painted or sculpted as male, and the left as female.)

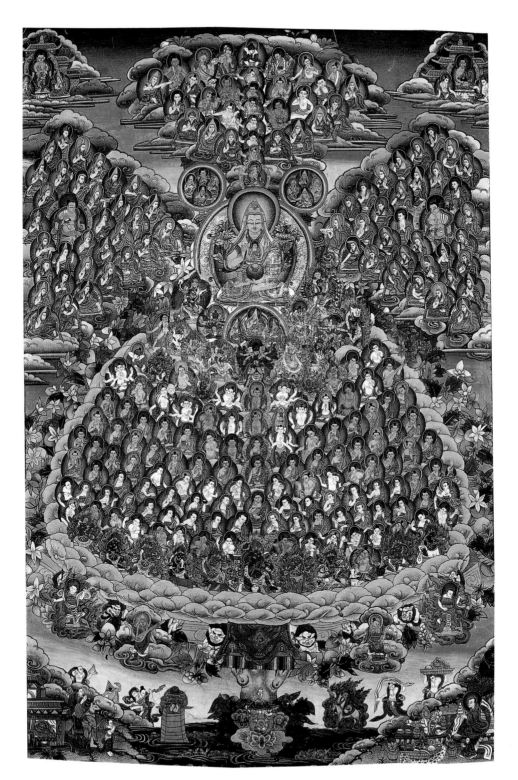

Buddhas
Assembly of Buddhas in the form of a tree (48 x 73 cm)

All control over physical practices and all desire for meditation have to be transcended. One cannot control and desire meditation. Meditation is much larger than oneself. Control and desire as such are the obstacles.

I hope I can be forgiven for quoting to Margo Anand from her own master: "If you are experiencing something, then I will not say it is meditation. It is still contemplation; it is still thought process. However subtle, it is still thinking … Meditation means cessation of the mind-totally; but not of consciousness, because if consciousness also ceases you are not in meditation, but in deep sleep. That is the difference between deep sleep and meditation … How to be mindlessly conscious,that is meditation" (*Rajneesh, Dynamics of Meditation,* 1972, 228). The original purpose of this book was to add another technique of meditation to those which were known in ancient India, even at the risk of damnation for disrupting sacred Hindu numerology. This 113th method of meditation also uses sex, but in a manner different from Siva's suggestions, and different also from the methods suggested by the Tantric and Daoist paths.

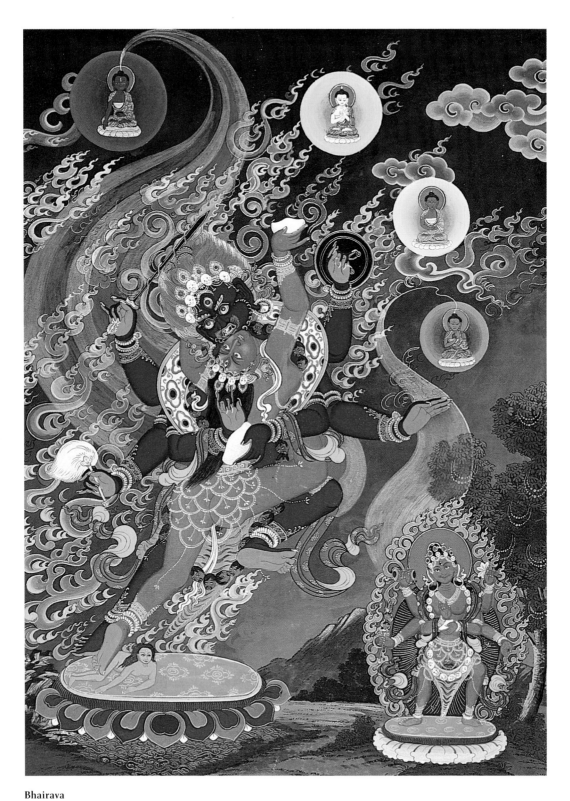

Bhairava
Terrifying form of Siva, with his female consort, in pose of sexual union analogous to Hindu Siva-Sakti; Newari thangka of 1989 (36 x 49 cm)

Silent Orgasm: Hunting and Orgasm Technique Combined

Polarity of Orgasm and the Gap after

The Technique:

The technique of transpersonal or mandalic sex is so simple that to me it is a mystery that it has not been reported by any of the modern or ancient Tantric or Daoist 'masters' of love. I state it at the outset in poetic form, imitating the Reps' version of the Vigyana Bhairava Tantra, for it should stand as a 113th method of meditation:

> Make love to exhaustion, explode,
>
> then enter the gap and be aware—
>
> revelation!

We noted at the end of Chapter Four that the basic principle of transpersonal meditative therapies is dialectic: in order to trigger utmost relaxation, silence and stillness, a state of choiceless awareness and non-judgmental acceptance, one is first thrown into physical hyperactivity, hyperventilation or deep catharsis. Generally speaking it holds true that the bigger the front, the bigger the back: the more you exhaust yourself at the active pole, the deeper you can go into silence and stillness at the passive pole.

The sex used here as a meditative technique likewise consists of two consecutive phases of equal importance—the active doer, followed by the passive observer. At the same time, this is a combination of the orgasm paradigm, using orgasm in the ordinary sense at the active pole, and the hunting paradigm, using the gap of peaceful silence at the passive pole.

In the first phase, by all means use all the preparatory rites and niceties you can learn from the ancient masters, but with one great difference: do not suppress orgasm at the end. The retention of semen, so urgently suggested by the Daoists and Tantrikas, at best will just not deplete your physical energy so much; but for this small physical advantage you are sacrificing a vital metaphysical potential of the sexual act: you do not enter meditation. You hold back from exhaustion, you stay in control.

It is understandable that one does not want to disappear in complete abandonment to orgasm, but that is exactly what is required in mandalic sex. As stated earlier, any meditation technique is an artificial death experience, of course death not of the body but of the ego. What method could be more?

To make the first phase even more powerful the partners can initially go into holotropic breathing for a long while, separately, without touching, then together by joining their bodies in any way erotic drives demand. I strongly feel that the less one relies on positions learned from instruction manuals or Tantra groups, the better; for these positions advertised in books are gross generalizations or reductionist models at best. Each human being is unique in his or her history and needs. Quit control! If anything can be your guide, then it is not previous knowledge which only takes you into the past and into your mind, but the unpremeditated cues from your partner's body: where it wants to be touched, what position it wants to go into, how long it wants to maintain a situation. Be totally in the here-and-now, and finally abandon your self completely to orgasm. Complete letting-go and surrender of any control is a precondition for any healing or transforming effect of mandalic love.

The most striking characteristics of manuals of lovemaking, from the Kama Sutra on, are their utter lack of fantasy and their insistence on keeping subtle control over body and mind. In comparison with the endless variety of culinary delights we have invented all over the globe to transform mere food into savory meals, the number of coital rites and variations invented and documented is surprisingly small. The outstanding exception is the imagination, artistry and variety of *shunga* (literally spring paintings), the erotic subgroup of the Japanese *ukiyo-e* woodcut prints of the Edo era (17th to 19th centuries).

A variation on the first phase: if you start with holotropic breathing, sometimes neither of you might feel like going into active sex or orgasm. In that case, just slip directly into the second phase when you have exhausted yourself in breathing.

The second phase of mandalic sex, the gap after orgasm, is of equal importance and could easily be longer than the first. The partners agree beforehand who will be the meditator and who the guide. After orgasm the partners disengage and the meditator lays prone on his/her back with eyes closed, making an

effort to be absolutely passive and aware of what is happening inside and outside of him/herself. The feeling is similar to that after holotropic breathing in primal therapy: the meditator is in a trance-like state, fully relaxed and passive, there is nothing left to do. You are just a watcher of whatever comes up from your usually dormant personal or transpersonal consciousness, but you are present enough to communicate your visions to your guide. View these inner visions passively, the way you must view an afterimage, for the more eagerly you grasp or seek, the more quickly it vanishes. Remain as passive and non-judgmental as you possibly can.

The guide relaxes by the partner's head, and when rapid eye movements are seen under the eyelids of the meditator, gently asks where he or she is, how he feels, etc. All this is done very slowly, lovingly, patiently, and without any pressure. Here the guide can practice real empathy and love for the partner. If love is total, it may even be possible to read the partner's mind and actually see the visions when they are described.

If nothing comes up, just accept and enjoy the emptiness and silence of your mind, of your whole self and of everything. The more often you do this meditation, the more this emptiness and silence will become familiar to you and will settle in you; one day you will feel it as being always present even in your everyday activities and noise. This is it. This is you.

I call this meditation *transpersonal* because it allows access to transpersonal levels of consciousness, it allows you to transcend yourself as a person. I call it *mandalic* because it has the potential to make consciousness so transparent that you become whole, that you consciously are what you have always been. Like meditating on a mandala, it is a technique for reintegrating the self with the whole.

Part of the alchemy of this beautiful meditation is that both of the partners come out of it thoroughly refreshed. Depression or exhaustion is never a result of meditation. The more whole you are, the more energy will be available to you. Thus the time immediately after orgasm, which is usually referred to as 'postcoital depression' by modern sexologists and which haunts their books as a great problem, can be transformed into something very positive, into the most precious moment of life, a moment of meditation. The traditional Tantric means of avoiding postcoital de-

pression was just the opposite, namely to suppress the orgasmic peak experience and turn it into a valley experience. Indeed a valley orgasm does not lead to post-coital depression, but neither does it lead to meditation. I am for both the peak and the valley, each in its right time and place.

With this meditation your life will be penetrated by deep gratitude and love toward the person who has helped you to find yourself, far more than toward anyone who has simply given him/herself to you as your lover. You will be able to face the bitter-sweet truth that you can never become one with one particular person only. With the whole, however, you can. This happens only in the second orgasm of any one sexual union, the Silent Orgasm.

Case Studies:

Without much psychological interpretation, which is always merely a matter of the conscious mind occurring after all experience has been completed, I present three examples of what might come up in the gap of the Silent Orgasm during the early stages of practice. These three episodes were experienced and illustrated by the same woman, a Japanese person in her mid-twenties, on three different occasions. In later sessions she often experienced nothing, but simply disappeared into all-encompassing emptiness. She entered meditation.

Episode A (see figures on page 148—149):

The first thing the meditator communicates to me after entering the gap is "I am a tree". I asked her to stay with this feeling (Drawing 1). Her second statement is "There is a small baby in my roots, now it's walking away"(2). Suddenly two more trees appear in her vision, one with blossoms the other with none, and "They are friends"(3, 4).

A hole appears at the base of the trunk (5) and that hole in her roots becomes larger and larger. She is overcome with sadness (6). She complains about pains in her ankles; I gently massage them. She sees that she is cut just above the roots (7).

She feels a tremendous sensation of freedom and performs a dance around the stump of the tree (8). Finally, the three tree stems float and rotate around her own eyebrows(9).

After a pause and some more holotropic breathing at my sug-

gestion, a new scene comes up. She sees herself in a dark tunnel and she is afraid of the light at the end of the tunnel (10). Then the bespectacled face of a doctor appears in front of her, cutting her umbilical cord (11). Now the two big feet of her mother are visible in front of her face. She also notices the big eyes of her mother in the background, wide open, even though she had a feeling that she died (12). Then she is bathed by someone, but the big feet of her mother stay visible close by (13).

Episode B (see figures on page 150—151):
She says she is in her backbone and it is very dark and there is a block at the spot between the kidneys, the spot known in acupuncture as the Gate of Life. She suddenly sees herself buried underground, having become food for a tree (1).

The scene changes to a large mountain of soft golden color (2). She asks the mountain, "Who are you?" and the mountain replies: "You" (3). Now she sees the mountain from high above; there are green luscious trees in a crater on its top (4).

She now rises above the clouds (5). The clouds coagulate with the setting sun in the distance; she descends(6). Many birds appear below the clouds and on top of the mountain (7). She becomes a bird too, flying away with them (8).

The scene of the flying birds now changes into one of many human bodies flying towards a bright light She is one of them (9). Then the place where there was bright light contains a fetus with a big umbilical cord, outlined in gleaming light. Since there is no exit she becomes worried about how to get out. Miraculously, she is suddenly out (10). At the end the huge mountain turns up again, and says: "I am you." (13).

The first thing she says to me after she comes out of the trance and openes her eyes is: "My body is not mine. And my spirit is not my body."

Poona, Junde 1980

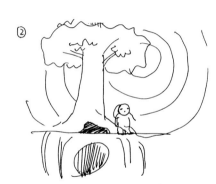

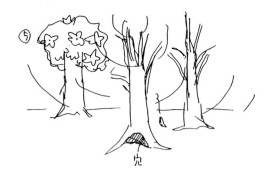

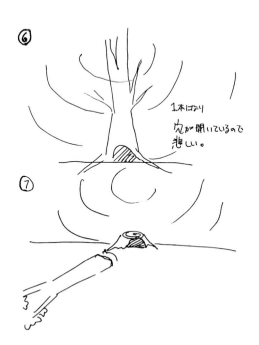

Episode A, sketched after mandalic sex therapy:
identification with a tree; birth-experience.

⑧

⑪

⑨ 3本の木が私のひたいっ所で
1本づつ まわっている.

⑫

⑩.

トンネル

⑬

Silent Orgasm: Hunting and Orgasm Technique Combined

149

Episode B, sketched after mandalic sex therapy: death experience; merging with bright light; perinatal womb experience.

⑦

*many birds
rise above
the clouds*

鳥が
おしよせてくる

⑨

明るい光

*all fly
towards the
light*

⑨' 人が たくさんあつまって 1つの 赤ん坊になる

Breathing

⑩

周りは明るい

光の中に赤ん坊
が入る

*only the
lines slimed*

⑧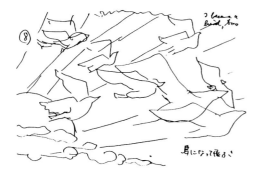

*I became a
bird, too*

鳥になって後を行く

⑪ 出れなくて悩む（出口が無い）

⑫ 出る

⑬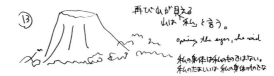

再び山が見える
山は「私」と言う。

opening the eyes, she said

私の象体は私のものではない。
私のたましいは私の身体のものかな

Episode C (see figures on page 153):

She is in a completely dark room with one bright window (1). Approaching the window she finds tree tops on the other side (2). She is sucked out of the window (3). She finds herself walking among trees (4), and along a tree-lined road (5). At the end of this road a huge white screen becomes visible (6). She flies towards it (7) and suddenly is in a clear bright light space (8).

Along the beach of a bay she sees a huge tower (9) which she enters and climbs (10). Having reached the top shejumpsdown (11). She vanishes into the earth and 'swims' through it (12). Slowly her body melts into water inside the earth (13). She is water (14).

The scene changes to a beach with a female figure walking along it. She feels she is that person (15). The sun rises and she separates from the figure (16) and then flies off towards the bright light of the sun on top of the clouds (17, 18).

1

IMPRINTING
Evolution, genetics, psychological experiences and even **smells** can trigger romantic reactions to another person. Scientists have recently found that animals may have an innate aesthetic sense and experience attraction.

2

ATTRACTION
The brain is revved up by **phenylethylamine** (PEA) and possibly the neurochemicals **dopamine** and **norepinephrine,** all natural amphetamines. These produce feelings of euphoria and elation. This stage can last for two to three years, then starts to wane.

3

ATTACHMENT
During this stage, larger amounts of **endorphins** (chemically similar to morphine) flow into the brain, leaving lovers with a sense of security, peace and calm.

"CUDDLE CHEMICAL"
The brain's pituitary gland secretes **oxytocin** ("the cuddle chemical"), which stimulates sensations during lovemaking and produces feelings of relaxed satisfaction and attachment.

TIME Chart by Nigel Holmes
Source: Helen Fisher, *Anatomy of Love*

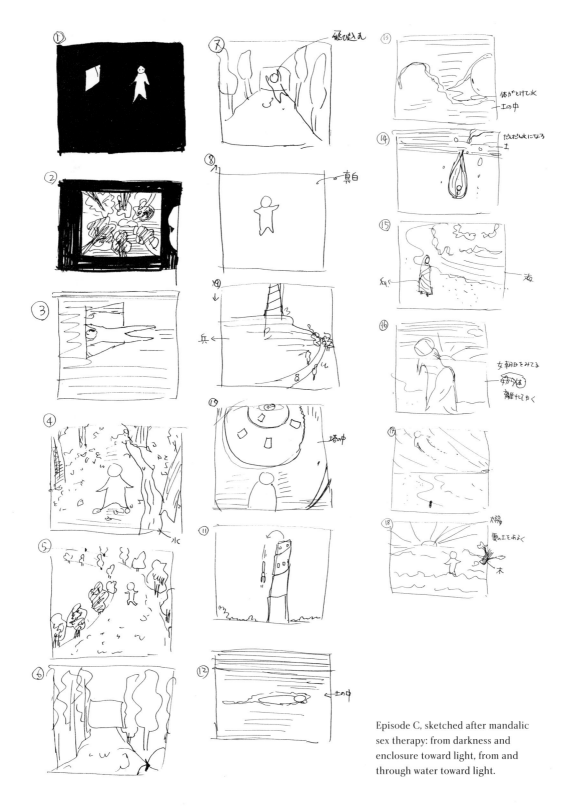

Episode C, sketched after mandalic sex therapy: from darkness and enclosure toward light, from and through water toward light.

Consequences

The fact that mandalic sex meditation has not been discovered before is probably due to an ancient defect of vision which has plagued Western psycholology and sexology, namely a preoccupation with endless analysis of the content of the mind rather than its transcendence. The mind itself is the disease, and that includes all subtle energy experiences. Meditation, no-mind, is the answer.

Mandalic sex meditation is not opposed to any normal sex practices in general nor to orgasm in particular. It is equally not opposed to what can be called *chemical love,* the love which just by the sheer force of natural attraction drives two persons to relieve themselves mutually, nor is it opposed to 'romantic love' which sublimates gross sex drives to a certain degree and transforms them into some aesthetic output. For what I mean when I speak of *chemical* or *romantic* love I refer the reader to a recent issue of Time Magazine International (Feb. 15, 1993) with its cover page title *The Chemistry of Love* and a major article on recent biochemical research on Love. These recent scientific insights explain romantic love, passion and sex as states triggered by naturally programmed and consecutively excreted intoxicating chemicals produced by the human body itself. See figures on page 152.

Mandalic Sex is also not opposed to the Daoistic or Tantric practices to enhance and prolong the joy of love-making. Mandalic sex includes and transcends all types of love-making. It includes love for purposes of reproduction, of emotional satisfaction and of meditation.

Mandalic sex meditation can also serve to release us from culturally encouraged pressures relating to sex, because it shifts the focus of attention away from skill or performance, as well as away from control or delay of orgasm. The focus is on the gap after orgasm, which is used for meditation. Any moment of meditation is *always* new, rejuvenating and energizing, whereas any sex technique is bound to become repetitive and thus boring with time. Mandalic sex may therefore be helpful in overcoming boredom in love relationships and dwindling attraction between married partners. In my experience mandalic sex meditation can be performed even without the partners being involved in the (ultimately temporary) intoxication of chemical, romantic or Tantric love. It can simply be used as a technique of meditation.

Mandalic sex meditation could be a natural extension of various transpersonal therapies, but there is the issue of ethics which would arise if it were to be practiced by a licensed professional. Basically, the rules of the established service professions preclude sexual engagement with patients. That is probably for the best, because when money and the mystique of the licensed healer are involved, meditation may not be well served. Meditation is everyone's birthright, and should not be exploited for commercial gain, much less monopolized by any profession, religious or medical. Furthermore, professional therapists tend to be so burdened by the preconceptions of their training that they know very little about the state of no-mind. On the other hand, absolute openness about the potential of mandalic sex meditation might prevent misunderstanding or misuse.

The leitmotif running through Feuerstein's *Holy Madness*, which contains a laborious scholarly synopsis of crazy wisdom masters of both the eastern and western kind, ancient and modern, is his constant preoccupation with the fact that certain enlightened masters might have in the past or may in the future abuse 'poor trusting disciples' sexually. He concedes, however, that enlightened masters are beyond morality and that their hazardous job is to lure their disciples out of their normal egotistic consensus reality, which includes the realm of morality. Yes, if you are attached to the ultimate sacred cow of physical sex so much, you can be exploited as in fact you constantly are by our film and advertizing industry. If you shift your attention from the physical sex act to the gap of meditation afterwards, the Silent Orgasm, no-one will be able to exploit you. To do this, you do not need a therapist or a guru.

The wonderful secret of meditation, as every meditator knows, is that it is a fountain of the most precious of all gifts this universe has to give: love. Love is even a yardstick by which progress in meditational practice can be measured. Love has always arisen out of meditation, but not necessarily out of sex, and most certainly not out of religion. Thousands of years of Judeo-Christian tradition have demonstrated that making love a law is futile, simply immature. Love is naturally present everywhere, and where it needs encouragement, it springs best from meditation. In mandalic sex, sex does not simply remain sex. It is transformed into the flower of meditation, which has the outwardly perceivable fragrance of love—love uncomplicated by lust or romance or control. This type of love carries the true feeling of life in its original unity.

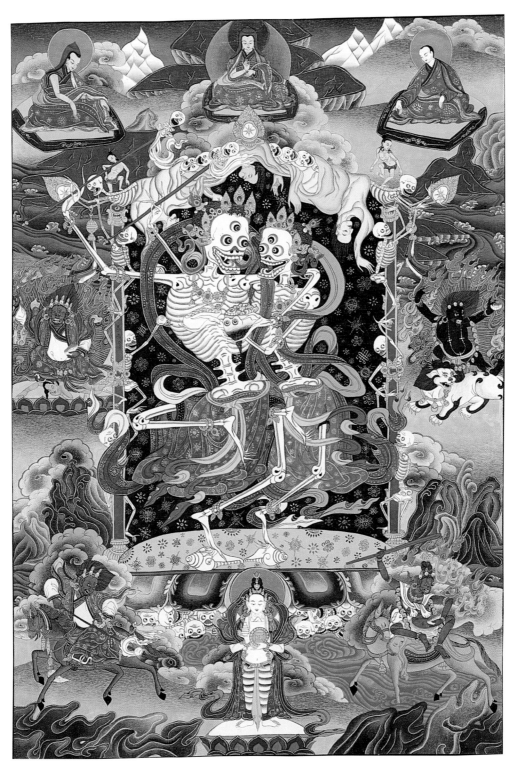

This image is often interpreted as the two demons of the charnel fields, the Citipati of Indian origin, portrayed as male and female skeletons in coition who dance on human corpses or, as here, on two shells in a cemetery. Sierksma identifies this icon as Yama, the Tibetan god of death, in a form known alternately as "the lord of the charnel fields brother-and-sister" and "the hero, the lord of the charnel fields conjoined with his female partner."

The Traditional Tantric Path

Scriptures and Arts

After my accidental discovery of mandalic sex meditation, I became curious as to whether this simple and powerful technique could not be found somewhere in Tantric literature or was not hinted at somewhere in Tantric art. Thus I ventured into a review of this vast topic.

The true approach to Tantra is to be initiated by a Tantric master and to practice sadhana meditation techniques under his or her guidance. The dedicated aspirant will search seriously for a master and, as an ancient Egyptian dictum reminds us, when the disciple is ready, the master appears. I was fortunate enough to have obtained some glimpses of Tantric wisdom with the invaluable assistance of a then-living master. However, the investigation in this chapter is not a direct reflection of practical experience.

A secondary means of benefitting from the Tantric path is to decipher and absorb the sayings transmitted by the flowers among the venerable masters of the Indian and Tibetan Tantric traditions. The works of such classical teachers as Tilopa, Marpa, Milarepa and Saraha, and texts such as the Vigyana Bhairava Tantra are readily available. It is important to be sure one has a correct translation of these beautiful texts, and it is very desirable to find commentary by an enlightened being; a scholar's commentary just kills these texts.

Of lesser efficacy is the study of scholarly treatises on Tantric ritual scripture, if possible in the original language. With this approach goes the caveat that a text does not necessarily contain the truth, even if it is old and written in Sanskrit. Tantra is ultimately based on personal experimentation, not belief in others. This chapter is in fact based on a scan of scholastic material, and on my own unguided observation of Tantric art.

Primary and secondary literature on Tantra has grown to such dimensions that Bharati, in 1965, estimated that a complete bibliography would run to seven hundred pages. I have found Bharati's authoritative one-volume summary of the basic teaching and main ritual practices of Tantra to be an excellent guide for

my purposes here: the search for a parallel to mandalic sex meditation in the Tantric canon; and an examination of how the custom of delaying orgasm and retaining semen slipped into traditional and modern Tantra, and whether such practice leads to the realization of meditation.

Difference between Tantric and Non-Tantric Hinduism and Buddhism

Hinduism and Buddhism originally contained nothing comparable to *philosophy* of the Western tradition, that is, the clarification of existential questions by the mind only. The closest Sanskrit word to *philosophy* is *darshan,* which means 'seeing' in the sense of direct insight and experience of one's reality by the whole psychosystem, not the mind only. Since ancient times Hinduism and Buddhism have always rejected the duality between the seer and the seen, the subject and the object, which is characteristic of Western philosophy.

Struggling with this difference, Bharati suggests the rather laborious compound *psycho-experimental speculation* for what otherwise might be called Tantric philosophy. In fact, non-Tantric as well as Tantric forms of Hinduism and Buddhism rely strongly upon a psycho-experimental rather than a mental-speculative or *philosophical* approach to reality. Their common source of insight is *sadhana,* spiritual exercise, and that includes both ritual and meditation, separately or in combination. What distinguishes the Tantric from the non-Tantric paths is the types of sadhana. As Bharati puts it, there is "no difference between Tantric and non-Tantric philosophy, as speculative eclecticism is pervasive; there is all the difference in the practical, the *sadhana* part of Tantrism" (*Bharati,* 17).

Nevertheless, Tantric and non-Tantric sadhana, both Hindu and Buddhist, share a single goal based on certain fundamental beliefs. The two key features of the common belief structure are the acceptance of some permanent absolute underlying the phenomenal universe; and the acceptance of reincarnation, including the possibility of its transcendence. The ultimate goal of all of the sadhana is liberation from the cycle of birth-death-rebirth.

It is unclear which arose first, Hindu Tantra or Buddhist Tantra; what is sure is that they have amply borrowed from each other over time.

Equation of Cosmic Biunity, of 'Siva and Sakti' with Human Biunity, of Male and Female

The world view of Tantrism is absolutely holistic. According to Bharati, the speculations of all tantric teachers have revolved around "the identity of the pheonomenal and the absolute world", an esoteric doctrine common to Hinduism and Mahayana Buddhism. He adds that "the doctrinary discrepancies between the various schools of speculative thought are *really* resolved in Tantric *sadhana*" (*Bharati,* 18). For the Tantric adept, the purpose of all sadhana is the wish to experience, to consume the unity of opposites of the phenomenal and real worlds; and not to think or speculate *about* such unity.

Reality may be one, but it is ordinarily experienced by the senses as a multitude of polarities. The quintessential polarity is defined as that between the active, creative energies and the passive, receptive energies in the universe. To illustrate this basic polarity, the Tantrists chose man and woman, or by speculative extension, a god and a goddess. But which is which?

Strangely enough, Hindu and Buddhist Tantrism developed opposite ascriptions to the two poles of male and female. In the Buddhist Tantra of India and Tibet, the male pole is related to the principle of active power, and the female pole to that of passive consciousness. But in Hindu Tantra, the male is seen as passive and the female as active. Nevertheless, the unified field of the gender polarity is taken by both systems as a most effective way of indicating the absolute, although the absolute is non-dual and therefore defies direct description and communication.

The unified duality of Tantra seems to have roots in the oldest known metaphysical system of the Indian region, *samkhya,* which explains the entire universe in terms of two principles. These are nature (prakrti), which acts to make all things happen; and pure awareness (purusa), which witnesses but does not act, yet without which nature could not act. "Nothing can happen in *prakrti,* which is the repository of all actions, if *purusa* were not there" (*Bharati,* 204). Bharati, by the way, makes a convincing argument that it is because mother-goddess worship was pervasive in the pre-Aryan culture of India, that the dynamic principle of the universe became homologized with the feminine pole in Hinduism.

In Tantric Buddhism another union of opposites—nirvana—came to stand for the highest goal. According to the type of prac-

tice, nirvana is variously conceived as the inseperability of wisdom and method (*prajna* and *upaya*); of emptiness and compassion (*sunya* and *karuna*); or of bliss and emptiness. The homologizations of those qualities with male and female principles do not follow a central pattern; wisdom and method are seen respectively as feminine and masculine.

Another difference between Hindu and Buddhist Tantra, despite the many shared principles, is the Hindu focus upon the evolution of the universe (from the union of Shiva and Shakti). This is in contrast to the Tantric Buddhist focus on one's own involution or return to the original unborn unity of emptiness and compassion.

Tantric Ritual and Meditational Practice

A central feature of Tantric practice is *maithuna*—sexual intercourse in ritualized form, whether performed actually or metaphorically. The purpose is the experiential actualization of the union of the opposites which are invested in the male and female partners. There are differences in actual Hindu and Buddhist Tantric sadhana which are of importance to our search here for historical precursors of the mandalic sex meditation described in Chapter Six.

One main type of Tantric practice incorporates the consumption of five taboo elements, commonly those known in the Hindi vocabulary as "the five Ms"—liquor, fish, meat, parched beans (an aphrodisiac), and sexual union. There are so-called left-handed and right-handed paths of this practice. In the right-handed practice the five elements are less taboo: only vegetable substances are ingested, and sexual union is restricted to wedded spouses or performed metaphorically, perhaps using flowers as symbols.

Bharati details the various ritual actions performed in the preparatory and central practices of the left-handed school, based on the instructions in many different manuals. Preparatory rituals may include the chanting and repetition of mantras (sound sequences with or without meaning); ablutions; worship of and offerings to various deities; and the taking of hemp, apparently as an aphrodisiac with the effect timed for the climax of the sadhana. Practitioners also paint mandalas with rice powder on the ground, usually yantra designs based on the geometry of oppos-

ing, interpenetrating triangles, drawn with the apex downward to represent the female principle, or upward for the male principle (see figure on this page). The overlapping of the shapes helps to trigger an experience of the union or inseparability of the two basic cosmic principles, which is of course the ultimate purpose of Tantric practice. The adept may then use imagination to awaken and elevate the dormant kundalini power; this can be called a meditation on the inner mandala constituted by the cosmicised body, with the polarity of the lowest and highest chakras (corresponding to Shakti and Shiva).

In the central part of the practice, the participants form a circle, with the female seated to the right of each pair in the right-handed school, or to the left in the left-handed school. Mantras invoking Shiva and Shakti are chanted in order to ritually purify the physical and subtle bodies, and four of the five "Ms" are consumed to "keep up the thought of feeding the *kulakundalini* at the basic level of mentation" (*Bharati,* 261). Then actual sexual union (maithuna) may be performed in a special position, while mantras are chanted to further promote the sense of union between Shiva and Shakti as embodied by the two adepts.

At the climax we discover a key difference between Hindu and Buddhist Tantric postulates. While the Hindu allows ejaculation of semen, the Buddhist retains it and also uses breath and thought to practice an inward or valley orgasm, thus extending the duration of the union. Bharati explains, "The Buddhist tantric's concern is purely esoteric, his method experimental. He has no stake in the ritual per se, and the notion of sacrificial oblation and libation means little if anything to him. His preceptors taught the spiritual and magical potentiality of the control of breath, thought, and sperm, and the importance of their retention. For the Hindu, on the other hand, the notion of ritualistic sacrifice is all-important. In fact, the idea of sacrifice being at the base of every religious act has remained focal in Hinduism, though the interpretations have changed … The ritualistic ideal of the Hindu is abandoning, renouncing, giving up of all the ingredients used, at times including one's own life" (*Bharati,* 266).

The period immediately after orgasm is not mentioned in Tantric scripture, nor are there instructions for ritual behavior after the partners have disengaged, according to the encyclopedic surveys of Bharati, Mookerjee, Khanna or Sinha. The potential for

Line drawing of the Shri Yantra, representing the cosmos as the result of the union of male and female principles. The four downward-pointing triangles symbolizing Sakti power, and the five upward-pointing triangles symbolizing Siva power. They are contained by rings of lotus petals, and centered around the *bindu,* the primordial point symbolizing the ever present origin. A yantra uses abstract geometry only, without deity imagery. Reproduced from Tucci, *The Theory and Practice of the Mandala.*

The Traditional Tantric Path

meditation before and during the orgasm, either outward or inward, is the crux of the recorded traditional Tantric practices, as well as the contemporary reworkings covered in chapter five. The *gap* following orgasm seems to have been ignored.

Summary

It is worth noting that only a small portion of the didactic literature deals with the sexual pratices for which Tantrism has become famous (or infamous). Bharati measures it as seven percent. Some sixty percent of a Tantric text is likely to deal with mantras, ten percent with the making and use of mandalas, and ten percent with the worship of deities.

In keeping with the absolute holism of the Tantric world, the sadhana allow the adept to consume the universe in its fullness under a sort of controlled or laboratory condition. Tantra does not condemn anything. It specifically promotes indulgence in taboo substances and acts. One text says, "By that act by which the beings burn in terrible hell for 100 million kalpas, by that very deed the yogi is released" (*Bharati,* 301, n. 9). Thus the Tantric vision implies that one should explore one's senses to the utmost, and not repress them. In this framework, *yoga,* or spiritual discipline, and *bhoga,* or indulgence in sensory pleasure, if done consciously, can lead to the same goal, which is meditation.

Many of the steps in Tantric ritual include disciplinary features which resemble the ascetic practices of *hatha yoga,* another ancient Indian school of meditation. The training to control mind, breath, and the flow of semen, like any other control by the ego over natural forces, falls within the realm of yoga. The question which arises here is whether yogic training is a prerequisite to Tantric practice.

Yoga demands an ascetic lifestyle; it centers around strict discipline, indeed, suppression, naturally with awareness, to achieve the desired sense of union. Yoga is practiced in solitude and celibacy, it is the path of the warrior, and the path trod by the Buddha. The literal meaning of *yoga* is *union.* If there is something to be unified, then yoga must hypothesize a split in the human condition which can and should be overcome and healed.

Tantra, on the other hand, accepts any lifestyle; it centers around a deep acceptance of, indeed, indulgence in anything, naturally also here, with awareness. Tantra is a compound of *tan,*

meaning *to stretch, to make transparent,* and the *krt* suffix indicating *instrumentality;* thus it literally denotes the technique of expansion or clarification. It can be practiced at any moment, anywhere, hence the assumption that it can be practiced in the sex act, too. Tantra is the path of the lover. It *begins* from thinking in terms of unity, wholeness. For Tantra everything is holy, even liquor. Samsara, the phenomenal world, and nirvana, the world as seen by the enlightened, are accepted as basically identical.

Both paths have a common goal, *moksa,* final liberation from the bondage of the cycle of birth and death. Yet the methods differ, and they tend to attract persons with different physical and psychological predispositions. Yoga appeals more to the relatively masculine, aggressive type, Tantra to the more feminine, passive type. Yoga is really a path of effort, Tantra of letting go. Conceptually and in terms of practice, the path of Tantra starts where the path of yoga leaves off. "The highest peak of Yoga is the beginning of Tantra—and Tantra leads you to the ultimate goal. Yoga can prepare you for Tantra, that is all, because the final thing is to be effortless, 'loose and natural'" (*Rajneesh,* 1979, 18). Indeed, the vision laid down at the opening of one of the highest texts of Trantrism is this:

> The Void needs no reliance,
> Mahamudra rests on nought.
> Without making an effort,
> but remaining loose and natural,
> one can break the yoke,
> thus gaining Liberation.
> *Tilopa, Song of Mahamudra*

From the earlier references to some procedures of Tantric sadhana, or spiritual exercise, one receives an unavoidable impression of discipline, ritual and practice, and very little sense of being loose and natural. That which is natural should not call for much practice. In short, sadhana as they are presented in Tantric literature seem predominantly ritualistic.

Each identification with a deity, each concentration upon a mantra, each visualization of a mandala represents human psychic forces and cosmic energies for the adept and is thus a tool for achieving spiritual ends including, we may assume, meditation. Yet it must not be forgotten that these endeavors still belong to the realm of form or mentation, of consciousness with content,

however subtle. The question which arises is whether these ritual practices can and do ultimately lead to the state of meditation, the point where all structure has to be left behind and the opposition of experiencer and experienced is completely overcome. I am left with some doubt. Certainly there must be some degree of effort and structure in any meditation technique. Those which I categorize as transpersonal therapy in Chapter Four, for example, are combinations of utmost effort and complete letting-go. I wonder where in the traditional Tantric sadhana the space for the letting-go phase is, in which consciousness might finally become transparent.

Having been with an enlightened human being for several years who worked as a master, I have seen firsthand that the most efficacious sort of guidance requires virtually no ritual based on previous religious belief or tradition. There may be other genuine masters who utilize a great deal of ritual, but I suspect that it is not central to the spiritual transmission. While the meditation techniques designed or transmitted by the master do have structure, this structure is utilized only to trigger the ultimate experience of meditation which has no structure. My sense is that 'spiritual rituals' arise when the direct guidance of a living master in meditation is not available. At a later stage ritual becomes self-fulfilling, in that it is no longer understood as simply a functional tool for meditation. This holds true for all ritual performed by a long-established religion. Eventually the performance of ritual may even be dropped altogether in favor of scholastic analysis and debate about its structure and meaning. Such studies fill libraries and propel innumerable symposia on the 'science' of religion.

Patanjali presented a precise definition of meditation in the opening lines of the Yoga Sutra (the basic text of all yoga practice):

Now the discipline of Yoga.
Yoga is the cessation of mind.
Then the witness is established in itself.
In the other states there is identification
with the modifications of the mind.

This is Osho's translation. Vivekananda renders the crucial second line, *yogas cittavrttis nirodha*, as "Yoga is restraining the mind-stuff from taking various forms." Bharati reads it as "the reversion

The Silent Orgasm

of the object-directed tendency of the mind." There are many ways to almost-say it. What is clear is that yoga (read meditation if you will) is not chanting or visualization, not any ritual or sadhana, spiritual or otherwise.

It should be emphasized again that this *cessation of the mind* can happen in so many ways without any effort. For it happens only when all effort or control is transcended, when there is no interference by you with any learned method. It can be triggered by the breaking of a pail, as with the nun Chiyono, or the splash of a frog jumping into a pond (Zen specializes in recording such unplanned moments).

Two years ago during spring I began to watch the blue irises budding slowly in my front garden. They faced away from the door, toward the morning sun. Each morning I would enjoy these signs of fresh life as I left for work. I even speculated over breakfast about how far they had grown overnight. But one morning I woke up with my mind cluttered by plans and expectations for the day. I had forgotten about the irises altogether. I opened the door to leave, and wow!—there they stood in full bloom, facing me frontally. My mind just stopped. It was not that I felt they were beautiful. I did not feel anything. I disappeared entirely as an experiencer, as a feeler, and the irises had disappeared, too. Not a single thing was left, and yet not a single thing had disappeared. There was only awareness without thinking, an empty awareness.

The flash of transcendence may well appear during a ritual practice, Tantric, sexual or otherwise. Though, I can state from my limited experience that there is no control involved. Unfortunately, the traditional Tantric rituals, at least when viewed through the third-hand method of published translations, seem dominated by the shadow of control. So too do the modern versions.

Fertility Magic and/or Spiritual Eroticism

Tantra in Art
Existence conceived in knowledge of its non-existence

Images and iconography are an integral part of most of the practices by which the Tantric adept moves toward the ideal of total experiential loss of the self and integration into the One. Having reviewed some of the literature of Hindu and Buddhist Tantrism, let us continue the search for intimations of mandalic sex meditation in the Tantric art traditions of India, Nepal and Tibet. Rather than a scholarly survey of the iconography jungle or the

historical complexities of Tantric art, this section discusses only a few examples which have been selected for their expressiveness and their relevance to our main theme.

Siva Lingam, Symbol of Creativity

It may surprise some readers that the most ubiquitous religious monument in India, almost as pervasive as the cross in Europe, is an erect phallus standing in a vulva, carved from stone in a more or less stylized manner. The Siva lingam might also be compared to the cross in terms of its power as a religious symbol. It represents procreation, which is connected not only to birth and love, but also, in the context of Hindu reincarnation belief, to death. These themes, birth, love, death, as we have stated before, provide the most essential points of departure for meditation.

Since prehistoric times in India the conjunction of Siva and Sakti, of consciousness and nature, has been visually represented and worshiped in the form of the *lingam* and *yoni,* the male and female sex organs unified as a sculpture. Saivism retains the symbol today, and it may be found almost anywhere, under trees, at street crossings, at riverbanks, as well as in the inmost cella of the Saiva Hindu temple. The symbol dates back to early magical structures of human consciousness which simply represented and then worshipped mysterious processes in the human being, in this case procreation. Later, the organs of human procreation, somewhat as pars pro toto, came to symbolize cosmic creation, too (see figures on page 167).

In Saivism the male Siva-lingam was homologized with the principle of formless consciousness, and the female Sakti-yoni with the principle of kinetic forces of nature, or the material substratum of the universe. One can hardly imagine a clearer visual symbol than the lingam-yoni icon, which has been called "the non-dual yet dyadic nature of the reality of Siva" (*Muller-Ortega,* 238). It points also to another paradox which is of great import for Tantric sadhana, namely that of a *continuous cosmogony* and of a *continuous return* to the original unity, or in other words, the simultaneous expansion and contraction of the cosmos. The unified male and female reproductive organs point towards individual creation and by extension to cosmic evolution as a whole. At the same time the two-as-one icon equally expresses the contrary desire of the adept to be reabsorbed into an original

Siva lingam seen against the Hindu temples of Khajuraho, presenting the impression of a man-made mountain from outside, or of a cave from inside.

Siva lingam near Agra.

unity, and by extension the reabsorbtion of the cosmic *multiverse* into a *universe*.

To enter Saivist speculation somewhat more deeply, Muller-Ortega in his remarkable essay on Tantric meditation employs concepts developed by the contemporary physicist David Bohm as an interpretive tool to throw some light on the non-dualistic worldview of Kashmiri Saivism. Bohm's model of the universe based on the concept of holomovement is outlined in Chapter Three within the holographic model of consciousness.

Speaking of the "metavibratory Heart of Siva", Muller-Ortega states: "If we were to adopt Bohm's vocabulary at this point, we might say that Siva is the holomovement, the undefinable and im-measurable universal flux. The Heart is the implicate order in which everything is enfolded into everything. Present within is the *visarga-sakti,* the continuous urge toward manifestation, to-ward the unfolding or explication of the infinite potentialities harbored within Siva. This gives rise to a series of explicate orders known as *kulas,* Embodied Cosmos, relatively autonomous struc-tures that nevertheless are marked or sealed by the implicate order within them. Importantly, the Emissional Power also is the continuous movement by which all of the *kulas* are continuously subsumed back into Siva" (*Muller-Ortega,* 234). He echoes Bohm directly when he says, "Each of the *kulas,* each explicate reality,

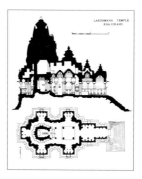

Plan and section of the Lak-shamana Temple in Khaju-raho, presenting the impres-sion of a man-made moun-tain from outside, or of a cave from inside.

contains the entire implicate order, and thus all of the other *kulas* as well" (*ibid.*, 237).

The Tantric sadhaka seeks to reverse the movement towards ever greater multiplicity and expansion by ritual action, which is tantamount to "activation of the implicate order within the explicate structure of the body. As the *kundalini* activates the hidden metaprograms of wholeness within the body, the consciousness of the sadhaka merges with the holomovement, becomes that which moves in the Heart; that is, experientially replicates the implicate order" (*ibid.*, 238).

Let us return to the lingam-yoni, for it contains further mystery and little-noticed symbolism. I am indebted to the poet Gary Snyder for a sharp observation, which I heard him make during a reading, namely that this icon of sexual union is portrayed as if seen from the inside of the female body. For the human being that is a primordial, forgotten viewpoint. Reality is presented inside out, as it were. How can we know whether it developed for sculptural or for symbolic reasons, purposefully or accidentally? I have found no comments regarding this peculiarity of vision in studies of the subject. Though rare, if not unique in the history of religion and art, it seems to have escaped the notice of almost all scholars.

Erotic sculpture on the surface of the shikkrara or main tower of a Khajuraho temple.

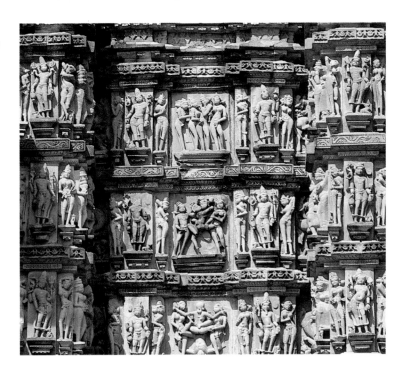

The Silent Orgasm

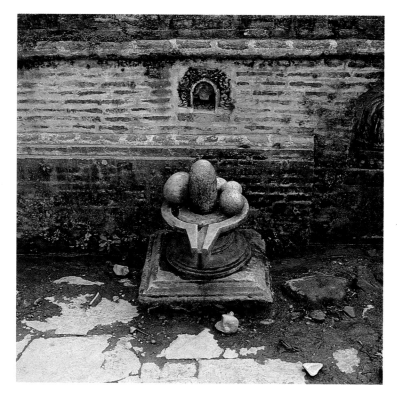

Siva lingam in a temple in Khajuraho (left).

Siva lingam in a temple on Mt. Abu, and at a well in the city of Patan, Nepal .

There is another surprising pecularity to this erotic sculpture, and that concerns its name: it is always blithely referred to as *siva lingam,* as if the *yoni* were not of equal physical and metaphysical import. Here we glimpse the suppression of the female that is so rampant in Hindu society.

The various paradoxes of the Saiva cult up to the age of Tantra are analyzed by O'Flaherty in her exhaustive study of Purana verses relating to Siva myths. The paradox of Siva as cosmic creator and destroyer is parallelled by that of ascetic Siva and erotic Siva, i.e. Siva seen as both the chaste patron deity of yoga and the sensual propounder of Tantra. These might simply echo the different facets of the apparent paradoxes of the human condition, such as birth and death, ecstasy and quiescence, fecundity and eroticism. Experientially, there is only one possible resolution, namely the transcendence of paradox by meditation. In the Hindu myths, however, these paradoxes reflect "the episodes in which ascetic and sexual impulses combine within an individual, each impulse allowed to develop the full expression of its power without impeding the expression of the contrasting impulse … These

The Traditional Tantric Path

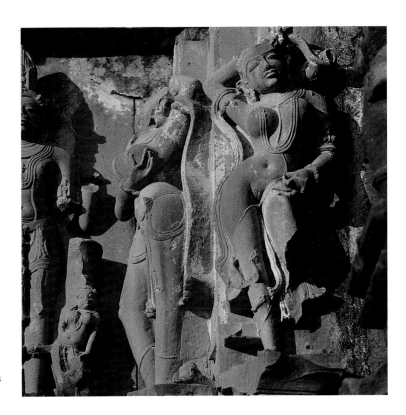

Erotic sculpture in the upper regions of the temples in Khajuraho.

fleeting moments of balance provide no solution to the paradox of the myth, for indeed Hindu mythology does not seek any true synthesis... The conflict is resolved not into a static icon but rather into the constant motion of the pendulum, whose animating force is the eternal paradox of the myths" (*O'Flaherty*, 317—318).

Later Tantric speculation and ritual grappling with the paradoxes of discipline and indulgence, control and release might well have roots in the earliest forms of Saiva myth and worship. Among the fruits are the myriad delightful episodes of Siva in his dual role of ascetic yogin and passionate lover; here we shall not indulge in the temptation to sample them. Suffice it to say that reading about the amorous adventures of Siva and his consorts, or the intrigues and fights of the gods surrounding him, one cannot help being reminded of similar stories in Greek or Japanese mythology, and coming to the conclusion that man made his gods in his own image and not the other way around. Surely these myths reflect nothing so much as the deep, often opposing structures of the human psyche and its quest to understand itself and the world around it in that age.

The Silent Orgasm

The Hindu Temple, Synthesis of Mountain and Cave

The architectural development of the north Indian temple reached its artistic climax in the 10th and 11th centuries, during the reign of the Chandela kings, in the period when Europe built its great Gothic cathedrals. The Hindu temples of the time were mostly dedicated to Siva. Some of the finest, and for our purposes the most interesting are the temples of Khajuraho, related to the Kaula and Kapalika cults of Saivism which centered around Siva-Sakti. Concerning these originally secret Tantric cults Pramod Chandra writes: "The aims of the Kaula adept and the Yogi are similar, and only the means adopted for the realization of that end are different. To the Kaula, the path is one of controlled enjoyment of the objects of the senses, for he realizes that in the ultimate analysis *yoga* and *bhoga* are one and the same thing. Various stages are postulated in the upward course of the spirit, the ultimate unity being achieved only in the last stage" (*Chandra*, 102).

Ritual partaking of the "five Ms," mentioned earlier, was part of the Kaula cult, as were orgies. Kapalika rituals were still more erotic and might even have included human sacrifice. Followers

The man-made cosmic mountain in the form of the northern Indian Hindu temple in Khajuraho from the 9th—10th century AD or of the southern Hindu temple as seen here at the Shore-Temple in Mahabalipuram from the 8th century.

believed "that deliverance lay in the unrestricted enjoyment of the senses, particularly women; for the Kapalika's ideal is 'to become incarnate in a form like that of Siva and enjoy the pleasures of love with a consort as beautiful as Parvati'" (*ibid.,* 104).

Given the Tantric roots, it is no surprise that the temples at Khajuraho are externally covered with erotic sculpture, which as it happens is of an artistic quality unequalled in architecture. Only on the lowest level do we find orgiastic scenes or copulation with animals; the higher rows of figures are mostly standing or engaged in complex sexual yogic asanas. The overall impression is not one of coarse fornification; the visitor instead feels that he is facing an elegant dance, a sensuous rite of spring (see figures on page 167 bottom and on page 168).

The Hindu temple as a whole can be understood as a synthesis of the archetypal forms of the mound and the cave, the result of the mass-creating and space-creating impulse of the human being. It can also be seen as synthesizing the pillar and the hut, the respective abodes of gods and humans, as I have analyzed it in a different context (*Nitschke,* 1993: 8—31).

From the outside, the north Indian temple has the shape of a mountain, the final stage of a formal development which started with the semi-global mounds of ancient stupas. Significantly enough, the tallest element of the structure is called *shikhara,* mountain peak. Entering this mountain of stones one ultimately ends up in a completely dark cella, called *garbha griha,* meaning *womb.* In Saiva temples this womb-space usually contains a stone lingam-yoni sculpture (see figure on page 167 bottom). Thus the temple as a whole symbolizes the play of Siva-Sakti as much as the individual sculptures which decorate its outside surface, while the sanctum sanctorum directly invokes this erotic play with the icon of the linked lingam and yoni.

The Tantric temple in Nepal, although basically a wooden structure, shows similar erotic symbolism with a lingam-yoni icon of stone in the inmost sanctum, and polychrome wooden sculptures around the outside depicting humans and deities in every kind of erotic asana. (An excellent account of Nepalese erotic temple sculpture is Tucci's *Rati-Lila.* Work of a similar scope or quality on the Tibetan temple is still missing.)

Divested of its theological and mythological superstructure, the Saiva temple and its central 'sacred' object are simply a fertil-

ity symbol of the type created by various early cultures. In Japan, there is the Tagata Shinto shrine near Nagoya where the 'deity's body' is a phallus, and the Ogata shrine nearby where it is a vulva. Each spring, enormous copies of these symbols are constructed and carried in a procession through the rice fields where they are consummated at the climax of the Honensai, the Festival for an Abundant Harvest. This is only one of many similar fertility rites still performed annually in Japan. The ritual genitalia are often made of rice straw or vegetables. See figures on page 179.

There is ample evidence that in ancient Japan such rites in spring and at harvest time incorporated actual as well as symbolic sex. People not only enjoyed a night of socially sanctioned promiscuity, but also believed that by some law of magic they could procure nature's fecundity at large by their own behavior and by the manipulation of man-made fertility images.

Fertility rites and symbols belong to the epoch of magical consciousness, the second epoch in the history of human evolution under the Gebser/Wilber model introduced in chapter three. That the ritual and symbolism survived up to the construction of Hindu temples in the 10th century, or even up to today, should

In external form both are related to the semi-global mounds of the oldest Indian stupas from the 3rd century BC, as they are still visible in Sanchi.

On the reliefs of the gates added to the stupa of Sanchi around 25 BC Buddha is still not portrayed in human form, but in the form of a tree symbolizing his enlightenment, in the form of the wheel of the doctrine pointing towards his first sermon, or else in the form of a stupa, representing his death.

not be taken as an indicator of their actual efficacy, but rather as evidence of a lack of integration of the magical structure of human consciousness into the historically succeeding ones—mythic, mental, and transparent—and consequently as a sign of retardation.

To recapitulate, the epoch of the magic (Gebser) or typhonic (Wilber) structure of consciousness is characterized by the first emergence of an awareness of a self distinct from nature. In that epoch man was basically oriented toward body and emotion and tended to worship natural idols through ritual. Anthropologists, led by Tyler and Frazer, have elaborated the modus operandi of the magical mind as following the two basic laws of *similarity* and *contagion.* The first law assumed that *like can produce like,* e.g. if one went into a frenzy of unrestricted sexual intercourse in early spring in the fields or the temples, nature would follow suit and produce ample crops. The relation between the reality of two Tantrikas making love and the idea, quoted earlier, that they have literally become Siva and Sakti, the very powers of cosmic creation, is nothing but a magical one. The belief is that what looks somewhat similar in its mode of operation is actually identical.

The Silent Orgasm

The second law of magic would hold, in our context, that by ritually touching and manipulating the lingam-yoni icon, which is believed to be empowered by the essence of cosmic Siva-Sakti power, the Tantrikas themselves will be imbued with cosmic power. In other words, to handle a specially carved piece of stone is to commune with and manipulate the forces it is meant to represent, forces of cosmic generation and destruction. All this is not said to condemn magic as a misperception of reality. It was the correct, and the only possible perception at an age when man still could not differentiate clearly between his body and the natural world, between the part and the whole, between a symbol and its referent; in other words, when similarity or contagion was accepted as identity.

It is not that Tantric ritual in medieval times was merely a set of magical rites, or that the associated sculpture and temples were only fertility symbols. Yet it does seem that a substantial part of the Tantrism of the time was still impregnated by the magical structure of consciousness. Even though Yogic and Tantric meditational elements in the Tantric ritual clearly belong to the transparent or integrated structure of consciousness, they were submerged in the magical layer.

There is a great difference between the sense of unity achieved by retrogression into a predifferentiated and more unconscious state of being, an immersion back into nature, and the sense of unity achievable by going into a super-conscious state which transcends duality and content, becoming fully aware. The former is easily brought about through the influence of alcohol or sexual license; the latter is the path of meditation.

Eliade, Tucci and Sinha recognized that, to a great extent, the formative force behind the prevalent erotic dimension of Hindu myth and ritual was the magical structure of human consciousness. Two thirds of Indra Sinha's recent *The Great Book of Tantra* are devoted to tracing Tantric practices back to their roots in earlier universal fertility cults. That fertlity magic at some point of history "kindled into gnosis" is what is fundamentally questioned in this book. Most other commentators have jumped on the bandwagon and celebrated Hindu Tantric ritual and art as expressions of erotic spiritualism; they assumed that at one time human sexuality had already successfully been used for spiritual ends, including ultimately meditation. It is probably from this

defective vision that claims arose that Tantric practices to trigger states of meditation could be replicated today, even by non-believers.

Eliade observed that the practice of "a sanctified sexual life reveals an experience that is no longer accessible in a desacralized society" (*Eliade* 1961, 172). Tantric ritual was based on body-cosmos homologies (like the chakras of yoga) and on sacramentalization of physiological processes (including sex) which are unknown to modern non-religious man. In this sense, talk of "the path of sacred sexuality for Western lovers" (the subtitle of a book by Anand Margo) seems to be a contradiction in terms, as well as anachronistic or at best wishful thinking.

In this age of the quest for an integrated or, as I call it, a transparent structure of consciousness, the distinction between sacred and profane ceases to have any validity. This age is marked by a return to the ordinary, the natural, but this time made absolutely transparent and no longer split into blocks which could be called sacred or profane, just as it would be inconceivable to divide nature into an inside and an outside.

The Hindu temple in its Nepalese transformation into wood: Durbar Square in Patan, Nepal, with the Krishna stone temple of 1723 in the foreground and the rest of the wooden Hindu temples in the back.

The Silent Orgasm

Durbar Square in Kath-
mandu, Nepal, with temple
dedicated to Narayan-
Vishnu from 1680.

Hierogamy and/or Unio Mystica

In order to discuss at least the most important themes and basic
symbolism appearing in Tibetan and Nepalese thangka-art, a
short description of the function of thangkas in Vajrayana Bud-
dhism might be of value with regard to our search for precursors
of the Silent Orgasm or Mandalic Sex Meditation.

Content and Function of Thangkas

Tibetan and Nepalese paintings with exoteric or esoteric content
are found as murals in temples and monasteries, as illustrations
in religious manuscripts, and on thangkas-paintings on cloth
which are typically hung on monastic or domestic altars for
ritual purposes, and can be rolled up for storage. With the
dispersion of Tibetans and Tibetan Buddhism in recent decades,
many ersatz thangkas painted for souvenir markets have become
available, mainly in Nepal. Genuine thangkas, with composition
supervised by Buddhist lamas, are still painted, and are used for
Vajrayana practice by Buddhists in Tibet, Nepal, India and other
countries.

The major influence on the figural presentation of Tibetan thangkas comes from the Indian artistic tradition, with some Nepalese stylization, whereas the presentation of nature clearly shows Chinese influence. According to Pal, no thangka has been dated earlier than the twelfth century.

The traditional functions of thangkas in Buddhist Tantrism include:

1. In rare cases they serve purely decorative purposes, hung on walls or pillars to create a sanctified athmosphere.

2. Thangkas have frequently functioned as a visual means for the transmission of the doctrine and history of Tibetan Buddhism, a quasi-scripture accessible to the mostly illiterate lay public. To this category of explanatory and narrative art belong pictorial biographies of Sakyamuni Buddha, representations of the famous acts and visions of Buddhist saints and records of the reincarnated lineage of the Dalai Lama and other prominent abbots.

3. Occasionally thangkas are newly commissioned for use in healing or funeral rituals or for a particular clerical ceremony. In these public ceremonial roles, the thangka has a somewhat magical function, being meant to induce health, longevity or a felicitous state in a future incarnation, and may even become an object of worship. In addition, in accord with Buddhist belief, the painter as well as the donor tries to reap some personal metaphysical merit from the devotional painting or donation of these thangkas.

4. Vajrayana practitioners use thangkas as tools for visualization; for identification with deities manifesting particular states of consciousness; and for meditation, in which those deities are transmuted into states of one's own consciousness where reality is ultimately void. Here the thangka functions as a mandala, a psycho- and cosmogram designed to support meditation.

The question of who actually created, not just painted, the anthropomorphic, theriomorphic or purely geometrical imagery on the various types of thankas is not answered in the literature on the subject. The images of some peaceful or terrifying deities are sometimes reported to have first been seen by some famous meditators of old in dreams or trancelike visions; then they became iconically fixed and were handed down as such by particular theological traditions. When it comes to the complex geometrical

compositions of mandalas, figurative or non-figurative, Giuseppe Tucci, the authority on Tibetan mandalas, holds the Jungian view that many meditators simultaneously had discovered similar patterns by "some mysterious intrinsic necessity of the human spirit". He says that "the Mandala born, thus, originally of an interior impulse became, in its turn, a support for meditation, an external instrument to provoke and to procure such visions in quiet concentration and meditation " (*Tucci* 1961, 37).

Before I introduce some examples of actual thangka art, the above basic logic behind many thangkas should be kept in mind. It is summarized by the repeated admonition in the Hevajra Tantra: "O Wise One, you should conceive of existence in knowledge of its non-existence and likewise you should conceive of Heruka in knowledge of his non-existence" (*Snellgrove*, 48). (Heruka is the deity of that Tantra.) Here again we encounter the inherently contradictory nature of any philosophical expression of the mystic experience, which to a great degree is also the theme of thangkas.

Explicit ferility rites in present-day Japan. *Honen-sai*, "Festival of Prayers for an Abundant Harvest", held annually on March 13 in two Shinto Shrines near Nagoya City: the 'deity's body' of the male deity in the Tagata Schrine is a phallus, that of the female deity in the Ogata Shrine a vulva. In the rite they are unified in the just opened rice paddies.

The examples of Nepalese and Tibetan thangkas to be discussed here are expressions of Vajrayana, an offshoot of Mahayana Buddhism. Vajrayana introduces a whole pantheon of deities which represent enlightened qualities of mind, with whom the practitioner identifies on the path to enlightenment. Often these deities are conceived of and represented as couples in sexual union and symbolize the masculine and feminine qualities of the enlightened mind. *Vajra* means *thunderbolt;* originally it was the divine weapon and emblem of the ancient Vedic god of the sky, Indra. In Vajrayana *vajra* came to mean *diamond* or *adamantine* and to signify the ultimately indestructible character of existence. Emptiness *(sunyata),* a term developed from the Mahayana concept of the void, is seen in Vajrayana as the immutable and transparent diamond nature of everything.

The concealed meaning of *vajra* in Tantric ritual was the male sexual organ in contrast to *padma,* (the lotus) which denoted the female one.

It might be correct to state that the central quest of Mahayana Buddhism for the experience of emptiness (sunyata) by detachment was replaced in Vajrayana by the quest for adamantine transparency *(vajra)* of consciousness by the transcendence of all polar opposites, that is, by the final abolition of all polar tension.

To comprehend what is transmitted by the iconography of Tantric Buddhism, it is important to grasp the polarity-in-unity which the images portray. According to Snellgrove, "It is this dominating notion of 'two-in-one' upon which the whole complicated structure of the tantras is reared … To understand it, one expects to meet with sexual symbolism at every turn, and this can only cease to be burdensome if one is able to see beyond the symbols to the ideas. The power and (in a sense) the profundity of these symbols is very great, for while on the one hand they refer intimately to the realm of sensual experience *(samsara),* they also indicate the two coefficients of mystical experience *(nirvana).* In fact these symbols indicate the identity of the one with the other, in a way in which no other symbols can possibly do. *Vajra* and *lotus* derive their whole significance from their masculine and feminine connotations" *(Snellgrove,* 24).

The symbolism of the *two-in-one* with its physical and psychological connotations includes the following elements.

Vajrayana Biunity
Physical homologies:

male	female
yogin	yogini
father:yab	mother:yum
(male sex organs)	(female sex organs)
diamond: vajra	lotus: padma
sun	moon

Psychological homologies:

dynamic principle	static principle
means: upaya	wisdom: prajna
compassion: karuna	emptiness: sunyata

The sun (Origin of Light) and moon (Reflection of Light) in nature function as prime symbols for the *unio mystica* in Hindu and Buddhist spirituality.

Tantra envisages enlightenment as the transcendence of these psychological polar pairs by direct practice of the physical union of yogin and yogini, or by their indirect symbolical union.

Having surveyed the general background of Tantra art, which Ajit Mookerjee called a visual metaphysics, let us examine the iconography of some particular thangkas which pertain to our subject.

The Traditional Tantric Path

The Kalacacra and Cacrasamvara Deities and the Yab-Yum Icon of Sexual Union

Kalacacra, translated as Wheel of Life, and Cacrasamvara, as Supreme Bliss, are the two great Tibetan guardian deities with the rank of Buddhas. In paintings they personify whole systems of Tantra with their own particular meditations for liberation. Both seem to have belonged to left-handed Tantra practices of the 10th century, thus using not only a female deity as consort of the male in the thangka symbol but also a yogini as life partner for actual ritual practice.

The content of a Kalachakra thangka is described by S. B. Dasgupta: "The Lord Kalacacra is saluted as of the nature of Sunyata and Karuna; in him there is the absence of the origination and destruction of the three worlds, he is the unity of knowledge and the known. The goddess Prajna, who is both with and without form, is embraced by him; bereft of origin and change, he is immutable bliss … he is the father of the Buddhas,—the ultimate original Buddha, the non-dual lord" (from An Introduction to Tantric Buddhism, quoted in Bharati, 222).

On thangkas the central deity is shown in full sexual union with his consort, their feet forcing another couple apart (see Figures on 183—185). The message is that a unio mystica, portrayed by the copulating deities, results in the undoing of ordinary consciousness which is dominated by passion and reproduction, symbolized here by the smaller procreating pair (representing ignorance and desire) being forcefully uncoupled. Because Tantra holds that " by passion the world is bound, by passion too it is released" (*Snellgrove*, 93), the carnal union of the sexes came not only to be used as symbol for the mystical union of the human psyche, but also—and this is the crux, the unique message of Tantra—as actual practice for its realization.

In other traditions, complete wholeness of consciousness has been successfully represented by less sexual symbols, such as the Chinese yin-yang emblem, the sri yantra of India with its interpenetrating triangles, or the sun and the moon. The efficacy of the Tibetan yab-yum icon in symbolizing the ideal goal of the path of Tantra is beyond question; but I have reservations about its efficacy in symbolizing the path to this goal. Sexual intercourse is suggested as the path, but the formalized, indeed standardized representation of yab-yum on thangkas gives no indi-

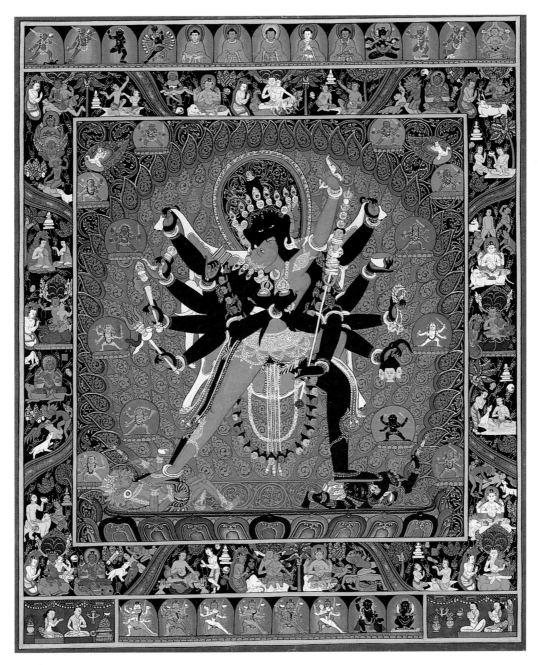

On the following pages: Newari and Tibetan Vajrayana thangkas (c. 1990) of the Kalacacra and Cacrasamvara type. The sexual union of a deity couple indicates human reintegration with the universe (41 x 50 cm)

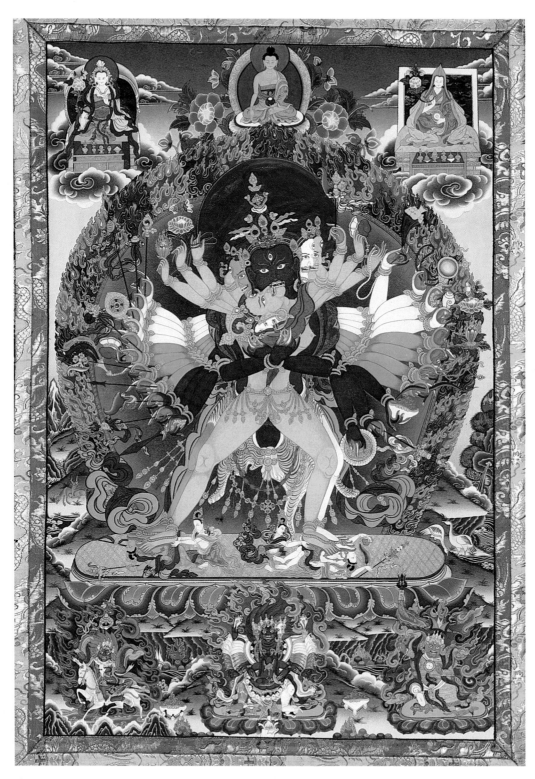

The sexual union of a deity couple indicates human reintegration with the universe (59 x 90 cm)

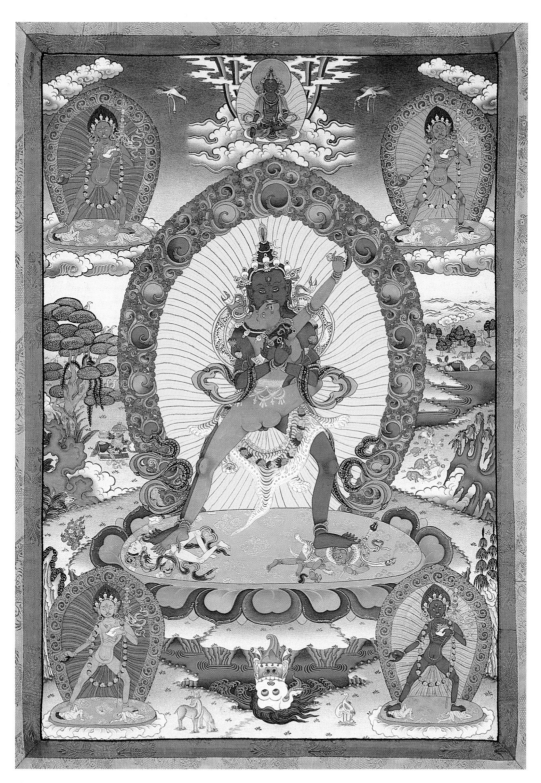

The sexual union of a deity couple indicates human reintegration with the universe (55 x 79 cm)

cation of how sexual union could trigger anything more than sensual pleasure or procreation, of how it could lead to enlightenment. Likewise there is no hint of such techniques as delayed orgasm or retention of semen, especially when the yab-yum partners are in sitting posture, where the active role seems to be played by the female.

Kalachacra-Cacrasamvara and other yab-yum icons have their paradigmatic model in the union of the divine couple Siva and Parvati of early Hindu myth. Divine marriage, or hierogamy, symbolizes the creation of the universe as a whole in various mythical traditions. For the religious mind of ancient times, any human marriage was valorized as an imitation of the first cosmic hierogamy. For us today, deities have never existed, and the paradigm of hierogamy is a reflection of the human procreative act.

Although the dynamic and static principles associated with the male and the female pole in Buddhist Tantra are reversed from those of early Hindu myth, their union still seems to constitute a divine hierogamy. The actual or symbolic sexual union of yogin and yogini in the Tantra ritual are in my view primarily an imitation of a first act of creation. The ritual relates in magical logic *(like produces like)* to creation as an *act of making the world,* in the sense of creating humans and all other beings and things. Then, with the evolution of human consciousness beyond purely magic or mythic logic, creation was equally seen as an *act of making oneself,* giving birth to one's own true nature, i.e. as becoming one with the universe. Only in the latter sense can we speak of a unio mystica which, as the thangkas portray, has the power of halting the normal process of procreation. Thus, the sexual union of the yab-yum icon may be interpreted both as a symbol of pro-creation, involving the aspirants' identification with a hierogamy, and as a symbol of self-creation, involving their carnal consummation, to achieve a reintegration with the whole.

It is very easy to imitate by ritual or to represent by painting a mythic paradigm, since there is no danger to the personal ego involved. It is very difficult indeed to achieve a mystical union with cosmic consciousness, for it is predicated on the disappearance of the ego. It is likewise easy to picture *techniques* of meditation on a painting, and close to impossible to portray the *content.*

Wrath and Death

Yama and Yami, God and Goddess of Death

A complex thangka iconography of wrathful deities was also developed, mainly to aid the practitioner in preparing to encounter them after death. In the Tibetan Book of the Dead it is stated that during the period of hallucinations the wrathful deities appear after the benign deities and that these visions are nothing but emanations of the individual's own consciousness, dulled by karma and unable to recognize its true nature as emptiness. Recognition of these deities as one's own thought-projections is the only medicine necessary for their dissolution.

Hence these terrifying gods have one source, an internal one, in the ego's thirst for life, in the clinging to the endless wheel of birth, death and rebirth called samsara; they originate from the attachment to form, from what Wilber calls the Atman Project. They are overcome by the dismemberment of the ego into empty transparent consciousness without content, into nirvana. Being 'blown out like a flame'—the literal translation of nirvana—is also called the Great Death, the death of the ego. This experience

Burning Ghat along the river Ganges in Benares: 24-hour meditation ground on the evanescence of all human form; just to die here is believed by Hindus to enable self-liberation.

of unbecoming will forever appear to the human being as the ultimate terrifying experience.

The wrathful deities may have an external origin, too. In the missionary conquest of East Asia, from Tibet to Japan and elsewhere, Buddhists always used the technique of accepting indigenous ancient gods and making them into special protectors of the new faith. When Tibet was converted to Buddhism, from the eighth century onwards, pictures of hell and of terrifying deities such as the Lord of Death were powerful tools to frighten the subjugated society and make it accept the new creed. In the succeeding era, it seems the Tibetans grew more and more afraid of their own gods. "Thus all Tibet tried to pacify their own fear and aggression in the never ending conciliation of the Terrifying Ones... The acculturatively dualist nature of Tibetan culture is impressively summarized by the Terrifying Ones in their double character of national gods and Buddhist protectors" (*Sierksma*, 161).

The ultimate in ferocity, aggressiveness and sexuality is the image of Yama, the God of Death, of ancient Indo-Aryan origin,

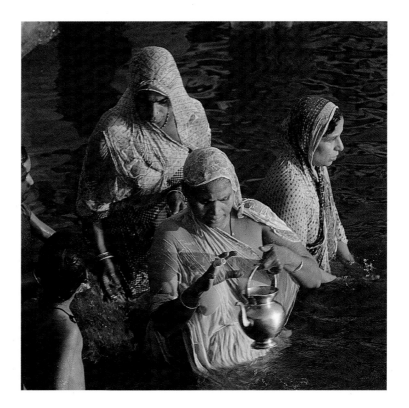

A daily morning ablution is taken as a step towards it.

The Silent Orgasm

whose alternate forms overlap with those of the Hindu god Siva. Naturally, for the lazy or the simple-minded it is easier to try to influence one's karma by praying to Yama, who is the ultimate judge over it, than to change it oneself by meditation. Yama is painted on thangkas in human form, colored black, red, or dark blue, with the head of a bull decorated with a garland of skulls. He stands naked with an erect sexual organ, astride a male buffalo, and often holds a club in one hand as a sign of judicial authority. Sometimes his twin sister Yami rides on one of his legs, in the ancient Indian manner of depicting a consort; there are no thangkas showing Yama and Yami in the more peaceful yab-yum posture.

The bull beneath the feet of Yama is shown copulating with a prone female partner. Sierksma interprets the tableau as "the god of death, perhaps too in his role of first man (as once in India!), treading down the primordial parents who started the wheel of life, and are as it were responsible for the endless chain of rebirth since then. Here Yama is death who is clearly present in life at the instant of its inception" (*ibid.*, 216). Since the primordial couple is still copulating, the message of the icon could be that yoga performed alone or with the yogini, but without complete physical union, cannot break the wheel of birth and death.

There are, however, bronze statues of Yama and Yami in full sexual union, and in this case the lower couple is separated by Yama's two feet. "Their separation through the union of god and goddess means the ending of the senseless proceation of sensory illusions" (*ibid.*, 229). This statuary form symbolizes a unio mystica, as in pictures of Kalacakra and Cacrasamvara.

As with Kalacakra and Cacrasamvara, the icon of Yama and Yami—in sexual union or not, riding a bull who is or is not in sexual union with a woman—can be read in two ways: in the magico-mythical sense that the act of procreation is an imitation of a first primordial couple in the process of cosmic creation; and/or in the esoteric sense that by a mystical union of male and female in a ritual context, all duality can be transcended to reach the end of the endless cycle of birth and death.

According to Tantric Buddhist lore Yama, the god of death of Indian origin, devastated nearly the whole of Tibet until he was finally defeated by Yamataka, *vanquisher of Yama.* But Yama's and

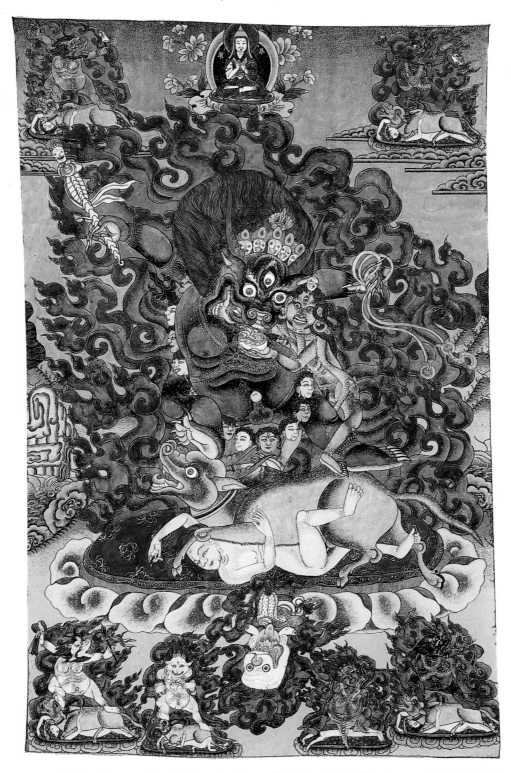

Newari and Tibetan Vajrayana thangka (c. 1990) of Yama with the head of a buffalo, alone or with his twin sister Yami, dancing on a primordial couple (53 x 76 cm)

Yamantaka's iconography have remained so similar that a closer analysis of this change of 'personality' would not bear any fruit for our concerns here.

Tibetans must have studied many ancient texts of India, including the Vedas. It is therefore not surprizing that Yamataka was also known as Vajra-Bhairava, one of the eight terrible manifestations of Siva. There was such a great functional similarity between Yamataka and Siva that both were also referred to as Mahakala, the Great Black one. Mahakala became the great protector of Buddhism who devoured enemies and adherents of other religions, and is known in seventy-five different forms, all of which can be traced to forms of Siva as conceived by Hindus.

Thangkas are used for visualization in meditation. Not only for a Westerner does this particular scene of a sexually aroused male with a bull's head dancing naked with his equally fierce consort on a buffalo copulating with a woman, all painted in dramatic detail and surrounded by a ring of wild flames, quite apparently have an aspect of terror, but also for a Tibetan who was born into a culture pervaded by such images. Thus the meditation can be regarded as incorporating a kind of shock therapy which confronts the meditator with the harsh truth of the evanescence of all forms of life; all are equally subject to birth, suffering and death. The gods were only created to enable the meditator to understand him/herself.

Vajrayogini, 'The Adamantine Female Ascetic' and Chinnamasta, 'The Split-Head Deity'

On our detective tour through Tantric scripture and art to discover the origin and logic of meditation techniques using sexual union, we cannot avoid gazing at the image of Vajrayogini, literally the *adamantine-female-ascetic*. She has already been mentioned as the partner in actual sexual union in left-handed Tantric ritual. In that role she is also known as a dakini, literally a *space-flyer*, a term which hints at a transparency of consciousness.

Painted on thangkas, Yoginis take on a less physical and more divine meaning. Often they are shown as a group of five with particular names, body colors, and adornments, symbolizing five types of wisdom and also the ultimate unity of all existence; in this case they correspond to the five Heruka Buddhas of Vajrayana (see figures on page 192—194). Some mandalas show Vajrayogini

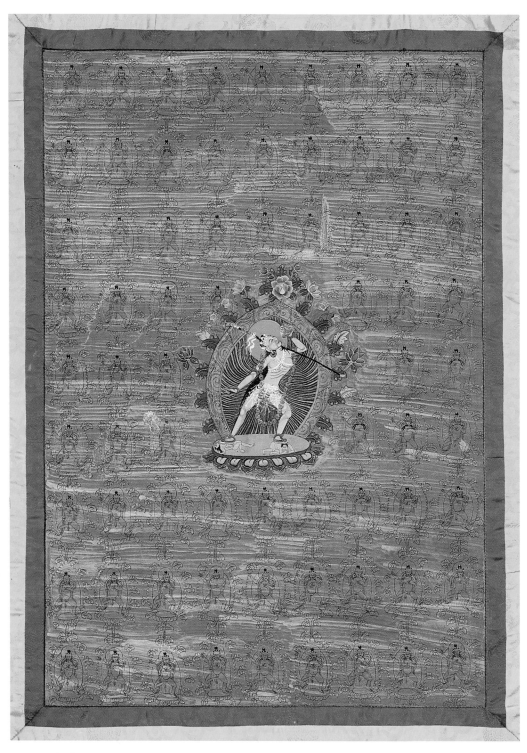

Newari and Tibetan Vajrayana thangkas of Vajrayoginis alone or in sets of five, standing on a primordial couple or a single vanquished human (53 x 75 cm)

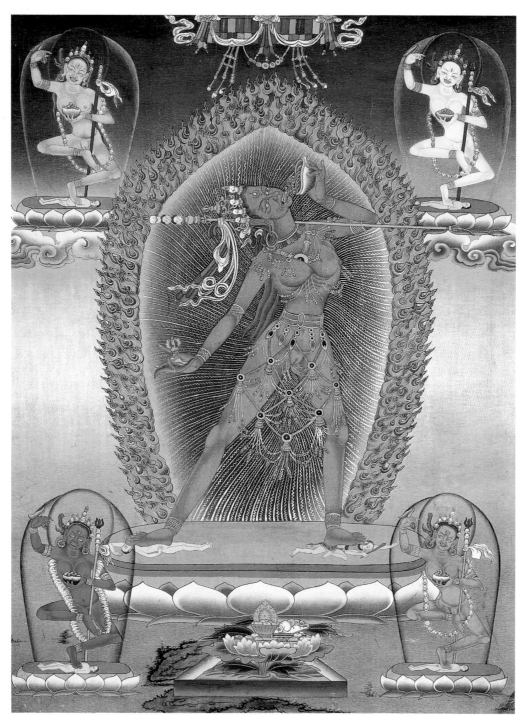

Newari and Tibetan Vajrayana thangkas of Vajrayoginis alone or in sets of five, standing on a primordial couple or a single vanquished human (39 x 51 cm)

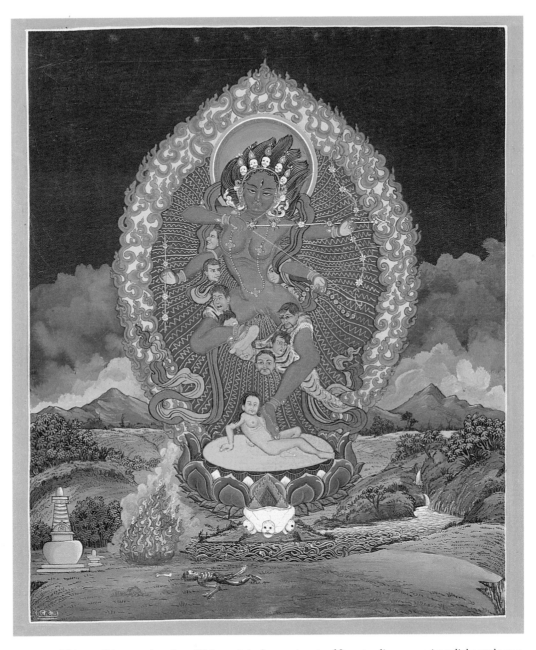

Newari and Tibetan Vajrayana thangkas of Vajrayoginis alone or in sets of five, standing on a primordial couple or a single vanquished human (25 x 30 cm)

as consorts sitting in yab-yum fashion with their wrathful male counterparts. Yoginis also appear on thangkas as two attendants at either side of the mother-goddess Kali, surely the fiercest anthropomorphic expression of the cosmic process of creation and destruction.

Yoginis are typically painted standing alone and erect, in a dancing posture with one leg stepping forward, or in a bow-and-arrow position. They too are contained within the stylized ring of flames. In their hands they hold a Tantric staff symbolizing the male principle, a hand-drum symbolizing the female principle, and a skull filled with blood, secret symbol of the five sacred ambrosias. They represent the Vajrayana union of wisdom (arrow) and means (bow), of emptiness and compassion, and echo the Hindu Tantric union of Siva-Sakti.

Symbolizing the union of wisdom and compassion in the psychological universe of Buddhist tradition (as Kali symbolizes the union of kinetic and static aspects of the physical universe of Hindu tradition), the Vajrayogini clearly functions as a visual icon of the unio mystica. Under her feet a separated male and female couple often appear, just as in the Kalacacra-Cacrasamvara icon. This is again a statement that the experience of mystical union between the meditator and the cosmos can stop the cycle of creation and destruction forever.

The images of Vajrayoginis alone provide no indication that the unio mystica can be achieved by sexual intercourse, actual or symbolic. The message of the Vajrayogini seems identical, whether she is shown dancing triumphantly on a single naked human corpse (figure on page 194) or on two separated living ones (figures on page 192—193). "These goddesses with their magic powers can be understood as personal initiation deities who help the Tantrika in his experience of mystical death and reincarnation, and represent feelings and thoughts in the karmic process of the human being" (*Lavizzari-Raeuber, 203*). Again we see that deities have been created in order for adepts to better understand themselves.

The most awesome form of a Vajrayogini is the originally Indian goddess Chinnamasta (literally 'split-headed-deity'). She holds her own chopped-off head in one hand, while the other hand grips the still-bloody sword. Blood is gushing from her headless trunk into the mouth of her own head as well as the

mouths of her two attendant dakinis. A garland of skulls hangs down from her neck. She dances on top of a couple in sexual union, representing Rati and Kama, the Indian goddess of sexual pleasures and god of love, respectively.

Exoterically speaking, Chinnamasta presents the basic paradox of natural life: from the moment of conception one is heading towards annihilation. The physical deathrate of humankind has been and still is 100 %. Birth and death are but two faces of the same coin. (I recall here that both Grof's and my own experiments with transpersonal therapy made the birth process also appear as a death process.)

Interpreted esoterically, the Chinnamasta icon combines and communicates visually the basic mysteries revealed by meditation. First, the blood forms a sort of flow chart of the vital energy or Kundalini, which rises through the three basic channels of the subtle body and is marked by polar opposition up to the subtlest levels of existence, represented by the two attendants who also feed on the blood. Second, transcendence of the cycle of birth and death is represented by the goddess dancing triumphantly atop a copulating couple. Third, consciousness without thought, the goal and the means of meditation, is symbolized by self-decapitation.

The entire scene is often set inside a circle of flames. By identifying with Chinnamasta, the meditator may come to realize the ultimate emptiness of the whole process of sensory existence. Yet the supreme dictum of Tantra reminds us: That by which the world is bound is that by which the bonds are released. In this sense, the Chinnamasta icon states that the realm of sensory experience or samsara (the copulating couple) and the realm of meditation or nirvana (the decapitated deity) are interdependent polarities, different aspects of a larger whole. The body is the indispensable instrument for liberation from the body and its transience.

At the end of our survey of classical Tantric art we find that the various respresentations of sexual union in the Hindu and Buddhist traditions offer two basic visions. They can be interpreted either as a symbol of hierogamy, the primal marriage of gods; or a symbol of unio mystica, the marriage of individual and cosmos; or both. As an intimation of unio mystica, the image of sexual union is a logical choice because it refers to an experience

of unity that is familiar to most people. Nowhere, however, have we encountered convincing evidence that sexual union in general, or any one particular method of such physical union, can actually lead to full transcendence of the 'disease' of duality. That remains only hearsay even in The Great Book of Tantra.

We should close with another glance at Chinnamasta. It would be hard to find a better or more concise visual representation of the nature of existence in its evolutionary process of creation and destruction, and the nature of meditation, which is a process of involution or reintegration with the original unity, the Ursprung which has always been present. Chinnamasta epitomizes the genius of Mahayana Buddhism in eschewing *devotion* to a historical figure, the Buddha, and demanding *self-identification* with transcendent truths by means of meditation (as the Buddha himself demanded). Symbols of the truths were invented and ritual actions were adopted in order to aid the work of meditation, which is to internalize, to become those truths. The icons of Tantra teach that the body is the indispensable instrument for liberation from the body and its transience.

For a caption to the image of Chinnamasta, we may draw on the Hevajra Tantra (*Snellgrove p. 92.*): "That world is pervaded by bliss, which pervades and is itself pervaded. Just as the perfume of a flower depends upon the flower, and without the flower becomes impossible, likewise without form … bliss would not be perceived."

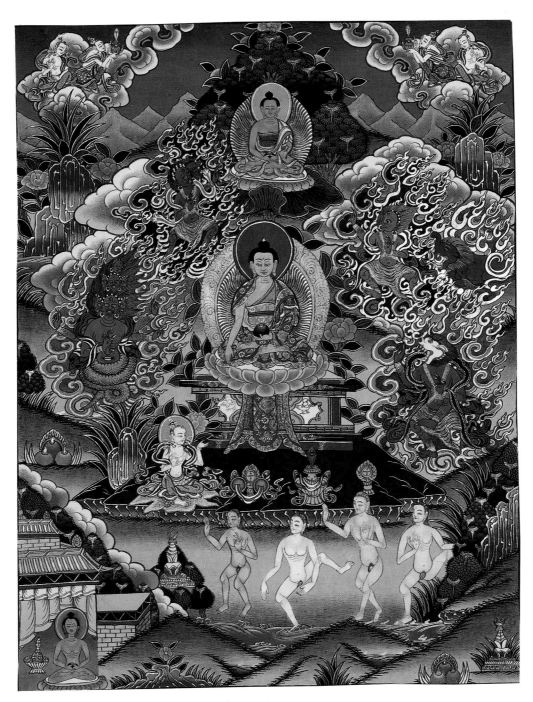

Temptation of Buddha (38 x 49 cm)

Meditation,
Creativity, Language

In spite of, or because of all the social and environmental up-
heavals of our time, a new human consciousness is quietly arising.
Significantly, this new consciousness is not being born out of the
old established world religions, nor out of the new ones which
are popping up in the developed nations like mushrooms after a
spring shower. It is created by the many unrelated individuals who,
as true seekers after their own original natures, rebel against the
established paradigms of thought and belief which society has
engraved into their egos. Thus it is rebellion against their own
egos. In this rebellion the old religions, including Hinduism and
Buddhism despite their novel appeal to the Western mind, are not
only of no help, but even become hindrances with their immovable
doctrines and rusty beliefs. Religious beliefs, more than anything
else imprison the human against authentic religious experience.

A case in point is the attitudes held by the sainted founders of
great religions on the topic of sex, a main theme of this book.
Both Jesus Christ and Gautama Buddha are reported to have been
tempted in their meditations by the devil who can only have
resided in their own minds. In each case the devil produced ap-
paritions of beautiful naked women bent on distracting the man
from his serene state of consciousness into the world of carnal
desire. Either the stories are true and thus must have been re-
counted by the great men themselves, or they were fabricated
later by followers. In either case, we may confirm that the mindset
behind the religion negates male-female sexuality. Why should a
woman's body disturb me if I am engaged in finding my own true
nature or that of the whole of reality? Why should this one part of
nature disturb my meditation more than, say, a male body or a
beefsteak or a spider? Can consciousness be made whole or inte-
grated by rejecting or fearing the surface, the physical reality of a
human body? Now knowing the potential of Mandalic Sex Medi-
tation the often grotesque Thangka illustrations of this event in
Buddha's life on thangkas could be interpreted not as temptation
away from meditation, but as an invitation to it, namely in the
form of the Silent Orgasm.

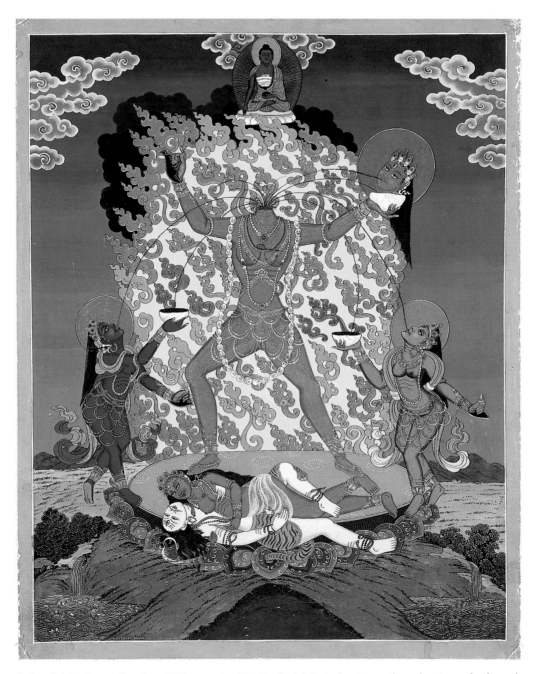

Left and right: Newari thangkas of Chinnamasta, with attendant dakinis, dancing on the embracing gods of sexual pleasure and love (38 x 47 cm)

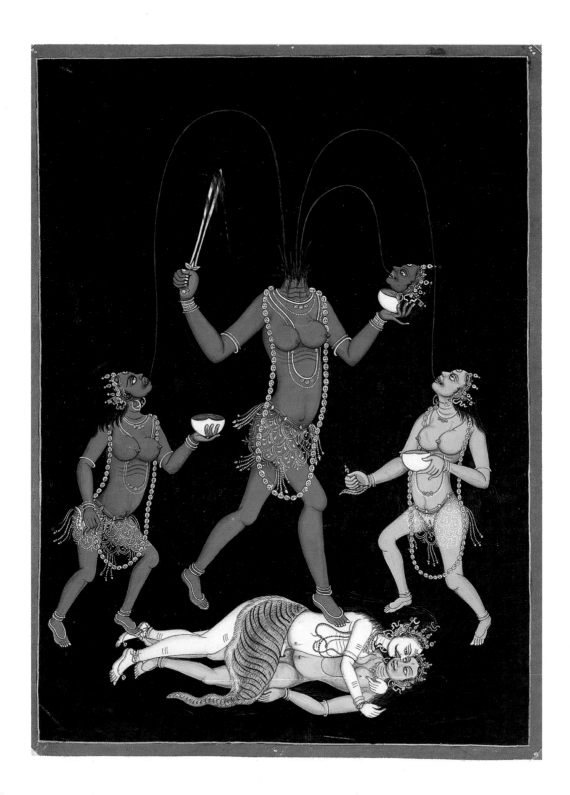

These episodes bear clear testimony of their own suppression of sex, which hit back at the first opportunity, namely when they lost control, when they were utterly relaxed. Suppressed feelings always do. Things might have been made right with the enlightenment of the two beings, but they were not. Jesus built his church on a man, Peter, and Buddha for a long time would not initiate women. Both religions established monastic communities with strict gender separation. The suppression of sex lives on in such forms as the pervasive Eastern belief that in order to attain enlightenment one first must gain a male body, or the Christian belief in the immaculate conception. Religions tend to find something basically wrong with the female body.

I use the term 'new consciousness' to mean having looked deep inside and transcended such prejudicial attitudes. Such an awareness accepts sex as a natural phenomenon which (like other phenomena of any sort) can be used to go outwards to create a new human being, and can also be used to go inwards to create oneself.

My glimpses of meditation have taught me that creation, ceaseless creativity, is the only basic law governing the universe. Nature never repeats itself. No leaf on any one tree is identical to the one next to it or to any other thousands of miles away. The only objects I know which repeat themselves are the human mind and some of its mechanical creations.

Creativity does not originate from the conscious human mind nor, as some would have it, does it flow from any level of the unconscious or transpersonal mind. It does not arise from the mind at all. Creativity is a spiritual phenomenon which arises from beyond the mind, which belongs to the 'fourth' level, a level "prior to consciousness" as N. Maharaj put it. Creativity is not only a spiritual quality, but the quality of the universe as such. As such it defies verbal encagement. Language is too restricted a tool to express it.

Meditation can tap it; that is why even a millisecond of meditation has such an energizing effect on the human system. Everything else, everything fixed, will sooner or later become stale or tiresome. I have found no exception. The reason for the sterility of the great religions is that they do no accept change and creativity. As institutions they cannot accept the paradox that our original source is always present at every moment, and likewise always

different each time we merge with it. No-one can catch truth, encage it, and sell it for all eternity.

The chance to taste this creativity is by no means limited to the mystic or the meditator. It is equally available to the scientist, the artist, the parent or the child. The lowliest artist, the most obscure inventor, the humblest housewife preparing an unrehearsed meal, all extend our vision of the universe, indeed the universe itself, with their personal gifts. As I am an integral part of this universe and as I learn, so too does the whole. Jean Charon's model of consciousness progressing simultaneously in the whole and the individual seems to approach a universal law of creativity (see Chapter Three).

The stagnant opposition among *objective* science and 'subjective' art and what we might call *transjective* mysticism can be superseded by tapping meditation. Each discovery, each intuition, each masterstroke comes from the unfathomable gap that is meditation. During meditation one enters these moments, or better, non-moments of discovery, of invention, of intuition consciously. Educational institutions which do not offer courses in meditation are neglecting to develop their students' creativity. Although some academics may find such a statement threatening or heretical, the truth is that meditation is not against the mind and logical reasoning, even if it goes beyond the mind. Meditation uses the mind and also recognizes the limits of the mind. The new consciousness of humankind will not allow itself to be pigeonholed in academic categories such as science, art, humanities or mysticism. It will claim and cultivate the full spectrum of creative potential. This is the ultimate delight of human activity, and here language can take me no further, although staying silent would not be adequate either.

As for language, I am daunted to look back over my own manuscript and find such weighty words as reality, unity, consciousness, void, bliss … Can we ever understand their meanings, when we cannot even understand a flower or a pebble? Part of our comprehension must always be to simply marvel at them. Non-comprehension, even ignorance in a sense, is and will remain in our nature. I only wanted to communicate something about techniques of meditation and the adventure of doing them. But to begin saying or writing something is to enter into a dialogue with the thousands who have spoken to the same point

before, and to fall deeper into the nets of the only tool at hand, language.

Language for me has become somewhat strange. Born and raised a German, I thought, felt and dreamt in that language for many years. After twenty years in the USA, I found myself thinking, feeling and dreaming in English. Then came fifteen years in Japan, and I switched to Japanese. Now I no longer feel at home in any of these languages, even the one I received with my mother's milk. They are like toolkits to me, to be pulled out for the appropriate situations. After using one or the other, I close it up and I just am, without language. In a sense I have then become a baby again, for babies exist without language. And how beautifully they exist, without the language-dominated conceptual mind, in a state close to no-mind.

At times when I do not need language, I feel that I am not missing anything. But when I must use it, I am immediately aware of how restricting a tool it is, and nowhere does it seem more inadequate than in trying to discuss meditation. To speak of meditation is to banish oneself from meditation. Speaking about techniques may be possible, but for approaching the nature of meditation, silence seems at first to be the better tool. And yet, meditation is certainly not only about silence, for it vibrates with abundant life.

I close this cookbook on meditation with yet another method of meditation, one which turned up along my particular life path: the technique of allowing oneself to be robbed of the language one has spent so much effort in mastering. It might demand most of a lifetime to escape from the ubiquitous influence of knowledge and reasoning dominated by language. One would be able to return to a state comparable to infancy, but with the very great difference of being conscious of it.

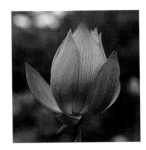

The Silent Orgasm

Glossary

Anapanasati
Yoga of awareness of ingoing and outgoing breath; Buddha's meditation technique.

Ardhanarisvara
Siva represented as archandrogyny, the left side of the body female, the right male, symbolizing cosmic biunity.

Asana
Yogic posture.

Atman
In Hinduism, one's individual consciousness, which is ultimately identical to cosmic consciousness or brahman.

Atman project
The various defenses the human being invents against an intuited atman consciousness or a consciousness of unity with the whole, the realization of which would demand one's dissolution as a separate ego. Coined by Wilber.

Bardo
'Intermediate state' (Tibetan) of samsaric, i.e. finite or phenomenal existence. According to Sogyal Rinpoche *bar* means 'in between' and *do* 'suspended'.

Bhairava
'Highest Reality', one of the eight terrifying manifestations of Siva, which are destructive in the sense of breaking down the ego. In Tantra, Bhairava is often the term for ultimate reality or the void. Implies, according to Singh's etymology, maintenance, withdrawal and projection of the world.

Bhoga
Enjoyment of sensual pleasures.

Bindu
'Point'. The extensionless point in the center of a yantra symbolizing original unity of the cosmos in its unmanifested state.

Brahma
The cosmic creator in the Hindu trinity, the two others being Siva, the destroyer, and Vishnu, the preserver.

Brahman
Absolute principle in Hinduism, cosmic or pure consciousness; equated in Tantric sadhana to the unity of Siva and Sakti, the male and female principles.

Cacrasamvara

'Assembly of mystic union' (Tibetan); translated by Snellgrove as 'supreme bliss'. See also samvara.

Chakra, also Cacra, cakra

'Wheel'. Pranic energy vortexes of the human 'subtle body'. Also, in Tantric ritual, assembly of divinities.

Chinnamasta

'Split-head deity'. Terrifying deity of Indian origin, a manifestation of the mother-goddess Kali; portrayed as cutting off her own head.

Citipati

A representation of the Tibetan god of death, → Yama, portrayed as male and female skeletons in coition.

Dakini

Vajrayogini, female Tantric adept.

Darshan, also

Meeting one's religious teacher or visiting a deity in a temple;
darsana also, philosophical theology. From Sanskrit *drs*, 'to see'.

DeHypnotherapy

Techniques of hypnotherapy used to awaken one from the hypnosis of the normal waking state of consciousness, and bring one into touch with deep layers of dormant consciousness. Coined by Osho.

Devi

Female deity.

Dharmata

Buddhist concept denoting the suchness of everything, the essence of reality as it is.

Dhyana

Meditation.

Garbha-griha

'Womb'. Innermost dark cella of a northern Hindu temple.

Hevajra

'Compassion-wisdom'. The Heruka or male wrathful deity at the center of the Hevajra Tantra system.

Holography

Three-dimensional photography in which visual information is stored on a plate as a hologram, a network of interference patterns which each hold numerous bits of information about the whole network (Welwood, in Wilber ed., 128).

Holomovement

Term coined by Bohm to describe his vision of the universe as "undivided whole-ness in flowing movement"; dynamic counterpart to a static hologram.

Holonomic

Having the nature of a hologram. Coined by Leonard.

Holotropic

Tending to move toward wholeness. Term used mainly to describe an intensive type of breathing or pneumocatharsis, or a type of therapy intended to activate the unconscious. Coined by Grof.

Ida

Vertical energy conduit in the left side of the subtle body, also known as the moon channel.

Jagriti

Waking consciousness, the first state of the 'three-plus-one' Vedanta model of consciousness.

Kalachakra

'Wheel of time'. A guardian deity of Vajrayana Buddhism; also an elaborate symbol for a system of Tantric meditation techniques, traceable to left-handed practices in the 10th century, often used on thangkas.

Kali

Popular Hindu goddess, and Tantric representation of Sakti, unifying the creative and destructive aspects of nature, portrayed with black skin, large breasts and a necklace of skulls. From Sanskrit *kal*, 'black', 'death' and/or 'time'.

Kapalika and Kaula

Sects of north-Indian Saivism which practiced extreme left-handed Tantric ritual; influenced erotic Hindu temples at Khajuraho.

Karma

Law of universal retribution; ethical principle of cause and effect continuing from one life to the next for each individual in the chain of transmigration through the six realms of existence up to enlightenment; probably originally derived from ex-periences of metempsychosis.

Koan

'Plan' or 'device' (Japanese). Unsolvable question given by a Zen master to a dis-ciple as an aid to concentration during meditation.

Kundalini

Dormant energy at the base of the spine, often translated as 'serpent power' and pictured as a coiled snake; to be elevated through yogic and Tantric techniques from root chakra to crownchakra.

Lamaism
Tantric Buddhism of Tibet.

Linga(m)
Stone phallus, symbol of Siva.

Mahakala
The Great Black One, a manifestation of the god of death.

Mahamudra
'Great gesture (posture)'. The void, final goal of Tantric meditation; also a certain Tantric sexual position.

Maithuna
Sexual union, Tantric copulation.

Mandala
'Circle'; cosmogram of the spatial and temporal structure of the universe, and psychogram of the inner structure of the human being; used as decoration or as a tool for ritual or meditation.

Mantra
A sound or sound sequence with or without meaning, uttered to effect a particular state of consciousness via sonic vibration; often imparted secretly by the guru; central tool of Hindu and Buddhist Tantric ritual and meditation (Buddhist Tantra is sometimes referred to as Mantrayana). From Sanskrit root *man*, 'to think' and suffix *krt*, 'instrumentality.'

Maya
Frequently used to denote the world as 'illusion' or 'a magic show'; denotes the entire phenomenal world, inside and outside the self, as experienced by normal waking consciousness, i.e. consensus reality.

Moksa
Final release from the bondage of the cycle of birth and death.

Nadis
General term for energy channels in the subtle body.

Nirvana
'The blowing out of the flame'. Liberation from finite or → samsaric existence.

Padma
Lotus; frequent Tantric symbol for female sex organ.

Parvati
The wife of Shiva.

The Silent Orgasm

Patanjali
Author of Yoga Sutra, the root text of yogic practice, written c. 2nd century AD but likely based on much older techniques.

Perinatal
Pertaining to episodes during and immediately before or after biological birth. Coined by Grof, from Greek *peri*, 'around', and Latin *natalis*, 'delivery.'

Pingala
Vertical energy conduit in the right side of the subtle body, also known as the sun channel.

Prakriti
The cosmic energy of nature, counterpart to purusa in the Samkhya philosophical system.

Prana
Vital energy contained in human breath and in the cosmos.

Psychohydraulics
Practices such as the pulling of kundalini energy from the bottom to the top cacra. Coined by Watts.

Puranas
'Ancient records' containing numerous instructions for ordinary life, devotional hymns, myths and biographies of the Hindu pantheon; recorded c. 1st century AD.

Purusa
Cosmic consciousness, counterpart to prakriti in the Samkhya philosophical system.

Qi
Vital energy; central concept of Chinese medicine and geomancy. In Japanese, *ki*.

Qigong
'Achievement of energy'; ancient Chinese healing practice in which vital energy is circulated in the body by combinations of movement, respiration and thought.

Rishi
Sage, especially one of those to whom the Vedas and Upanishads were revealed.

Sadhaka
Devotee of spiritual exercises.

Sadhana
Spiritual exercise, in the form of either ritual or meditation.

Saiva, Saivite
Denoting anything or anyone related to Siva worship.

Sakti
Feminine, kinetic principle of the universe, counterpart to Siva, the masculine, passive principle; also, divine consort to Siva as deity.

Samadhi
'Conjunction' or 'totality' (called 'yogic enstasis' by Eliade). Continuous paradoxical state of mystical union of absolute emptiness and fullness, the goal of all meditation and yogic practice.

Samkhya
'Discrimination'. The earliest Indian philosophical system, c. 500 BC.

Samsara
Phenomenal or finite experience marked by the cycle of birth and death in one of the six realms of transitory existence; antithesis of → **nirvana**.

Samvara
'Union', mainly in the sense of unio mystica. Described in Hevajra Tantra as "the single union of all phenomenal forms".

Sannyasi(n)
Spiritual initiate; originally a religious medicant subsisting on alms, the fourth and last stage in the life of a Brahmin.

Satori
Glimpse of enlightenment (Japanese).

Shikhara
'Mountain peak'. The highest structure of a northern Hindu temple.

Siva
Deity of the Hindu trinity, along with Brahma and Vishnu. The destroyer; also, when portrayed with Sakti, the masculine, passive principle of cosmic consciousness.

Skandhas
In Buddhism, the five psychosomatic constituents of the human being: form, feeling, perception, intention, consciousness.

Sobna
Dream consciousness, the second state of the 'three-plus-one' Vedanta model of consciousness.

Sunya
Buddhist notion of 'emptiness' or 'void'; a positive sense of presence devoid of 'thingness' (different from the Western, negative sense of 'the void' as a hollowness; 'horror vacui').

Sushupti
Dreamless consciousness, third state of the 'three-plus-one' Vedanta model of consciousness.

Susumna
Central vertical energy conduit of the subtle body, located in the spinal column, along which kundalini rises.

Tantra
'That by which consciousness is expanded or made transparent' (from Sanskrit *tan*, 'to stretch, expand, make transparent', and *krt*, 'instrumentality'). Also used as title of the numerous ritual and magical scriptures of Tantric Hinduism or Buddhism.

Thangka
'That which can be rolled up' (Tibetan). Religious scroll painting used for decoration, transmission of doctrine, ritual, or visualization in meditation.

Upanishads
'Esoteric doctrines' appended to the Vedas, the oldest dating from 600 BC; foundation of the metaphysics developed in Indian philosophy.

Vajra
In the vedas, 'thunderbolt', divine weapon of Indra, the god personifying the firmament or athmosphere. In Vajrayana, 'diamond' or that which is indestructible and absolutely transparent, i.e. ultimate nature (Vajra sattva is 'absolute being'). In Tantra frequently the male sex organ.

Vajrayana
Usually 'Diamond Vehicle'; my translation is 'Transparency Vehicle'. Branch of Mahayana Buddhism in which the notion of the void is replaced by that of the diamond or vajra; originated in India with the brothers Asanga and Vasubandhu, 4th/5th century AD.

Vajrayogini
'Adamantine female yogic ascetic'. Actual female partner in left-hand Tantric ritual practice, also called dakini. Depicted on thangkas as the consort of a wrathful deity, or as a solitary representation of the five Heruka Bhuddhas.

Vedanta
System of philosophical-theological speculation based on the Vedas and Upanishads.

Vedas
Foundation texts of Hinduism, probably composed between 1500 and 1000 BC. From Sanskrit *vid*, 'to know'; often rendered as 'hymns of divine knowledge'.

Yab-yum
'Father-mother' (Tibetan). Icon of male-female sexual union, the Vajrayana equivalent to a Hindu deity couple.

Yama
Vajrayana Buddhist god of death, portrayed with the head of a water buffalo, often with his twin sister yami.

Yantra
Cosmogram/psychogram of abstract geometric form (rather than the anthropomorphic and pictorial forms of a mandala), used in ritual and meditation. From the root *yam*, 'to support', and suffix *krt*, 'instrumentality.'

Yoga
'Yoke'. Mystical discipline using asceticism and meditation to unite individual and cosmic consciousness.

Yogini
Female ascetic or yogin. See vajrayogini.

Yoni
Vagina; symbol of Shakti.

Bibliography

Aivanhov, Omraam Mikhael, Cosmic Moral Laws, Editions Prosveta, 1984, Vol. 12.

Akahori, Akira, Drug Taking and Immortality, in Kohn,L., Taoist Meditation and Longevity Techniques, Ann Arbor: The University of Michigan, 1989.

Anand, Margo, The Art of Sexual Ecstasy, Los Angeles: Jeremy P. Tarcher, 1989.

Baharati, Agehananda, The Tantric Tradition, Westport: Greenwood Press, 1977.

Berendt, Joachim-Ernst, Das Dritte Ohr [The Third Ear], Hamburg: Rowolt Verlag, 1988.

Bohm, David, Wholeness and the Implicate Order, London: Ark Paperbacks, 1983.

Capra, Fritjof, The Tao of Physics, Berkeley: Shambala Publications, 1975.

Chandra, Pramod, The Kaula-Kapalika Cults At Khajuraho, in Lalit Kala No. 1 & 2, India, 1955, 1956.

Charon, Jean E., Der Geist der Materie, [The Spirit of Matter], Frankfurt: Ullstein Verlag, 1977.

Chia, Mantak, Taoist Secrets of Love—Cultivating Male Sexual Energy, NewYork: Aurora Press, 1984.

Chia, Mantak & Maneewan, Healing Love through the Tao—Cultivating Female Sexual Energy, New York: Healing Tao Books, 1986.

Coomaraswamy, Ananda, K., Christian & Oriental Philosophy of Art, New York: Dover Publications, 1956.

Da Free John, The Dreaded Gom-boo or The Imaginary Disease that Religion Seeks to Cure, Clearlake: The Dawn Horse Press, 1983.

Dasgupta, Sh.B., An Introduction to Tantric Buddhism, Calcutta: University Press, 1950.

Dowson, John, A Classical Dictionary of Hindu Mythology and Religion, Ludhiana: Lyall Book Depot, 1970.

Eliade, Mircea, Yoga—Immortality and Freedom, NewYork: Bollingen Foundation, 1958.

Eliade, Mircea, The Sacred and the Profane—The Nature of Religion, NewYork: Harper and Row, 1961.

Evens-Wentz, William Y., and *Dawa-Samdup, Kazi,* The Tibetan Book of the Dead, London: Oxford University Press, 1960.

Feuerstein, Georg, Holy Madness—The Shock Tactics and Radical Teachings of Crazy-Wise Adepts, Holy Fools, and Rascal Gurus, Arcana Books, 1990.

Fremantle, F. and Trungpa, Chögyam, The Tibetan Book of the Dead—The Great Liberation Through Hearing in the Bardo, Berkeley and London: Shambala, 1975.

Gebser, Jean, Ursprung und Gegenwart, [Origin and Presence], Band II & III, in Jean Gebser Gesamtausgabe, Schaffhausen: Novalis Verlag, 1986.

Getty, Alice, The Gods of Northern Buddhism, Rutland, Vermont: Charles Tuttle, 1962.

Grof, Stanislav, and Halifax, Joan, The Human Encounter with Death, New York: Dutton, 1978.

Grof, Stanislav, Beyond the Brain—Birth, Death and Transcendence in Psychotherapy, New York: State University of New York Press, 1985.

Grof, Stanislav, The Adventure of Self-Discovery, New York: State University of New York Press, 1988.

Guenther, Herbert V., The Royal Song of Saraha—A Study in the History of Buddhist Thought, Seattle: University of Washington Press, 1969.

Hanh, Thich Nhat, The Sutra on the Full Awareness of Breathing, Berkeley: Parallax Press, 1988.

Hume, Robert Ernest, The Thirteen Principal Upanishads, London: Oxford University Press, 1962.

Huxley, Aldous, The Perennial Philosophy, Glasgow: Fontana Books, 1961.

Jackson, David P. & Janice A., Tibetan Thangka Painting—Methods & Materials, London: Serinda Publications, 1984.

Janov, Arthyr, The Primal Scream, New York: Dell Publishing Co., 1970.

Janov, Arthyr, The Anatomy of Mental Illness, New York: Berkeley Publishing Co., 1977.

Kersten, Holger, Jesus lebte in Indien, München, Knaur Verlag, 1983.

Khanna, Madhu., Yantra—The Tantric Symbol of Cosmic Unity, London: Thames and Hudson, 1979.

Kohn, Livia, (ed.), Taoist Meditation and Longevity Techniques, Ann Arbor: The University of Michigan, 1989.

Krishna, Gopi, The Awakening of Kundalini, New York: E. P. Dutton, 1975.

Krishnamurti, U.G., The Mystique of Enlightenment—The unrational ideas of a man called U.G., Goa: Dinesh Vaghela Cemetile Corp., 1982.

Kuhn, Theodore S., The Structure of Scientific Revolutions, Chicago: University of Chicago Press, 1970.

Lauf, Detlef Ingo, Secret Doctrines of the Tibetan Books of the Dead, Boston: Shambala, 1989.

Lavizzari-Raeuber, A., Thangkas-Rollbilder aus dem Himalaya, Köln: DuMont, 1984.

Leadbeater, C.W., The Chakras, Madras/London: The Theosophical Publishing House, 1927.

Leary, Timothy; Metzner, Ralph; Alpert, R, The Psychedelic Experience—A Manual Based on the Tibetan Book of the Dead, New York: University Books, 1964.

Leonard, George, The Silent Pulse, New York: E. P. Dutton, 1978.

Lodö, Lama, Bardo Teachings—The Way of Death and Rebirth, San Francisco: KDK Publications, 1982.

Maharaj, Sri Nisargadatta, The Nectar of the Lord's Feet, Longmead: Element Books, 1987.

Maharshi, Ramana, Talks with Sri Ramana Maharshi, Tiruvannamali: Sri Ramanasramam, 1978.

Majupuria, T. Ch., Erotic Themes in Nepal, Kathmandu: Smt. Shakuntala Devi, 1978.

Michell, George, The Hindu Temple—An Introduction to its Meaning and Forms, New York: Harper & Row, 1977.

Mishra, Rammamurti S., Yoga Sutras—The Textbook of Yoga Psychology, New York: Anchor Press/Doubleday, 1973.

Monroe, Robert A., Journeys out of the Body, New York: Anchor Press, 1973.

Mookerjee, Ajitand Khanna, Madhu, The Tantric Way, Boston: New York Graphic Society, 1977.

Motoyama, Hiroshi and Brown, R., Science and Evolution of Consciousness—Chakras, Ki, and Psi, Brookline, Mass.: Autumn Press, 1978.

Motoyama, Hiroshi and Brown, R., Theories of the Chakras:Bridge to Higher Consciousness, Madras/London: The Theosophical Publishing House, 1981.

Muller-Ortega, P.E., Tantric Meditation: Vocalic Beginnings, in Goudriaan, Teun, ed.: Ritual and Speculation in Early Tantrism, Albany: State University of New York Press, 1992.

Namdak, Tenzin, Heart Drops of Dharmakaya—Dzogchen Practice of the Bön Tradition, Ithaca: Snow Lion Publications, 1993.

Neumann, Erich, The Origins and History of Consciousness, Princeton: Princeton Univ. Press, 1954.

Nitschke, Günter, From Post-Modern to New-Age Creativity, in Kino Hyoron No. 20, Kyoto: Kyoto Seika University, 1989.

Nitschke, Günter, The Architecture of the Japanese Garden, Köln: Benedikt Taschen Verlag, 1991.

MA-Place, Space, Void, in From Shinto to Ando, London: Academy Editions, 1993, p. 48–61.

Norbu, Namkhai, Dream Yoga and the Practice of the Natural Light, Ithaca, New York: Snow Lion Publications, 1992.

O'Flaherty, Wendy Doniger, Asceticism and Eroticism in the Mythology of Siva, London: Oxford Univ. Press, 1973.

Pal, Pratapaditya, Tibetan Paintings—A Study of Tibetan Thangkas, New Dehli: Time Books International, 1988.

Rajneesh, Bhagwan Shree, Dynamics of Meditation, Bombay: A Life Awakening Movement Publication, 1972.

Rajneesh, Bhagwan Shree, The Ultimate Alchemy-Discourses on the Atma Pooja Upanishad, Vol.1, Bombay: Anand-Shila Publications, 1974.

Rajneesh, Bhagwan Shree, No Water, No Moon, Poona: Rajneesh Foundation, 1975.

Rajneesh, Bhagwan Shree, The Book of the Secrets-Discourses on Vigyana Bhairava Tantra, 5 Vols., Poona: Rajneesh Foundation, 1974–1976.

Rajneesh, Bhagwan Shree, Tantra, The Supreme Understanding—Talks on Tilopa's Song of Mahamudra, Poona: Rajneesh Foundation, 1975.

Rajneesh, Bhagwan Shree, Vedanta-Seven Steps to Samadhi, Poona: Rajneesh Foundation, 1976.

Rajneesh, Bhagwan Shree, The Four States of Consciousness, in Sannyas Vol. 3, No. 2, Poona: Rajneesh Foundation, Foundation, 1976.

Rajneesh, Bhagwan Shree, Yoga—The Alpha and the Omega, Talks on the Yoga Sutras of Patanjali, Vols. 1–10, Poona: Rajneesh Foundation, 1976–1978.

Rajneesh, Bhagwan Shree, TAO—The Three Treasures, Talks on Laotse, Poona: Rajneesh Foundation, 1977.

Rajneesh, Bhagwan Shree, The Search—Talks on the Ten Bulls of Zen, Poona: Rajneesh Foundation, 1977.

Rajneesh, Bhagwan Shree, The Divine Melody, Poona: Rajneesh Foundation, 1978.

Rajneesh, Bhagwan Shree, The Tantra Vision—Talks on the Royal Song of Saraha, Vol. 2, Poona: Rajneesh Foundation, 1979.

Rajneesh, Bhagwan Shree, Unio Mystica—Talks on Hakim Sanai's 'The Hadiqa', Vol. 1, Poona: Rajneesh Foundation, 1980.

Rajneesh, Bhagwan Shree, Meditation—The First and Last Freedom, Cologne: The Rebel Publishing House, 1989.

Rawson, Philip, Sacred Tibet, London: Thames and Hudson, 1991.

Reps, Paul, Zen Flesh, Zen Bones, New York: Doubleday Anchor Books, 1961.

Sabom, Michael B., Recollections of Death, New York: Harper & Row, 1982.
Sierksma, F., Tibet's Terrifying Deities—Sex and Aggression in Religious Acculturation, Tokyo: Charles E. Tuttle, 1966.
Singh, Jaideva, The Yoga of Delight, Wonder and Astonishment: A Translation of the 'Vijnana-Bhairava', Albany: State University of New York Press, 1991.
Sinha, Indra, The Great Book of Tantra, Rochester, Vermont: Destiny Books, 1993.
Snellgrove, David L., The Hevajra Tantra, Vol. 1 and 2, London: Oxford University Press, 1959.
Sogyal, Rinpoche, The Tibetan Book of Living and Dying, New York: Harper Collins, 1992.
Stevens, John, Lust for Enlightenment-Buddhism and Sex, Boston: Shambala, 1990.
Thurmann, Robert, E. F., The Tibetan Book of the Dead, New York: Bantam Books, 1994.
Tucci, Giuseppe, The Theory and Practice of the Mandala, London: Rider & Co., 1961.
Tucci, Giuseppe, Rati-Lila-Studie über die erotischen Darstellungen in der Nepalesischen Kunst, Genf: Nagel Verlag, 1969.
van Gennep, Arnold, The Rites of Passage, Chicago: The University of Chicago Press, 1960.
Varenne, Jean, Yoga and the Hindu Tradition, Chicago, The University of Chicago Press, 1976.
Vivekananda, Swami, Raja Yoga, Calcutta: Advaita Ashrama, 1982.
Waddell, Austine L., Tibetan Buddhsim, New York: Dover Publications, 1972.
Watts, Alan, Erotic Spirituality, New York: Collier Macmillan Publishers, 1971.
— TAO—The Watercourse Way, New York: Pantheon Books, 1975.
Weiss, Brian L., Many Lives, Many Masters, New York: Simon & Schuster, 1988.
Wilber, Ken, ed., The Holgraphic Paradigm and other Paradoxes, Boston & London: Shambala, 1985.
Wilber, Ken, Up from Eden—A Transpersonal View of Human Evolution, Boston: Shambala, 1986.
Wilhelm, Richard, The Secret of the Golden Flower, London: Routledge & Kegan Paul, 1931.
Woodroffe, Sir John (Avalon, Arthur), Sakta and Sakti, Madras: Ganesh, 1918.
Woodroffe, Sir John (Avalon, Arthur), Serpent Power, Madras, 1954.

Audio and Video Tapes

Chakra Breathing, Meditations of Osho, Poona: Rajneeshdam.
Chakra Sounds, Meditations of Osho, Poona: Rajneeshdam.
Mystic Rose Meditation, Meditation with Bhagwan, Poona: Rajneeshdam.
The Invitation, Lecture 14, 28/8/1987, Poona: Osho Commune International.